My way is crossed by a single thread that connects everything.

Confucius

Art Center College Library
1700 Lida St.
Pasadena, CA 91103

ART CENTER COLLEGE OF DESIGN

3 3220 00236 1280

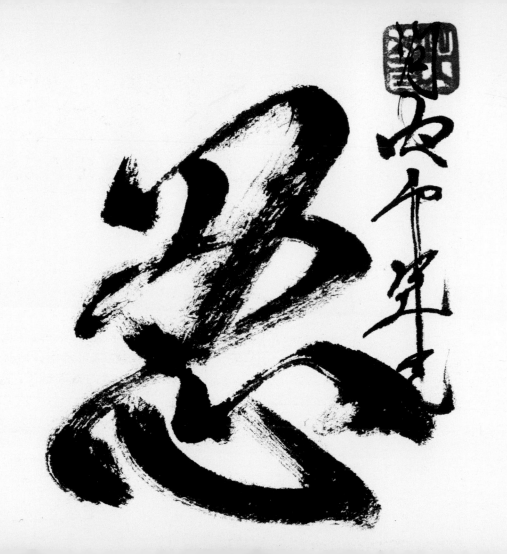

181
F 668
2007

AWAKENINGS
ASIAN WISDOM FOR EVERY DAY

Danielle and Olivier Föllmi

Foreword by Nan Huai Chin

Art Center College of Design
Library
1700 Lida Street
Pasadena, Calif. 91103

Ajahn Chah • Ananda W. P. Guruge • Aung San Suu Kyi • Buddha • Buddhadasa Bhikkhu • François Cheng

Chuang-tzu • Confucius • Taisen Deshimaru • Steve DeMasco • Dogen Zenji • Han Fei Zi • Nan Huai Chin

Meng Jiao • Okakura Kakuzo • Keizan Jokin • Issa Kobayashi • Lao-tzu • Lieh-tzu • Feng Menglong • Milarepa

Pu Yen-T'u • Shosan Suzuki • Shunryu Suzuki • Thich Nhat Han • Kenji Tokitsu • Chögyam Trungpa • Cheng Tsao

Tseng-tzu • Sun Tzu • Cao Xue Qin • Yoshida Kenko • Chao Yong • Han Yu • Meng Zi • Mo Zi • Hong Zicheng

ABRAMS, NEW YORK

Contents

Paths of Perfection

17 June to 4 August

Light Comes from Within
Conquering through Kindess
From Agitation to Calm
Returning to Simplicity
Appearances Are Misleading
Contemplating without Wanting
From Wanting to Giving

The Art of Living

5 August to 1 September

From Pride to Humility
Neither Holding nor Abandoning
Learning to Unlearn
Learning to Be

The Art of Success

2 September to 15 October

Awareness of the Self
No Need to Run
Every Step Is a Victory
From Fear to Courage
A State of Trust
Heroes of Enlightenment

The Art of Loving

16 October to 26 November

The Discipline of Openness
Sadness and Tenderness
Sharing our Hearts
Welcoming the World
Pure Goodness
A Single Brushstroke

Great Fullness

27 November to 31 December

Inexhaustible Emptiness
Cosmic Being
Celebrating the Journey
Art Is Life, Life Is Art
There Will Be No Ending

Art Center College of Design
Library
1700 Lida Street
Pasadena, Calif. 91103

Foreword by Nan Huai Chin

It was the best of times, it was the worst of times,
it was the age of wisdom, it was the age of foolishness,
it was the epoch of belief, it was the epoch of incredulity,
it was the season of Light, it was the season of Darkness,
it was the spring of hope, it was the winter of despair,
we had everything before us, we were all going direct to Heaven,
we were all going direct the other way…
Charles Dickens

In the modern world, thanks to Western culture which favours the promotion of material progress, we can easily travel around the world, we have splendid houses, and we lead our lives with all modern comforts. At first sight, it would seem that we live in an era of happiness; and yet we struggle to make our way in a competitive society, we are in fear of murderous wars, and we are drowning in a sea of unquenchable desires. Thus we live in an era of great suffering unprecedented in human history. Humanity is now facing an existential crisis that springs from the contrast between material abundance and spiritual poverty.

Sometimes we may be disappointed, but let us not despair, for we have the responsibility and the opportunity to perpetuate the ancient wisdoms that will enable the new generation to flourish. In order to bear on our shoulders this pillar which will carry the bridge between past and future, we must renew the ancient spirituality of the West and of the East. We must select those facets that will bring us spiritual nourishment and help us to enrich and fulfil ourselves and one

another. We must promote an exchange between the two cultures so that together we can deal with this great crisis now confronting humanity.

In an attempt to solve the current problems of the world – the environment, the diminution of natural resources, world peace – as an old man of ninety who has seen much of life, I would like to propose something that seems to me universal. Let us consider a fundamental, cosmic law: that of change, of mutation.

We must acknowledge that the law of Nature, the Dharma of the cosmos, the routine of all life, is subject to this rule of mutation. In both the material and the spiritual world, there is nothing that does not change. We must seize on this principle of change and follow its course. Not only must we follow it, but we must also have the wisdom to foresee it, prepare for it, and anticipate its consequences. Taoist wisdom tells us that in the stream of life we need only go with the natural flow. If you wish to stop that flow and utilize its strength, you will lose your energy. If you try to go against the flow, you will be drowned. Taoists also tell us: '*Follow the course of life, channel the current, and you will be carried in the right direction, you will profit from things without difficulty.*' To those who wish to dedicate their lives to preserving Nature and improving the future of humankind, I invite you to embrace the principle of change and work out a course of action...

Lao-tzu said: '*Having reached the extremity of the void, firmly anchored in quiet while ten thousand beings burst forth as one, I myself contemplate the return. People prosper at every opportunity, but they always return to their roots. To return to one's roots is quiet.*' In the change and movement of things there is quiet...It is easy to lose oneself in the change and to forget the quiet. We exhaust ourselves through pointless movements, and we use up all our natural resources, wasting our energies on all kinds of excesses, of luxuries. In order to maintain the health of body and mind, it is essential that everyone should cultivate the art of resting in quietness.

Lao-tzu said: '*Have you succeeded in harmonizing your body and soul so that they move in unison and do not drift apart? Have you succeeded in breathing as deeply as possible, as flexibly as possible like a newborn babe?*'

Let us calm our agitation, let us find our peace again, as relaxed as a newborn babe. I suggest you try two simple methods:

• The postures of meditation can be varied in ninety different ways. What is important is not the posture but the way you look into yourself, like a mirror of what is happening in your mind. Meditation allows you to find quiet.

• The song of the mantra will also help you to connect with yourself in inner peace. Once you hear the song, you will return quite naturally to a state of calm. Whether you are high in the mountains or down in the desert, if you chant a mantra, you will acquire a serenity that will move you to tears. They will not be tears of sorrow but of blessing and of gratitude. Your whole body will open up like a flower, and your cares will disappear completely. This joy of being in solitude, in quietude, can never be bought with money.

In China, the words that signify 'life' are *shan ming*. '*Shan*' means everything that contains life, '*Ming*' means everything that has a soul. It is that of which the Buddha speaks: body and soul are united, are One. To what does this 'life' lead us? What are these values? In China there is an old saying: '*Life is lighter than a feather, death is heavier than a mountain.*' It is this ancient tradition that influences the countries of Asia. Asian culture puts emphasis on kingship, filial devotion, fidelity, justice, morality. We respect those who devote their lives to a good cause for humanity, to the rule of justice and peace. Life and death are thus transcended.

And yet today this fine old code is gradually disappearing in the face of modernism. Current education places emphasis on the truth of knowledge, of pragmatism, and it is dissipating traditional culture…as a result, everyone follows the daily grind of life, but forgets to really live. Most people live without living – they no longer have roots or culture. They forget the meaning of their lives, the value of their lives.

Currently, the cultures of East and West have thus been disrupted; we are fighting for survival, and we forget to actually live. It is the duty of intellectuals to save the situation. We are preoccupied with earning more and more money – that is the aim of our careers. In the I Ching, the word 'career' means busying oneself in the service of the people, for the wellbeing of others. If everything we do is for ourselves, that is just a job. Let us never forget the true meaning of life.

Twenty years ago, when I wanted to invest in the railways of my native region of Wenzhou, I proposed four conditions to the Chinese government: '*Let us retain Communism as a Utopia, let us realize Socialism through social aid, let us improve management by emulating the efficiency of Capitalism, and let us disseminate traditional Chinese culture.*' I wanted to give all the profits to the villagers who lived along the railway line.

But the Chinese government did not accept these conditions. I gave the money with the sole intention of doing something for the people, and I did not gain a penny.

Once we truly realize that the world belongs to everyone, without egotism, we shall be invincible.

Mo-tzu insisted on the development of technology. He himself was a pioneer in science and in Chinese architecture. He was a world citizen. Whenever there was a war somewhere, he would go there to protest and to try and stop it…All his life he pleaded against war and advocated love. In promoting the rule of harmony on Earth, he was a fine example for the world of today.

By relying uniquely on the development of technology, we are plunging into the abyss of misery. It is time for us to bring together the sciences, the arts and the qualities of the spirit. Our wellbeing derives from the unity of these three things, and hope springs from this unity…

A lesson given by Nan Huai Chin in October 2006
at the Taihu Great Learning Centre in the province of Jiangsu.
Edited by Lin Liao Yi.

Who governs this?

Who maintains this?

Who, without acting, pushes and makes this move?

Chuang-tzu

The mountains of Huangshan, source of inspiration for traditional Chinese painting and literature. China.

The Tao begets the One.

Lao-tzu

A man bows on leaving the Buddhist temple of Sensoji before going back to work. Tokyo, Japan.

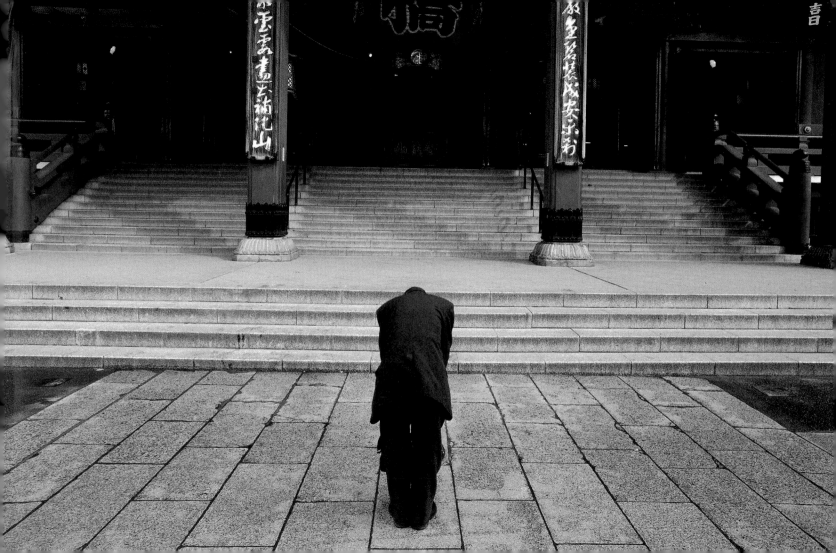

The One begets the Two.

Lao-tzu

A performer at the festival of Jidai Matsuri, which commemorates the history of Kyoto, Japan.

The Two begets the Three.

The Three begets all things.

Lao-tzu

Lin Ke Zi with his wife Pinbin and their son Xi Duo Lang. Xingping. China.

Through the One, the Sky is clear,
Through the One, the Earth is stable,
Through the One, minds are luminous,
Through the One, the ten thousand things are created.

Lao-tzu

Cranes gather among the flowering cherry trees by the lake at the shrine of Tsurugaoka Hachimangu in Kamakura, Japan.

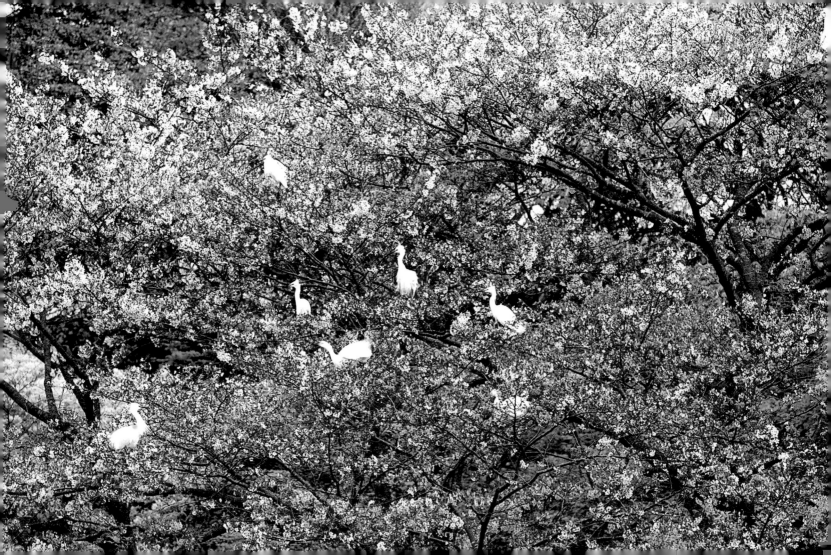

The cosmos is everything:
the stones, the mountains, the trees, the flowers, the grasses, the stars…
all that is nature and all that is not nature,
the artificial and all products that are human, material and spiritual,
and space and time.

Dogen Zenji

Koyasan, a centre of the esoteric school of Buddhism established in AD 816 by Kodo Daishi, one of the most venerated religious figures in the history of Japan.

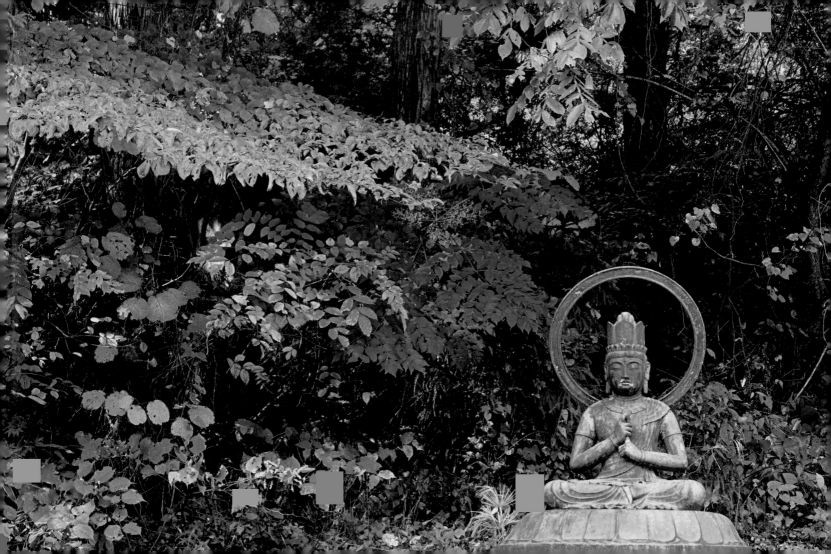

The whole cosmos, the whole universe is here and now,

both the distant past and the distant future,

eternity is here and now.

Dogen Zenji

After a day in the fields, the villagers of Minnanthu in Myanmar return to their homes.

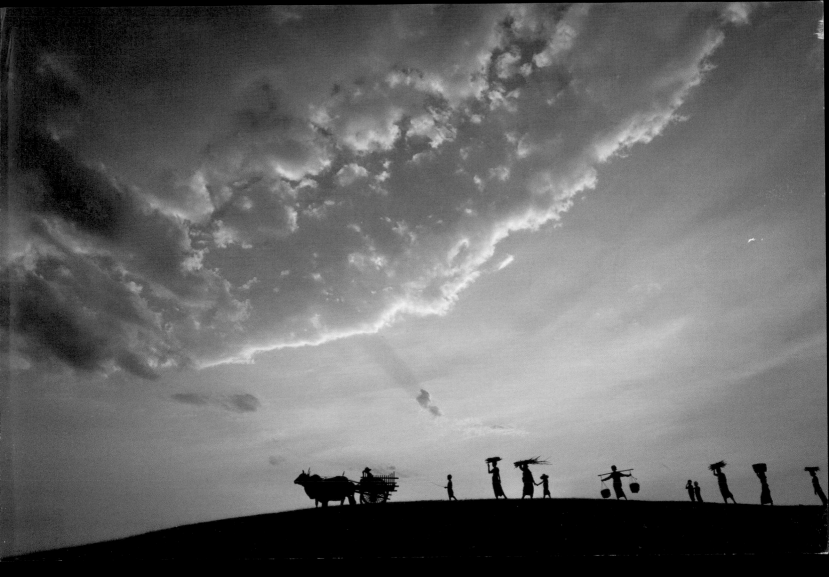

The Tao is great,

Heaven is great,

Earth is great,

and Mankind is great.

This is why *Mankind is one of the four Great Powers of the world.*

Lao-tzu

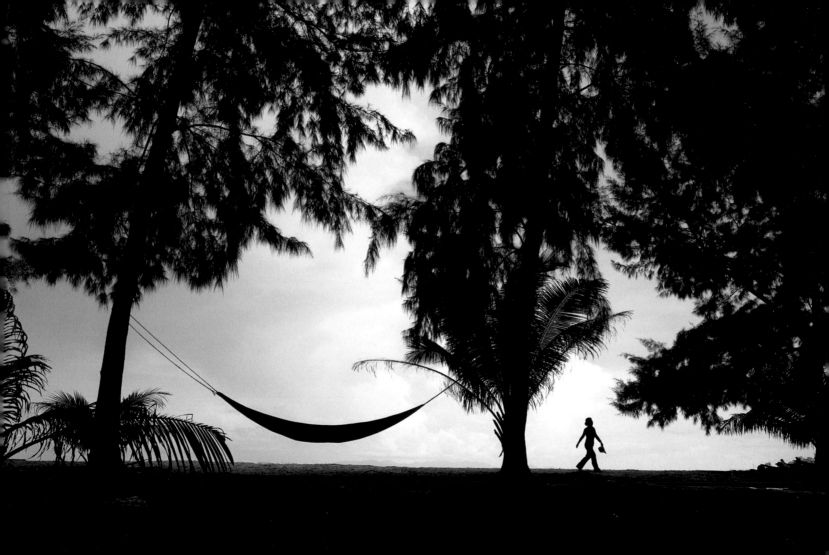

Heaven and earth are one.

Myself and the cosmos are one. All lives are one.

They have the same root. They have but a single body.

The wise man has no ego.

Jo Hoshi

Cherry trees in flower — an occasion for national celebration in Japan, attracting painters and photographers.

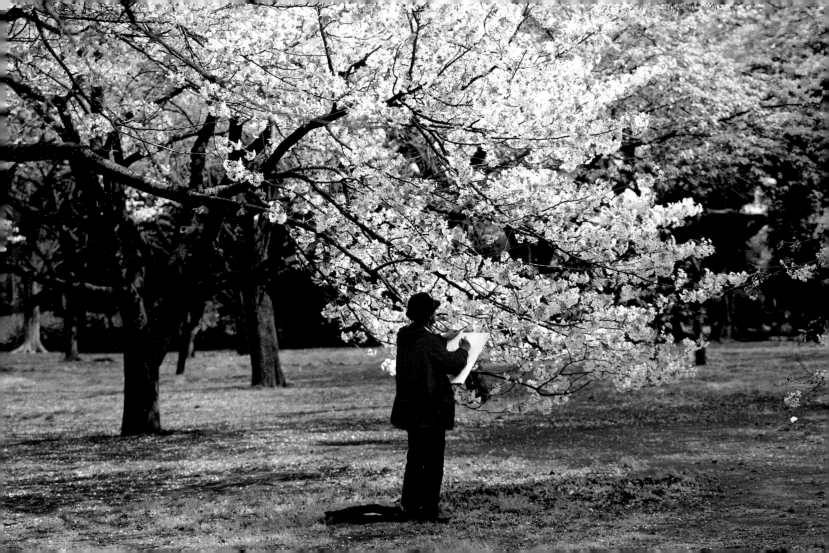

Heaven gives,

Earth receives and allows to grow,

Man accomplishes.

Only a man in perfect accord with himself,

in perfect sincerity,

can go to the limits of his own nature…

François Cheng

Ploughing near one of the 2,300 pagodas at the enchanting site of Bagan, Myanmar.

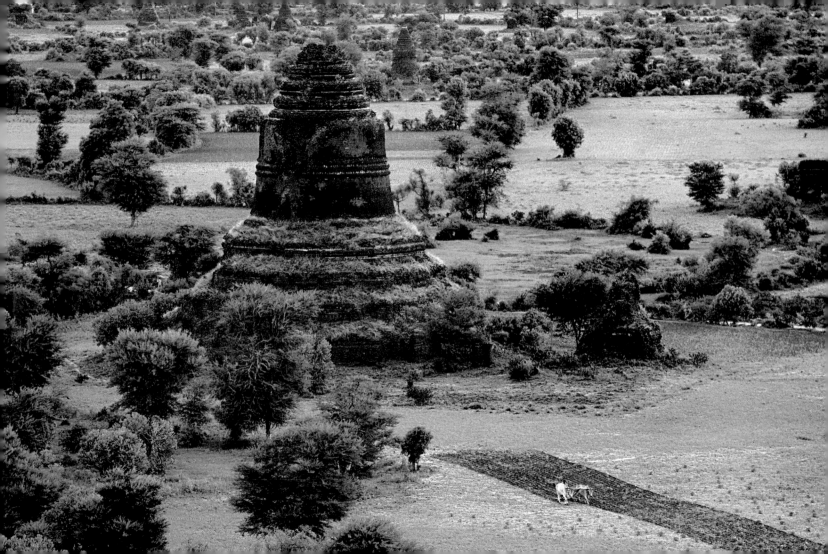

Like space,

Meditate without centre or limit!

Like the sun and the moon,

Meditate in brightness and clarity!

Like the mountains,

Meditate, unmoving and unshakeable!

Like the ocean,

Meditate, deep and unfathomable!

Milarepa

The mountains of Huangshan, source of inspiration for traditional Chinese painting and literature. China.

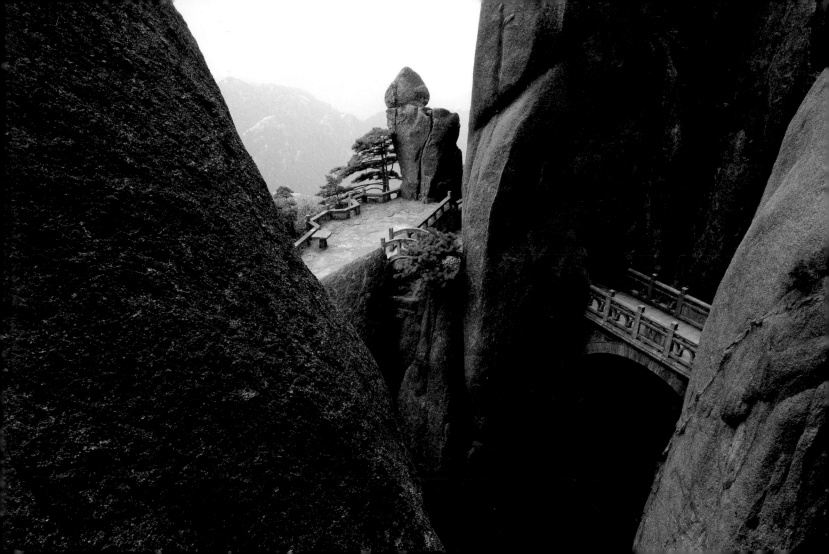

Your nature and your destiny are not within your own power:

it is heaven and earth that gave them to you.

Your children and your grandchildren do not belong to you,

they are loaned to you by the sky and the earth.

Emperor Guan

Bountieng, aged 3 months, in a wicker cradle protected by a mosquito net in the village of Ben Sop Jam, Laos.

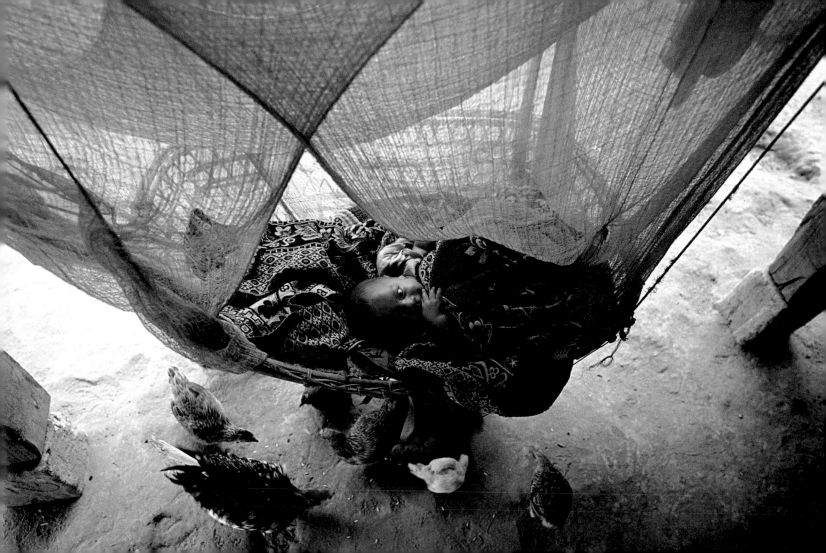

We should conform very closely to the cosmic order.
We should look at our limited consciousness,
and follow cosmic wisdom.

Dogen Zenji

In the village of Zhouzhuang, the Buddhist temple of Quanfu founded in 1086 and rebuilt in 1995. China.

When the human brain is calm,

in a state of deep serenity,

this human microcosm is the perfect and

harmonious image of the macrocosm.

Master Taisen Deshimaru

Lair, aged 4, from the village of Nong Khiaw, Laos.

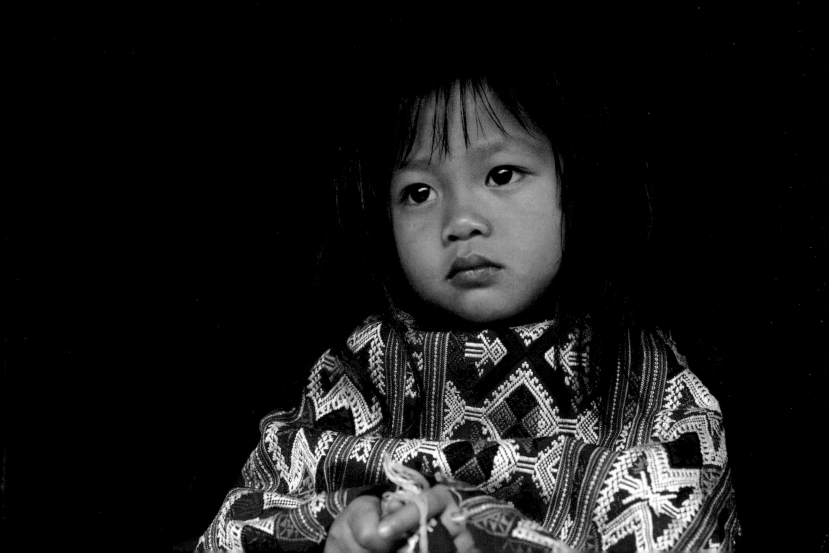

Come close and I will speak to you:

To meet an elder without respect is to lack ceremony.

To see a sage and not to honour him is not to be in charity with man.

Chuang-tzu

In the region of Dali, a Naxi farmer from Yunnan, on his way to the weekly market. China.

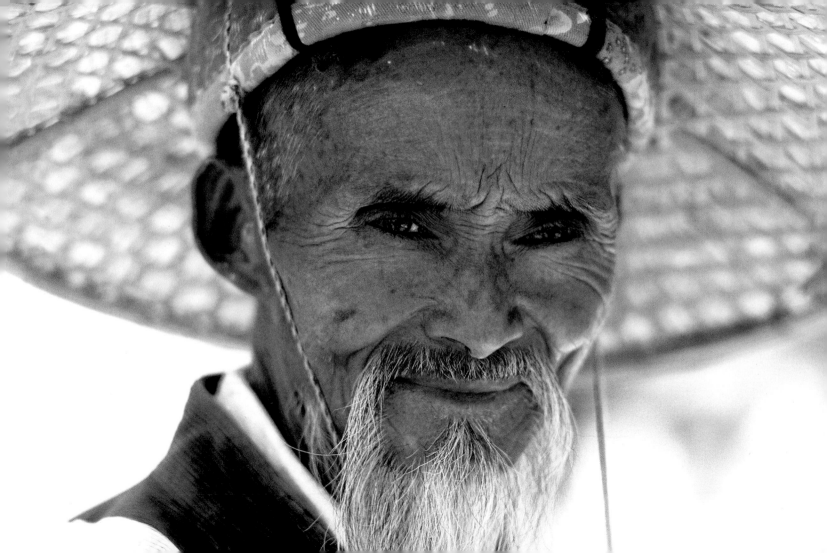

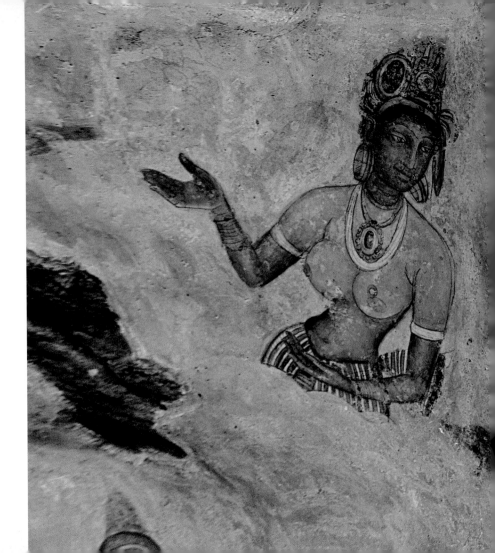

We are awakened through poetry,
we are affirmed through ritual,
we are fulfilled through music.

Confucius

Paintings of female figures in the citadel of Sigiriya, Sri Lanka.
The delicate colours have remained bright for 1,500 years.

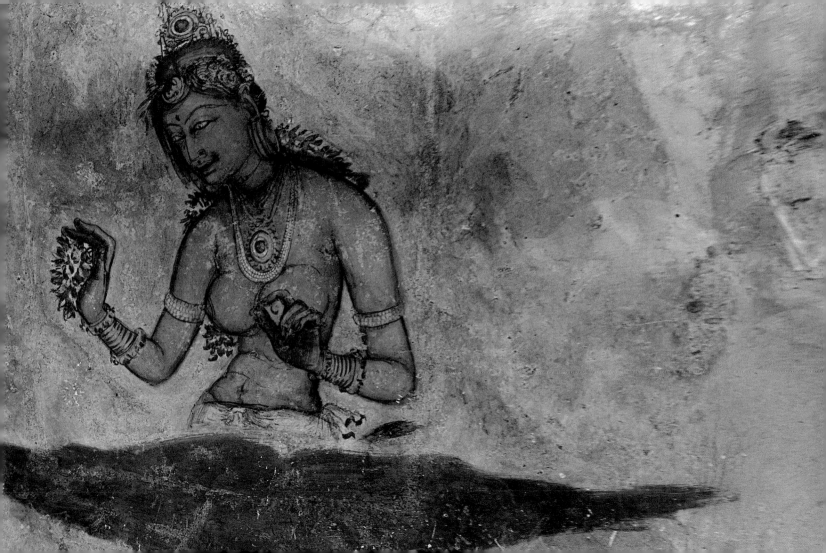

The champions of humanity, the guardians of human wisdom
have courageously expressed kindness and authenticity in the name of all beings.
Let us venerate their example and recognize the path that they have cleared for us.

Chögyam Trungpa

Statues of Buddha inside the grotto of Pak Ou, on the banks of the Mekong – a place of pilgrimage where hermits once lived. Laos.

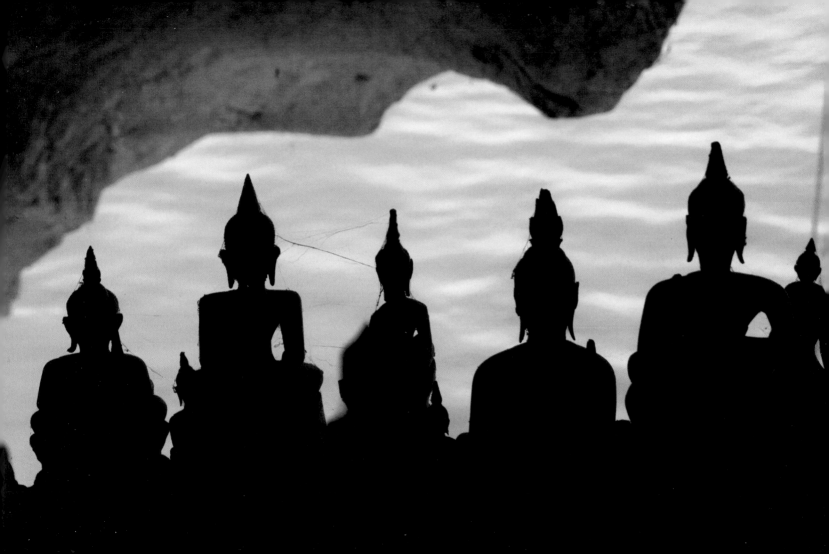

The voice of the ancestor brings enlightenment.

Korean proverb

Phyu Pyu Lin, aged 24, praying at the monastery of Nat Htaung Tike in Bagan, Myanmar.

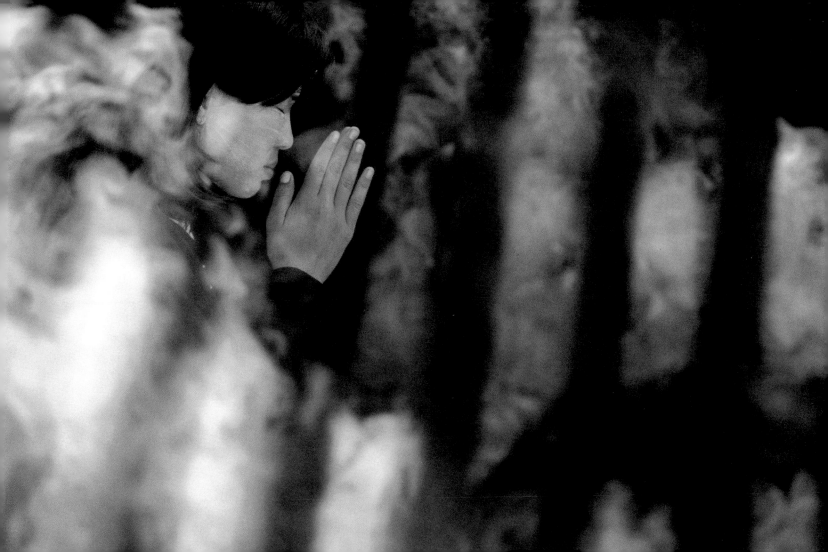

We must discover the link between our traditions and our personal experience of life.

It is the now — the magic of the present moment —

that connects the present with the wisdom of the past.

Chögyam Trungpa

In Tokyo, outside the most famous shrine in Japan, the Meiji Jingu, built in honour of the Emperor Meiji and his Empress Shoken.

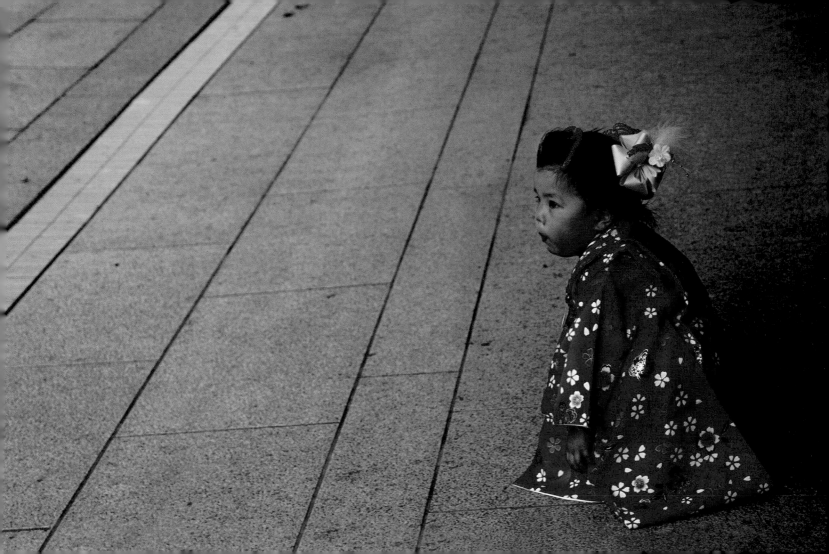

When the dead are honoured

and when the memory of the most distant ancestor remains alive,

the strength of a people attains its fullest expression.

Confucius

Centre of the Shingon school of esoteric Buddhism, Koyasan is also a huge cemetery with nearly
200,000 graves of samurai, famous figures and ordinary people amid a forest of hundred-year-old cedars. Japan.

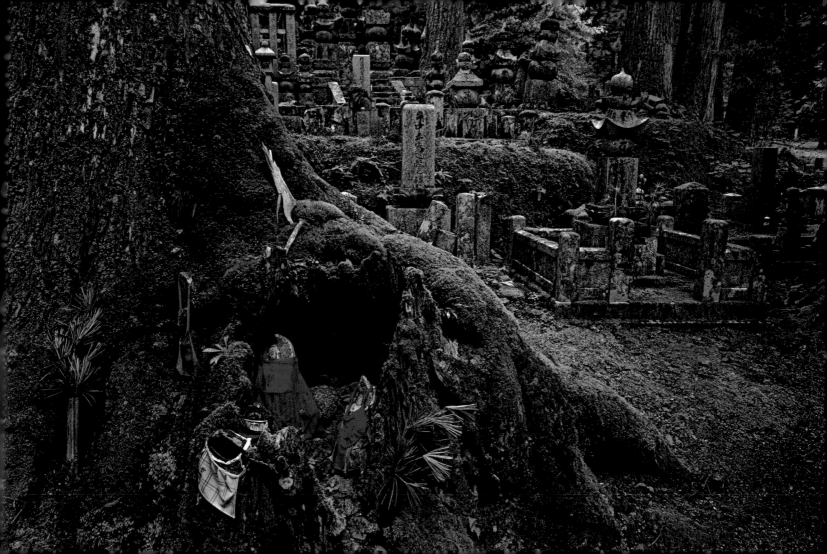

I transmit, I do not invent.

Confucius

Primary school pupils in the village of Ben Sop Jam, taking their first examinations. Laos.

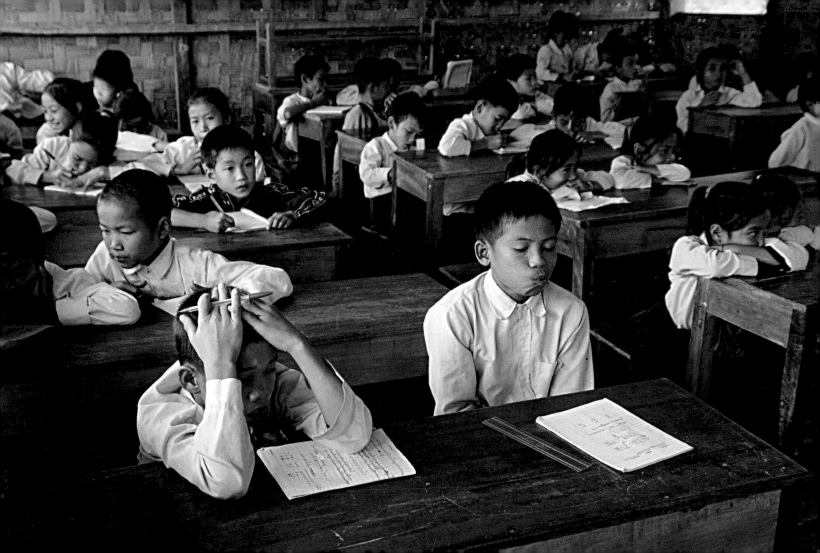

Keep in mind the age of your father and mother.

Let this thought be a source of joy and of concern.

Confucius

A villager from Ban Houey Ko leaves the distant health centre, carrying his elderly mother, who has a broken arm. Laos.

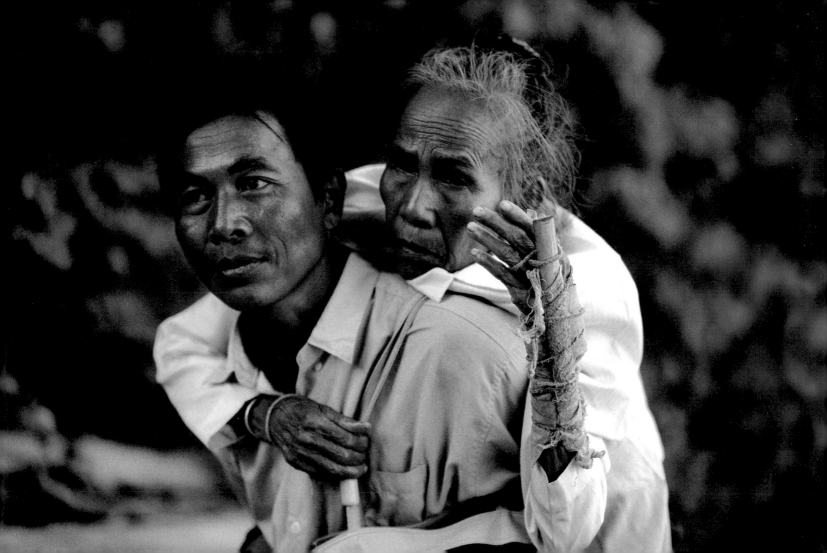

Just as a line is defined as a succession of points,

our lives may be defined as a succession of heres and nows.

If we understand the basic quality of the present moment, which never returns,

we can realize the importance of Zen practice.

Master Taisen Deshimaru

Shin Yay Wata, aged 19, a monk at the monastery of Nat Htaung Tike, Myanmar.

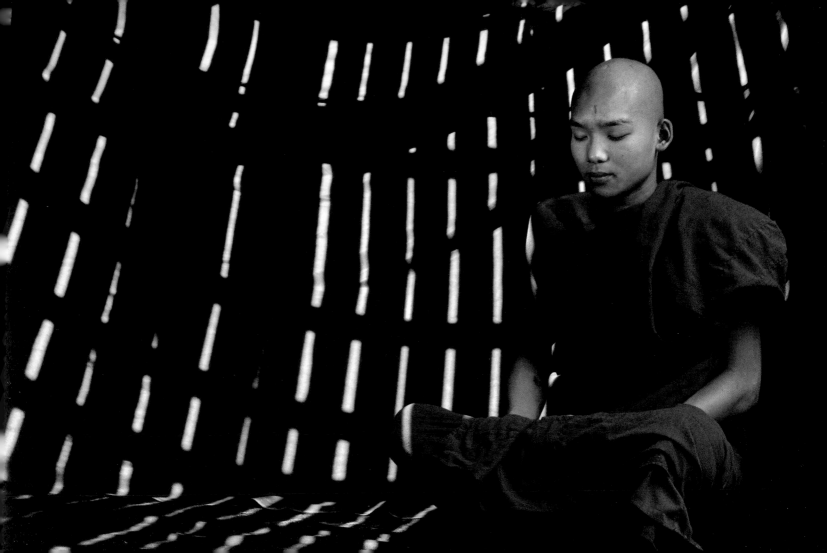

The actions of our daily life
like waking, washing, lighting incense
do not seem very important,
but they comprise the whole cosmos.

Master Taisen Deshimaru

The public tap in the village of Ban Houey Ko, on the banks of the Mekong, Laos.

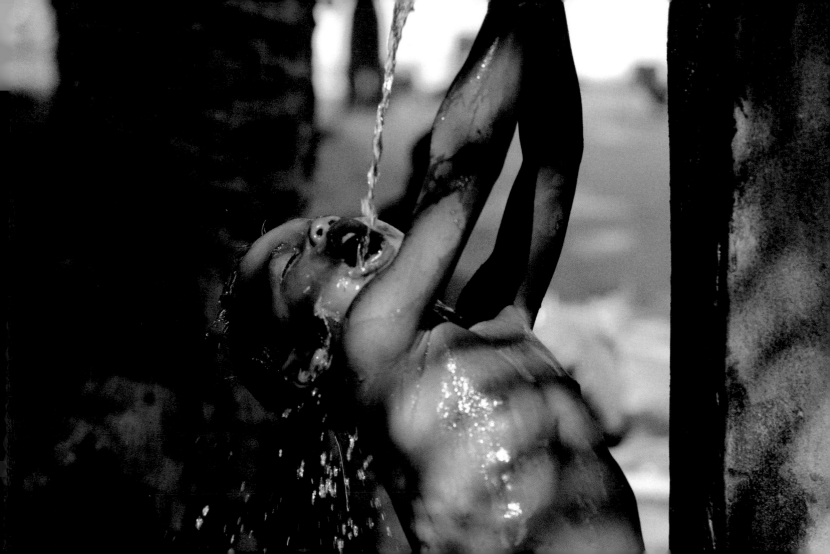

In our daily actions,

let us concentrate on details with great care and attention,

let us make this an ingrained habit for the behaviour of our bodies and minds.

Like protecting a newborn child…

Master Taisen Deshimaru

Thiwa Morpoku, aged 25, in traditional Akha costume, eating a meal of rice and pulses. Thailand.

Treat people with respect to gain respect,

and this is true power.

Steve DeMasco, Kung Fu Master

Tenderness and understanding – Wannaporn Weerawatpongsatorn, aged 7, resting on her sister's lap, both of them dressed in traditional Akha costume. Thailand.

Through meditation, we practise resurrection in every moment.

This is the practice of living in the everyday.

We must not lose ourselves in the past or in the future.

The only moment in which we are alive, in which we may touch life,

is the present moment, the here and now.

Thich Nhat Hanh

A man prays at the Shwedagon pagoda of peace, the most venerated Buddhist shrine in Myanmar.

Art Center College Library
1700 Lida St.
Pasadena, CA 91103

*Inner life is always lived and understood
through a form that is aesthetically,
and therefore ritually perfect.*

Zen practice

Pau Jin Wu in her kitchen in the village of Chong Lui, in the Zhuang region, China.

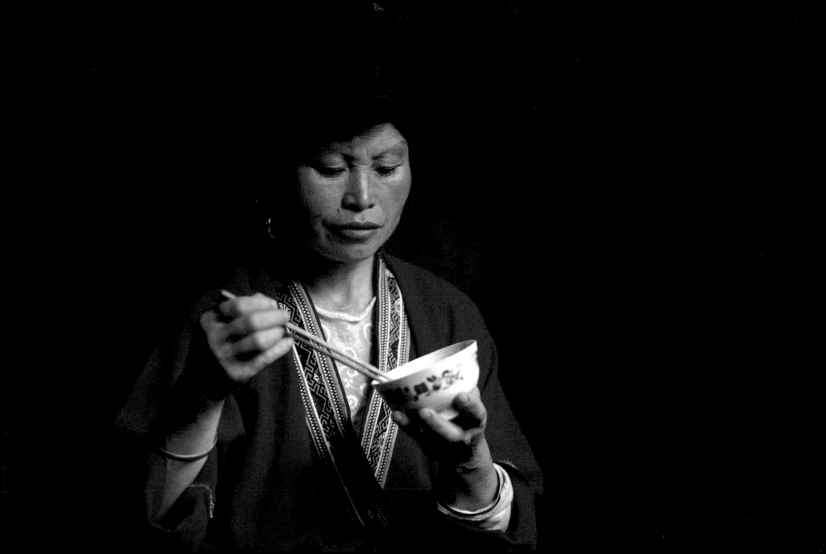

The blue mountain is the father of the white cloud.

The white cloud is the son of the blue mountain...

Many things may be like the white cloud and the blue mountain:

man and woman, master and student.

They depend on one another.

They are completely independent, and yet dependent.

This is the way that we live, and the way that we practise Zen.

Master Shunryu Suzuki

In winter, a shepherd takes his flock to drink in the valley of Tso Kar in Ladakh, at 4,000 metres (13,000 ft). India.

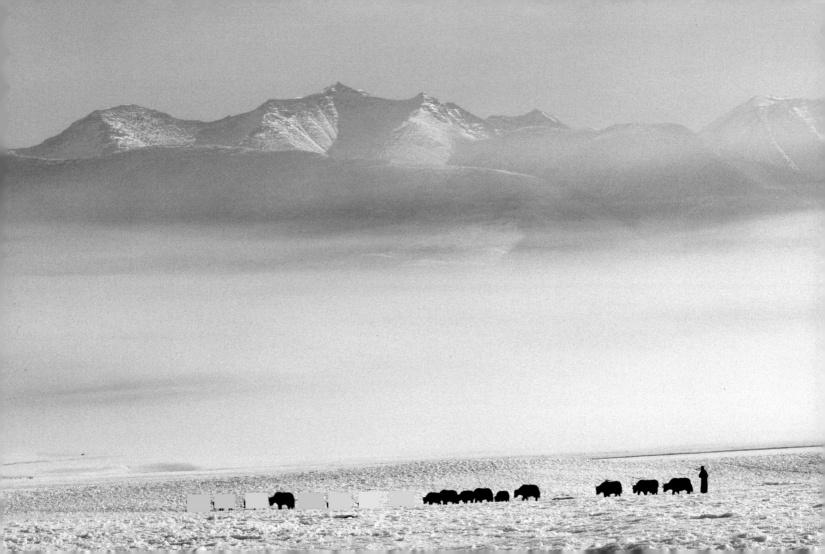

When I touch paper deeply, I touch a cloud.

If we look into the nature of paper, what do we see?

We first see a cloud.

Because without the cloud, there would be no rain and the trees would not grow...

And what else do we see?

We see the sun, because without the sun, the trees would not grow,

and we also see the earth...

Thich Nhat Hanh

Ting Xue Yue, aged 17, in the village of Yong Zhi in the Kham region of China, learns a traditional song at Tibetan New Year.

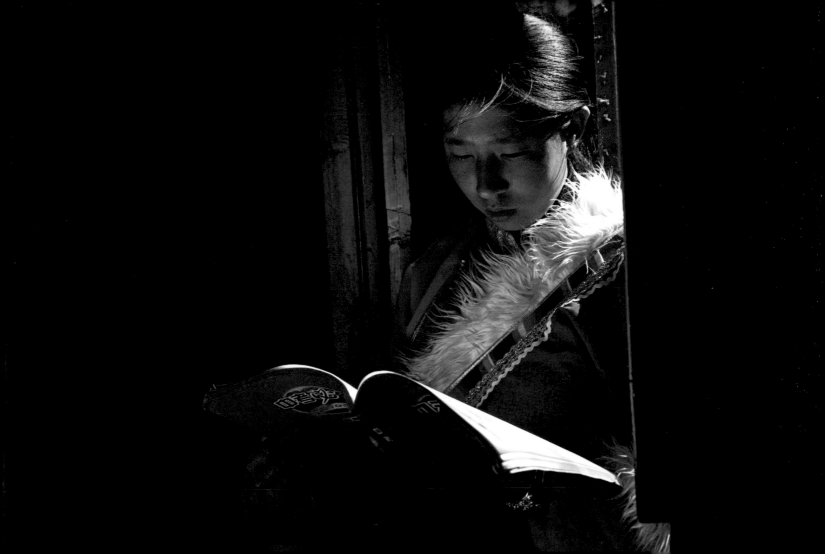

This leaf is one with the other leaves;

with the branches, the trunk and the roots of the tree;

with the clouds, the stream, the earth, the sky and the light of the sun.

If one of these elements were absent,

the leaf could not exist.

Thich Nhat Hanh

The famous gardens of the Temple of Tenryuji,
one of the five great Zen temples in Kyoto, Japan.

The present moment is the source of a chain of interdependence.

This absolute point includes all changing phenomena,

all impermanent existence,

the entire cosmos.

Master Taisen Deshimaru

Local people dance at sunrise in Lu Xun Park, Shanghai, China.

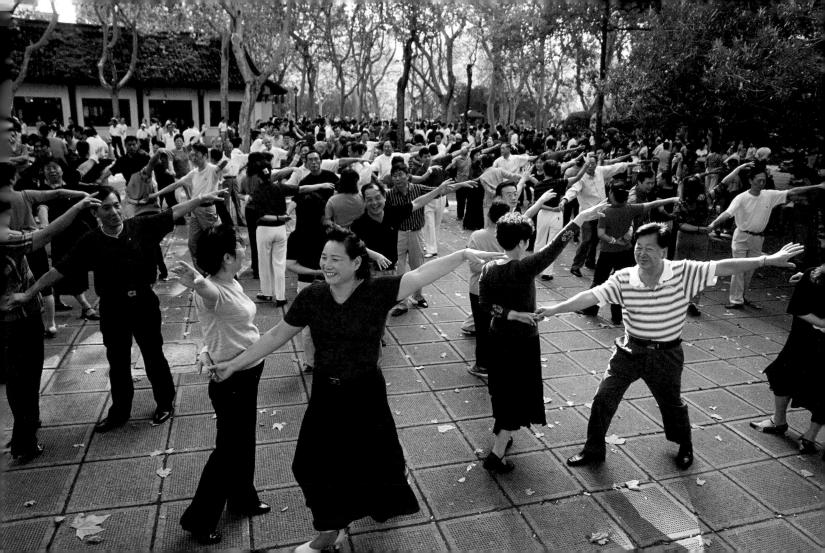

Living together is an art.

Thich Nhat Hanh

Village life in Ben Sop Jam, on the banks of the Nam Ou, Laos.

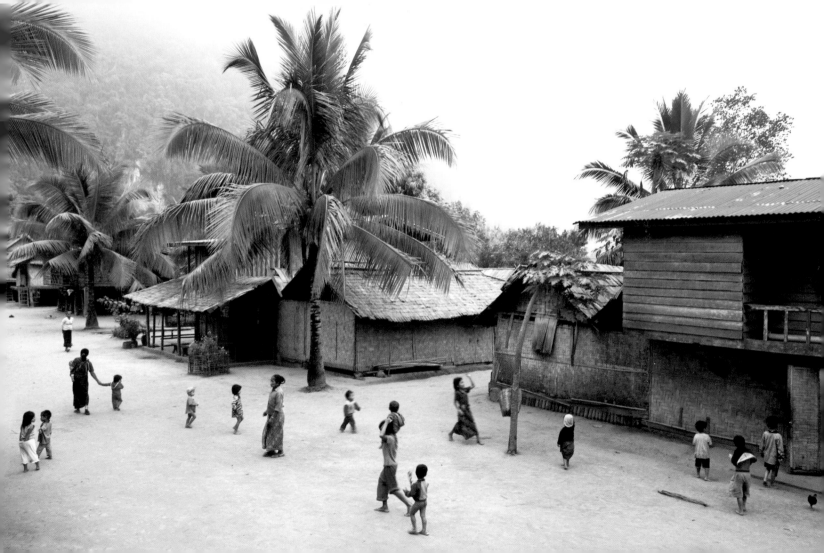

Respect for others follows the recognition of our connection with them.
It means that relationships become easier,
and communication flows more smoothly.

Sogyal Rinpoche

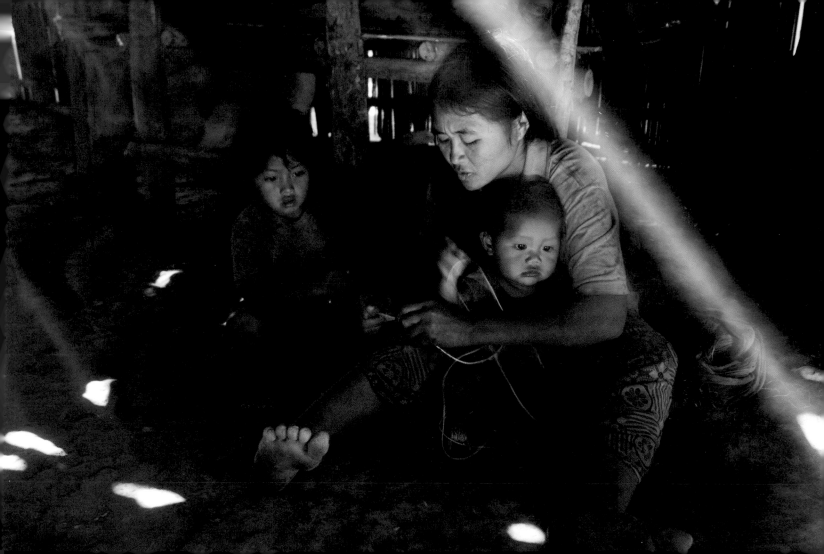

The good man does not use others as a tool.

Confucius

Virtue is harmony;

the way is order.

Virtue that excludes no one is goodness;

the way in which everyone has a place is justice.

Fidelity means understanding the duties of everyone and so loving mankind.

Chuang-tzu

Villagers gather in the main square of Kusunzhai in the province of Yunnan, China, for a traditional annual feast.

The more things are forbidden, the more the people are poor.

The more weapons there are, the more the land is troubled.

When the people rely on their own skills

then strange new things appear.

The more the number of laws and rules grows,

the more the number of thieves and criminals grows.

Lao-tzu

A pot of offerings at the pagoda of Shwedagon in Yangon, where crows come to feed. Myanmar.

Virtue is the home of the wise man,
duty is his path,
kindness is his garment,
prudence is his torch,
and sincerity is his seal.

Chuang-tzu

Monk resting at the monastery of Nat Htaung in Bagan, Myanmar.

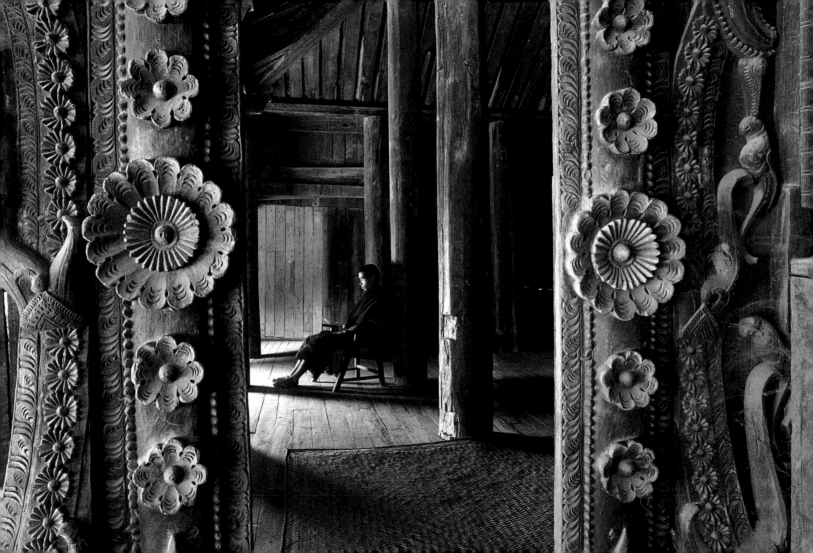

A noble who is carried in a litter is only a man;

so is the man who carries him.

Chinese proverb

In the heat of the dry season, a cart-driver waits for customers. Myanmar.

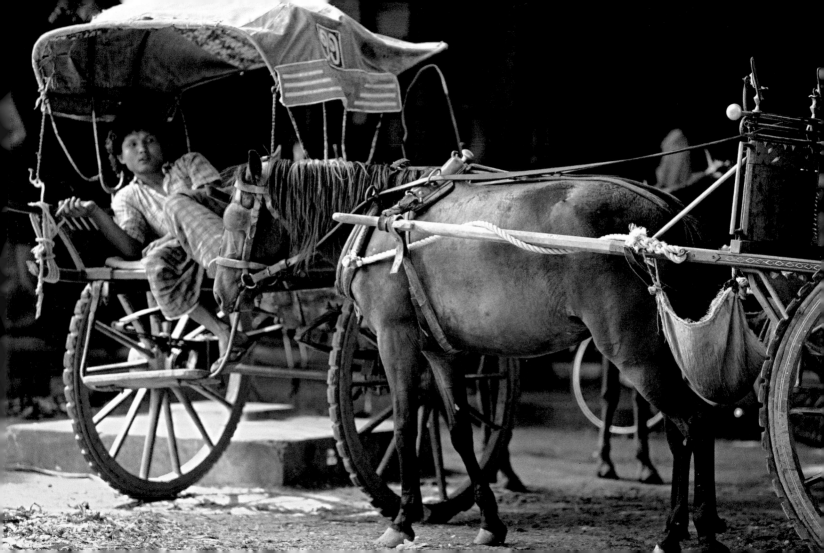

Do not exalt men of merit,
fighting will cease.
Do not pay attention to rare things,
robbery will cease.
Do not display anything that leads to envy,
people will have peace in their hearts.

Lao-tzu

The new town of Pudong on the Huangpu river, Shanghai, China.

A bodhisattva does not venerate those who respect laws,*

does not hate those who break them,

does not respect experienced followers,

does not scorn beginners.

Master Taisen Deshimaru

** An enlightened being.*

Sculpture of the Buddha in the temple of Wat Rong Khun, Chiang Rai, Thailand.

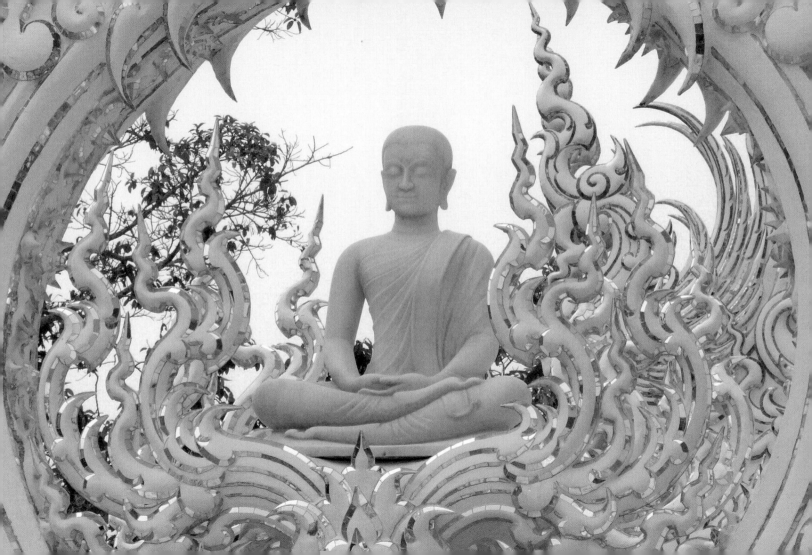

It is greatness to consider all differences identical.

Chuang-tzu

Yi, a peasant woman, at the market in Dali, Yunnan province, China.

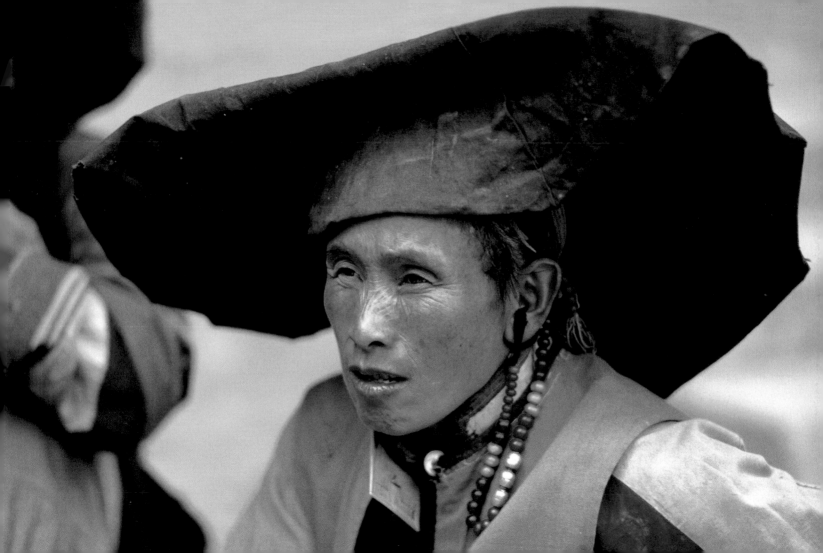

Our body is our temple.
We should therefore respect it,
understand its importance
and always return to it:
it is our refuge.

Thich Nhat Hanh

Pad Songsiri, from the Mlabri people, warms his hands by the kitchen fire in his hut in the village of Huany Yuak, Thailand.

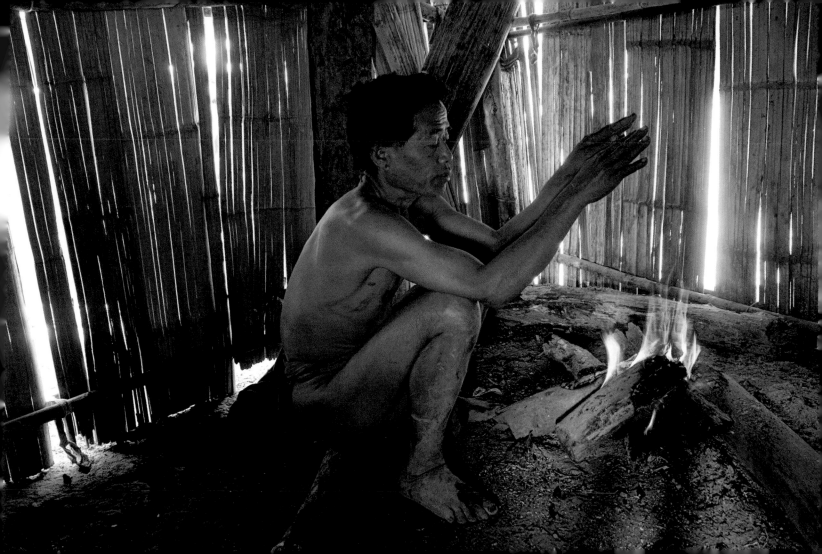

Outside, I grasp the means of creation.

Inside, I collect from the spring of my soul.

Chang Tsao

The ruined temple of Beng Meala, hidden in the jungle of Angkor, Cambodia.

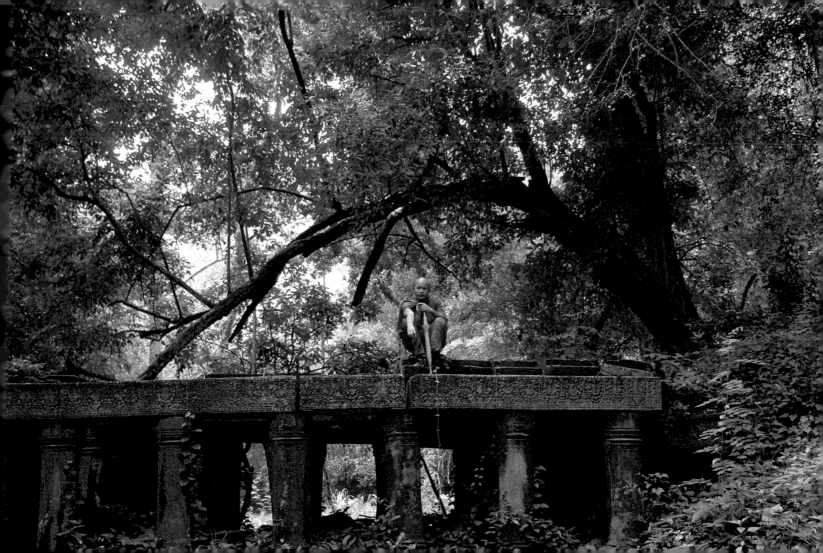

In a single gaze, we should see the whole cosmic garden:

in a single breath, feel it

in a single listen, hear it

in a single mouthful, taste it

and through our body alone, touch it.

Master Taisen Deshimaru

A boy has fun with the family bicycle, Cambodia.

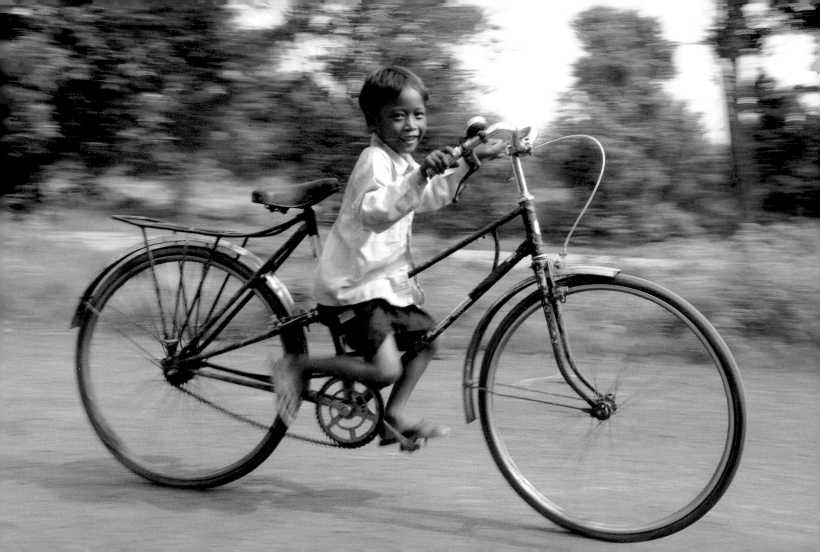

Let us be receptive, attentive to the highest degree,
with every one of the cells of our bodies.
We think with our bodies,
unconsciously, all duality, all contradictions
are easily overcome.

Master Taisen Deshimaru

Lukther, aged 6, playing in the sand on the banks of the Mekong, Laos.
Overleaf: A fisherman returns to his village on the banks of the Mekong, Laos.

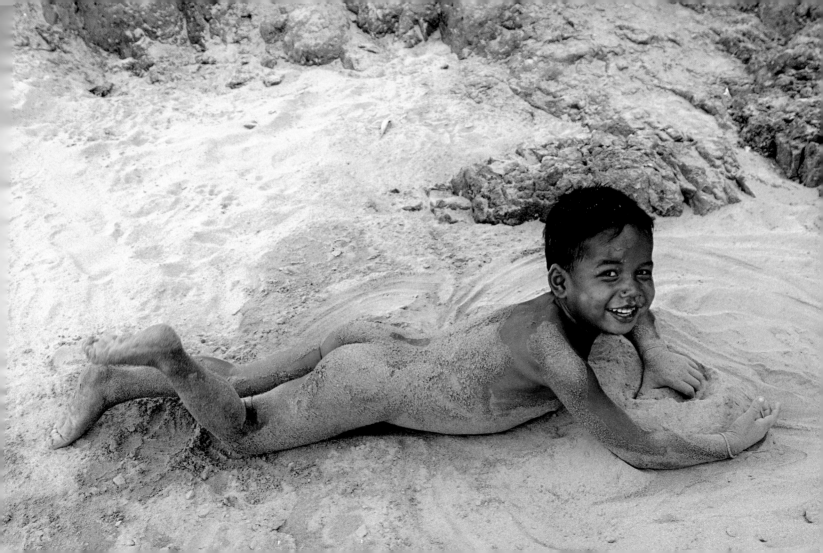

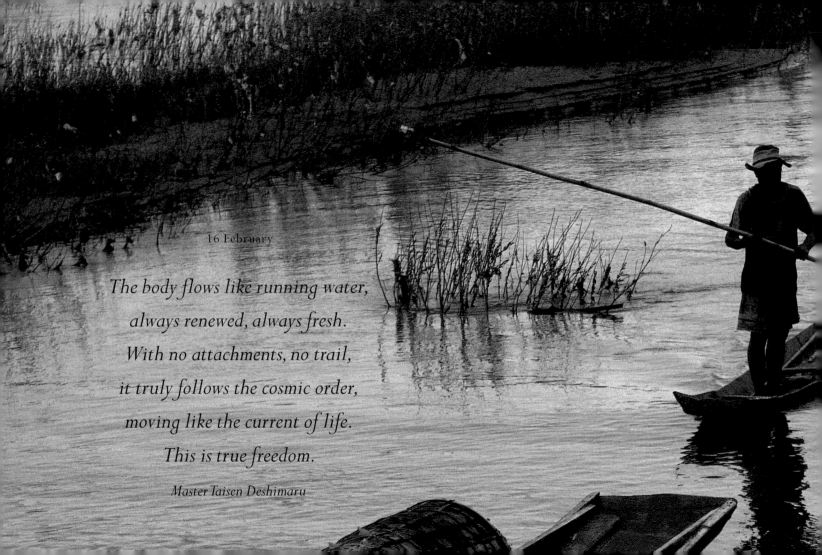

16 February

The body flows like running water,
always renewed, always fresh.
With no attachments, no trail,
it truly follows the cosmic order,
moving like the current of life.
This is true freedom.

Master Taisen Deshimaru

If we understand our doubts, our sufferings, our life,
with the very depths of our minds,
with every cell in our bodies,
this is enlightenment.

Master Taisen Deshimaru

In the gardens of Liu in Suzhou, China, a young musician plays the mandolin.

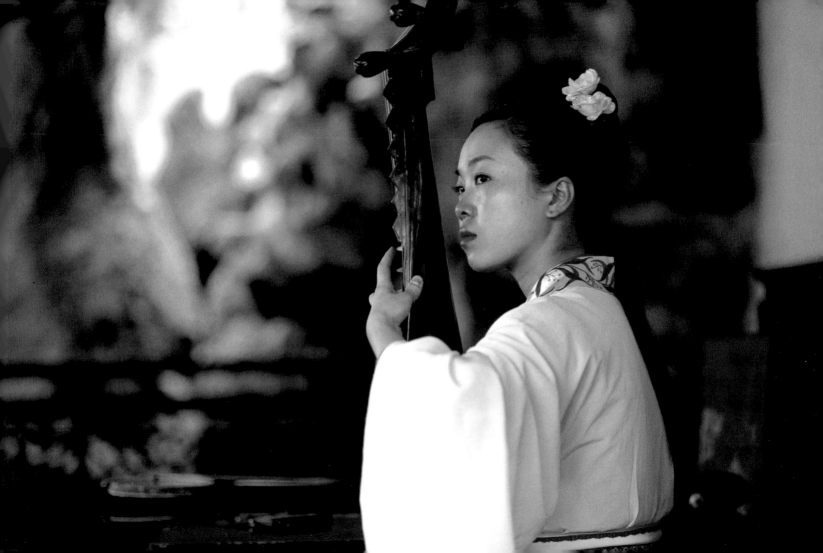

We cannot prolong our lives,

but we should not hasten our deaths.

Lieh-tzu

A great-grandmother, aged 103, from the Naxi community in the Kham region of China.

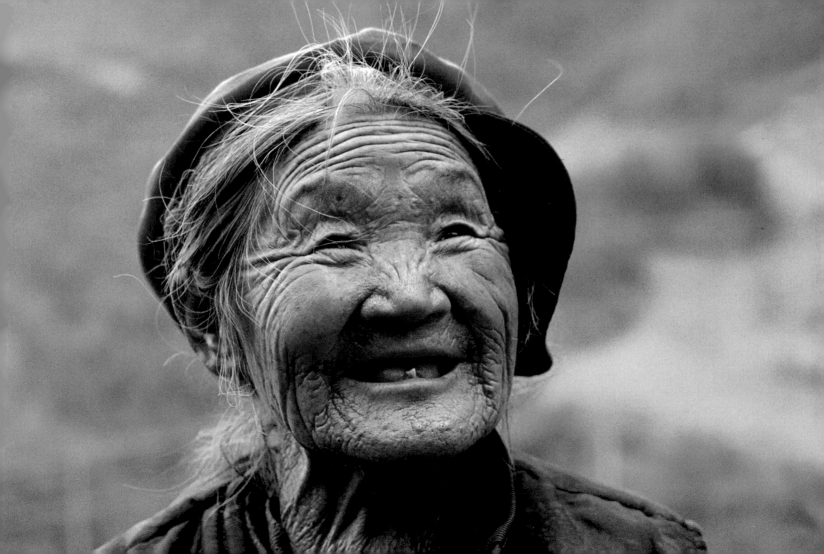

If there were one word that could guide the action of a whole life,

would that word not be consideration?

Do not act towards others as you would not wish others to act towards you.

Confucius

A man from Ayutthaya pays homage to the Buddhas decapitated by the Burmese army in 1767. Thailand.

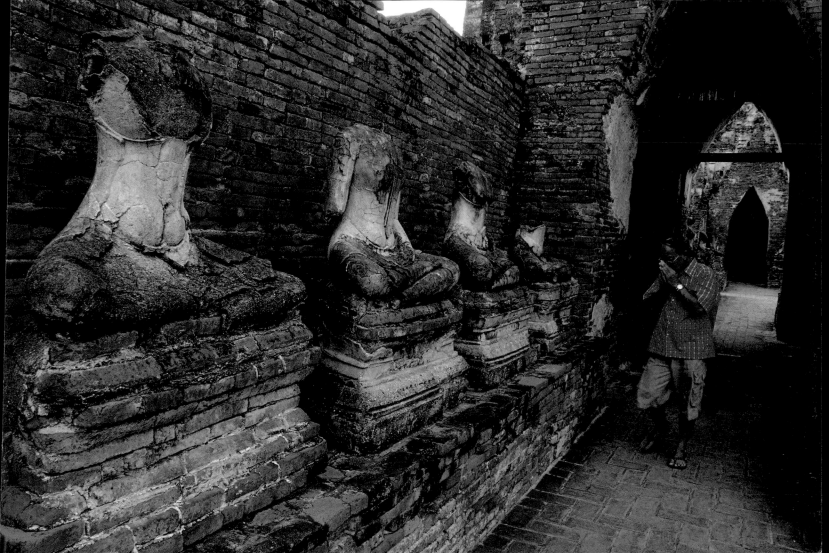

That which is identified as heaven is the Tao.

That which adapts to the earth is virtue.

That which is created in all beings is righteousness.

Chuang-tzu

A shelter on the teak bridge of U Bein, 1.5 km (1 mile) long, in Amarapura, Myanmar.

Justice rules the affairs of men, propriety rules their hearts.

Confucius

Passengers form orderly queues as they wait for their train at Kyoto Station, Japan.

The honest man sees things from the point of view of justice,

the vulgar man, from the point of view of his own interests.

Confucius

Paddy fields are the major resource of the Mekong Delta, Vietnam.

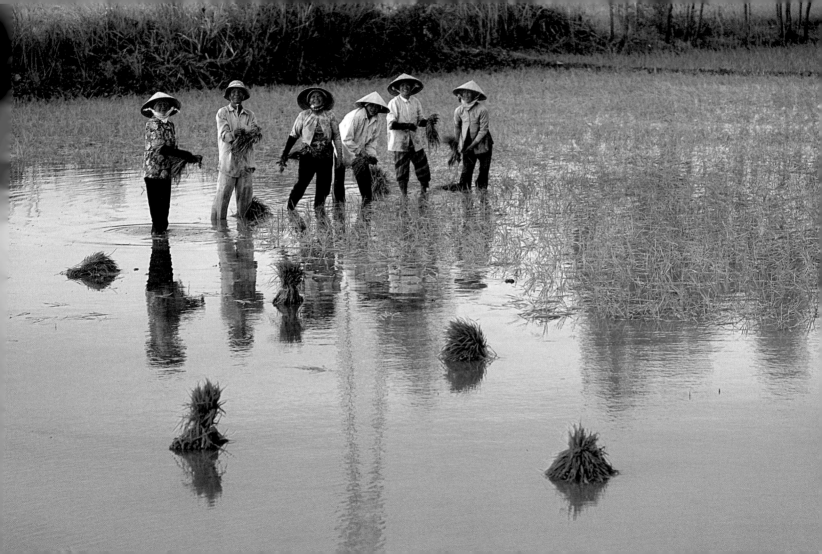

Propriety always means uniting the strong and the weak.

Huai-nan-tzu

Thin Thin Aye and her first child, in the village of Tharanar, Myanmar.

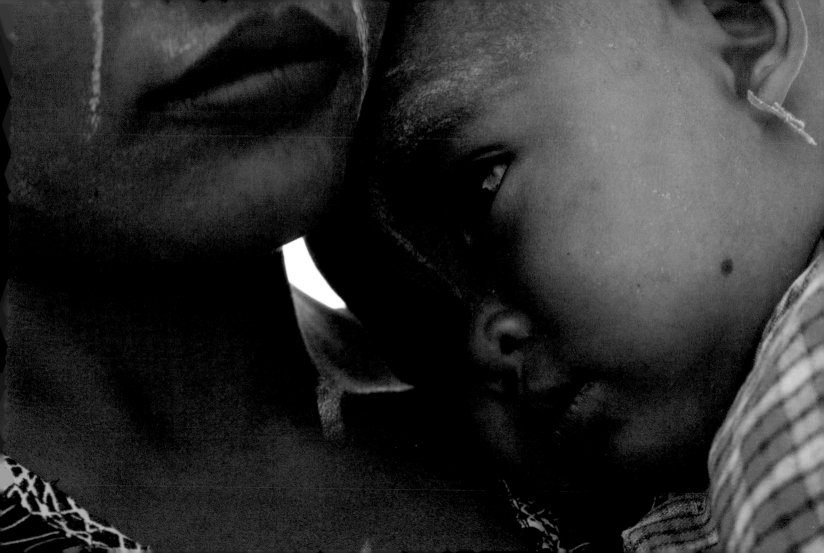

We must communicate the respect that we feel towards others.
It is for this reason that we should be aware of our own behaviour.

Chögyam Trungpa

At the sanctuary of Chionin in Kyoto, a Jodo monk – one of the largest Buddhist schools – instructs the faithful. Japan.

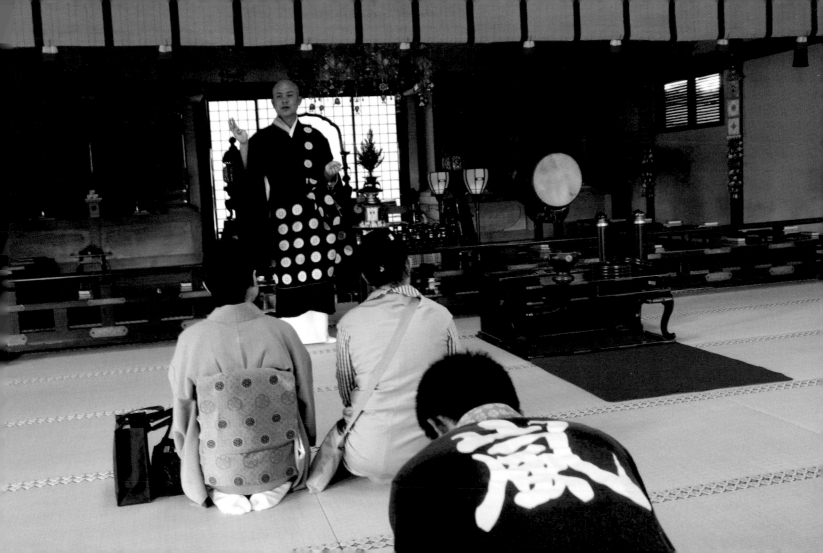

To greet someone, you must leave your own place.

Li Qu Li

The entrance to the temple of Rengejoin, an important centre of Japanese spiritual life, Koyasan, Japan.

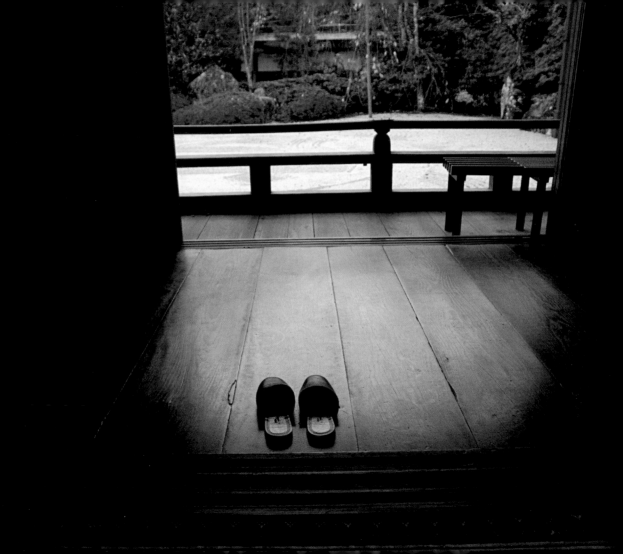

Buddha can be found in the simplest of things, right before your eyes,
as long as you truly wish to see him.
To do this, it is essential to find the right balance,
balance that holds onto nothing and yet rejects nothing.

Ajahn Chah

A farmer on his way home in the region of Longji, China.
Overleaf: In Myanmar, suitors are offered bougainvillea as a token of love.

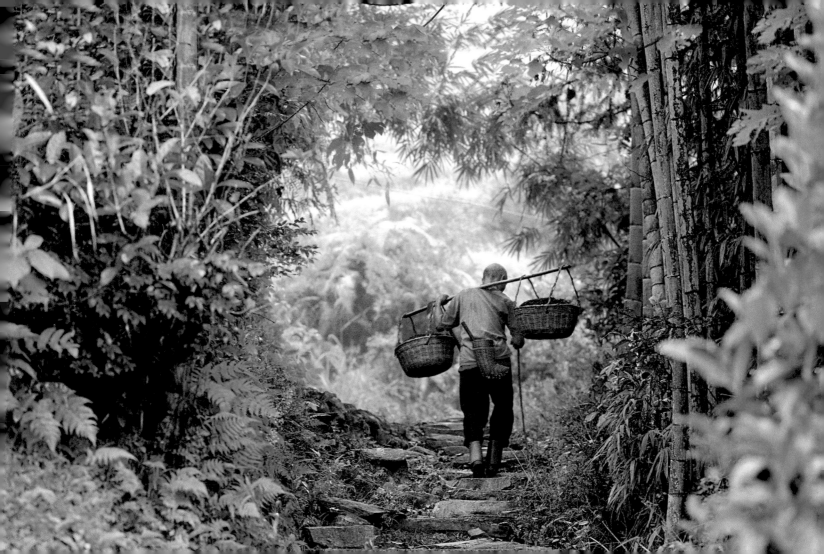

27 February

Richness means embracing the variety of differences.

Chuang-tzu

Peace and quiet are the things a wise man should cherish.

He does not rejoice in victory,

because to rejoice in victory

is to rejoice in the massacre of men.

And when one rejoices in the massacre of men,

how can one prosper among them?

Lao-tzu

The pagoda of Shwedagon in Yangon, built a century after the birth of the Buddha, is 98 metres (320 ft) high and the most venerated shrine in Myanmar.

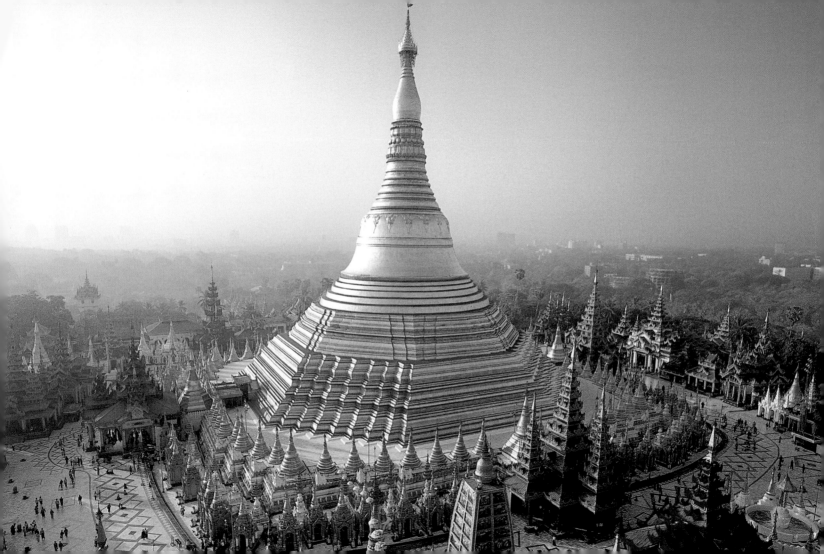

In the sphere of human relationships,
the principle of respect means never making plans against anyone else,
freeing oneself from any sense of competition and any tactic
designed to impress anyone.

Master Okakura Kakuzo

The floating market of Phong Dien in Can Tho, in the Mekong Delta, Vietnam.

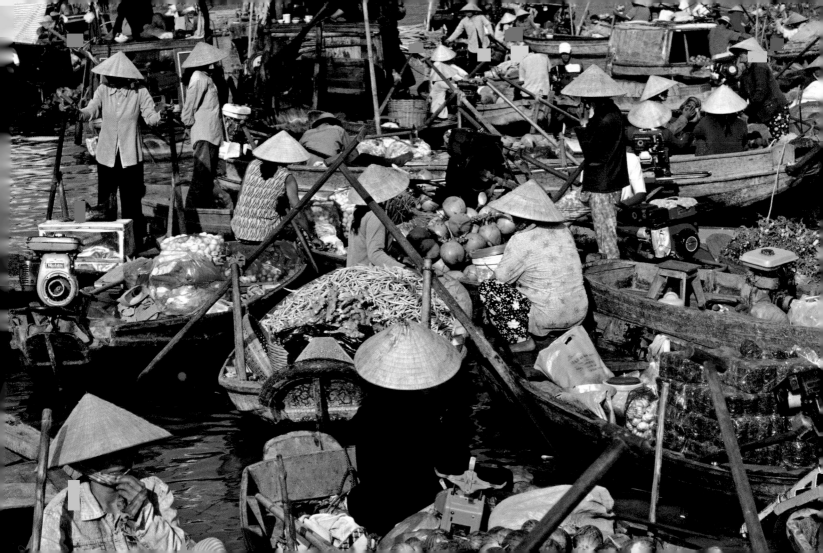

Only in helping others can we continue to help ourselves.

Steve DeMasco, Kung Fu Master

A little girl, her face decorated with the crushed bark of the thanaka tree, at the market in Mandalay, Myanmar.

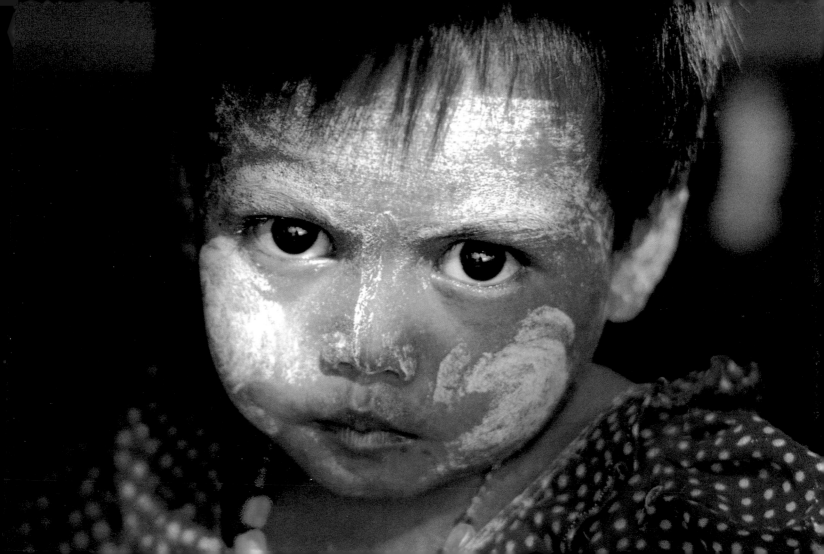

An exile has no treasure:

those who are human and those who are close to him,

he must make them his treasure.

Tseng-tzu

A passenger boards a ferry during the monsoon. Myanmar.

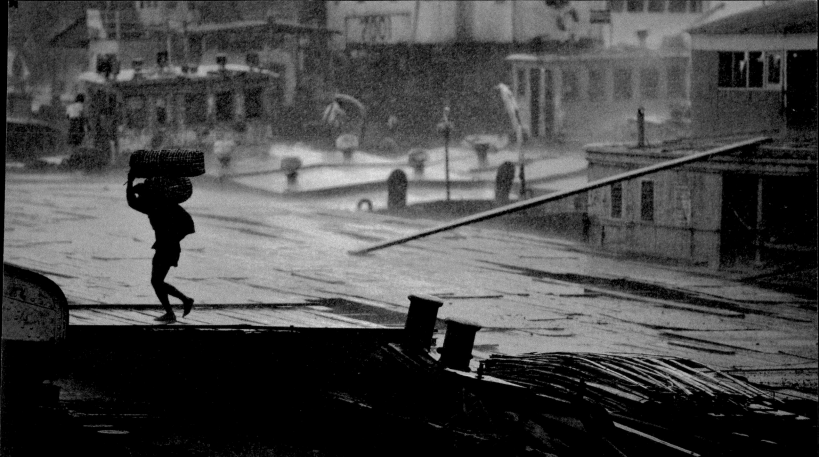

Whoever has virtue is a relief to his fellows.

Whoever does not is a burden in vain.

Lao-tzu

Ma Xiao Mei, aged 7, returning from the fields in the land of the Hani, Yunnan province, China.

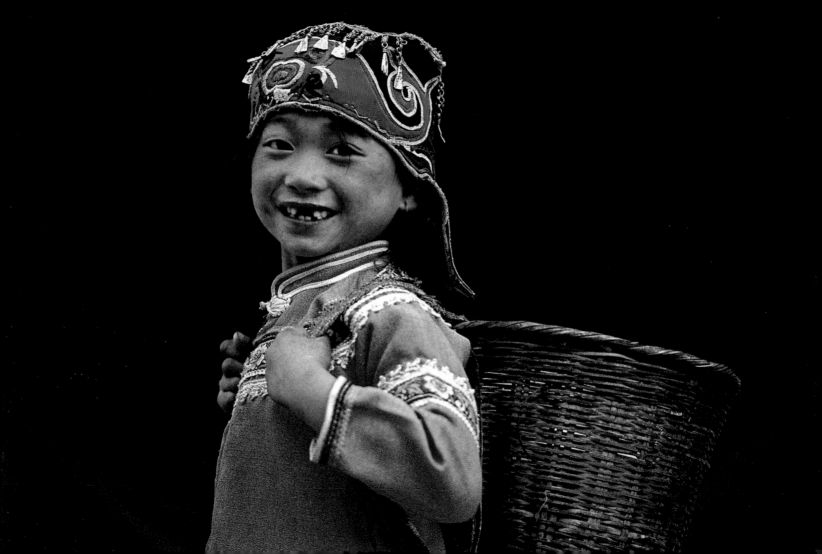

The Way of Wisdom:

working without fighting.

Lao-tzu

The sacred mountains of Huangshan, China.

Death and life, duration and destruction,

misery and glory, poverty and wealth,

wisdom and ignorance, blame and praise,

hunger and thirst, heat and cold,

these are the alternating troubles that make up Destiny.

Those who do not let themselves be affected by these events

keep their soul intact.

Confucius

Si, aged 26, returns from the fields in the evening to her village of Hau Thao, Vietnam.

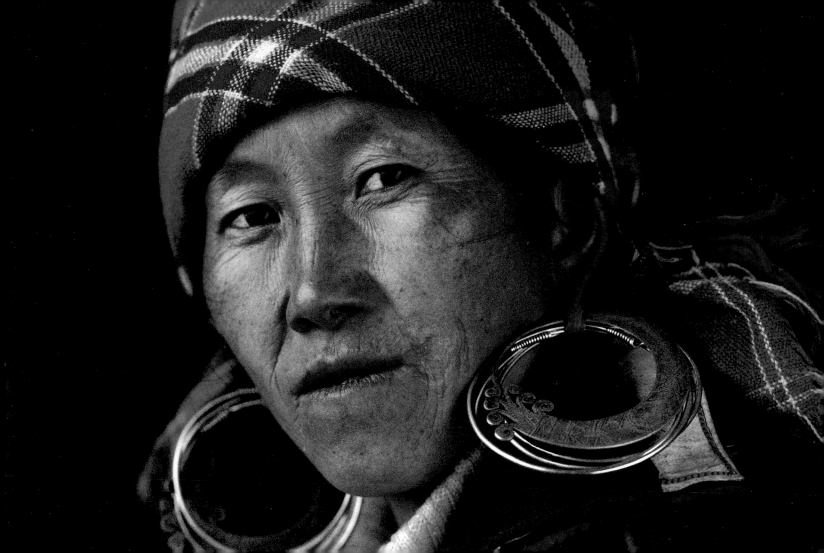

A wise man should be like a well-tuned instrument which,
rather than echoing with all the sounds of the world,
always plays the right note.
All the wise man's efforts may therefore be devoted
to the fine tuning of this instrument
which is himself.

Tseng-tzu

Mr Wu, a teahouse musician in Zhouzhuang, China, sings the *tanzhi*, a traditional Suzhou song.

Your ideal is heavenly.

Mine is only human.

Chuang-tzu

A young father with his first child in the village of Ban Houey Ko on the banks of the Mekong, Laos.

If you are not ready to exchange your own happiness
for the suffering of others,
you will never know happiness, in any life.

Shantideva

The market outside the pagoda of Ananda during the festival of Pyatho, Bagan, Myanmar.

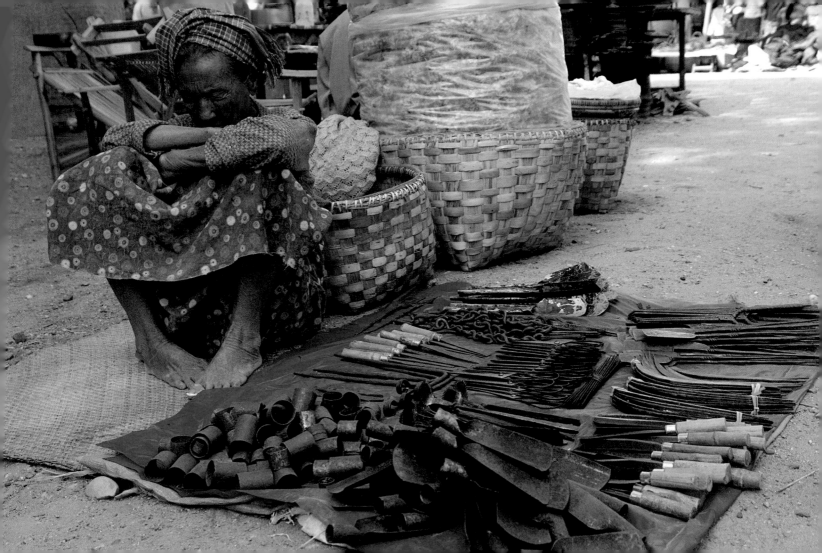

Care for beings, feed them without seeking to enslave them.

Work without demanding in return.

Be a guide and not a master.

This is mysterious Virtue.

Lao-tzu

Ko Kyaw Shin, aged 58, is reunited with his son Shin Thu Zana, aged 8, a novice monk at the monastery of Lawka Nandar, Myanmar.

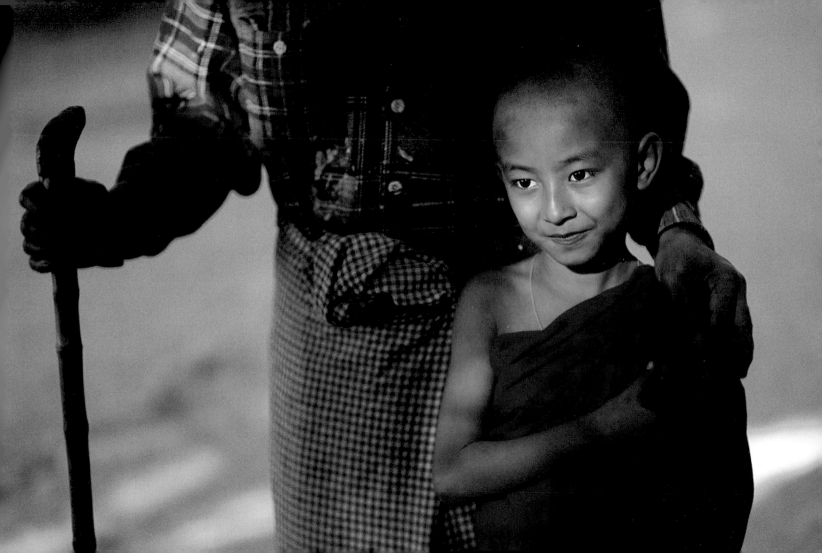

The just teaches the unjust.

The unjust is the substance of the just.

Not revering this subtle teaching,

not respecting this raw material,

brings great error.

Whatever the knowledge,

the essential remains an enigma.

Lao-tzu

Blackboard at a village primary school in the Longji region, China.

时间如流水...

写道...先寿的时顺，且...水盆 过去...
候，日子从洗碗里过去，时...
过去的日子里，有些　　　人白白浪费了大好时光，
生最大的遗憾是时间不能倒流，珍贵的时间往往是
去了以后才知道珍贵，　　　珍贵自己的青春年华大
要了！...有珍惜时间的　人，才能攀上理想的
峰。

记住：　　时间就是生命
时间就是胜利
时间就是财富！

龙脊校出版
2006.6.1

你是大地，
是大地上的树苗，
们的滋养，
长出强壮枝叶。

你是乘风破浪的船，
是一根篙，
那神圣的过程。

我感谢父母，因为他们养育了我，
我感谢老师，因为他们培养了我，
我感谢朋友，因为他们问候了我，
我感谢身边的每一个人，因为他们

One who possesses kindness possesses courage,
but one who possesses courage is not necessarily kind.

Confucius

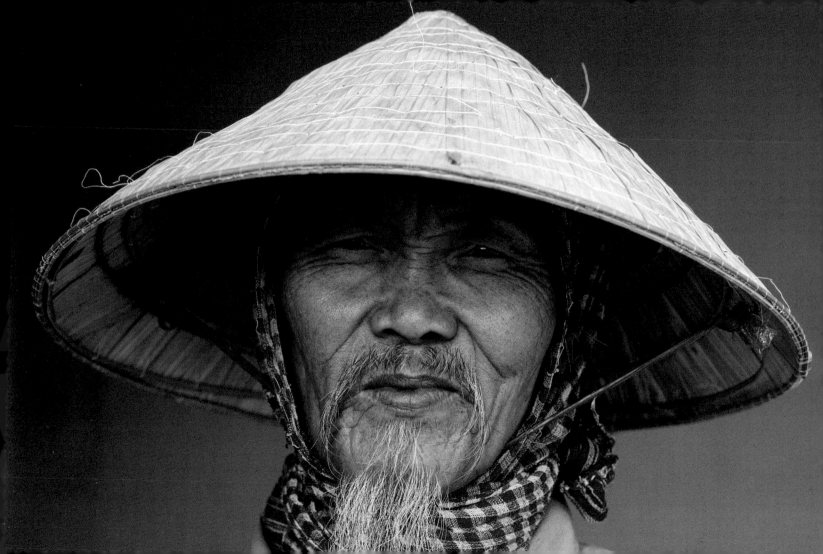

When you know your adversary and yourself,
you can fight a hundred times without danger.
When you know yourself, but do not know your adversary,
sometimes you win, sometimes you lose.
When you know neither yourself nor your adversary,
you always lose.

Chuang-tzu

A local resident practises martial arts in Lu Xun Park, Shanghai, China.

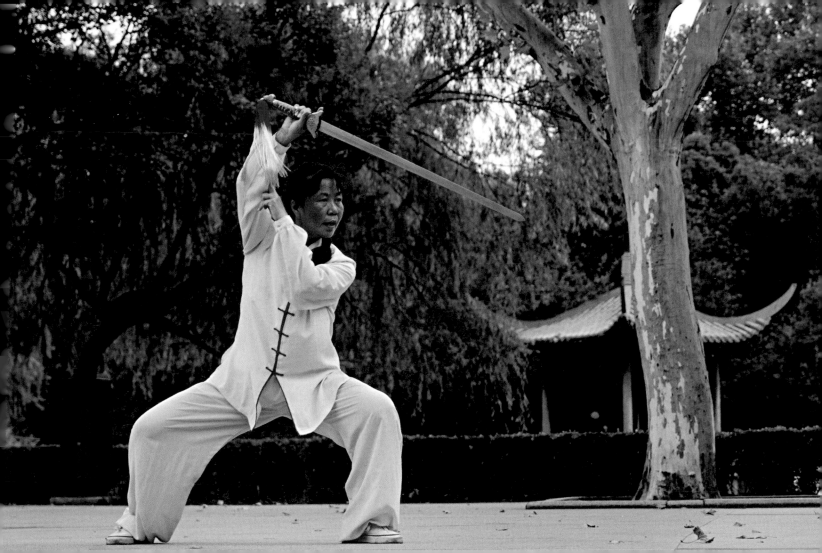

A wise man
is one who hears what makes no sound
and sees what has no shape.

Zen practice

Flowering cherry trees at the temple of Kenaiji in Ueno Onshi Park, Tokyo, Japan.

To know others is to have wisdom.

To know oneself is to gain enlightenment.

To master others is to have strength.

To master oneself is to have power.

To know what is sufficient is to be rich.

To act with determination is to have will.

Not to lose one's place is to endure.

To die without being forgotten is to be eternal.

Lao-tzu

Daw Phwar Nyunt, aged 85, in Sagaing, one of the main centres of Buddhism in Myanmar.

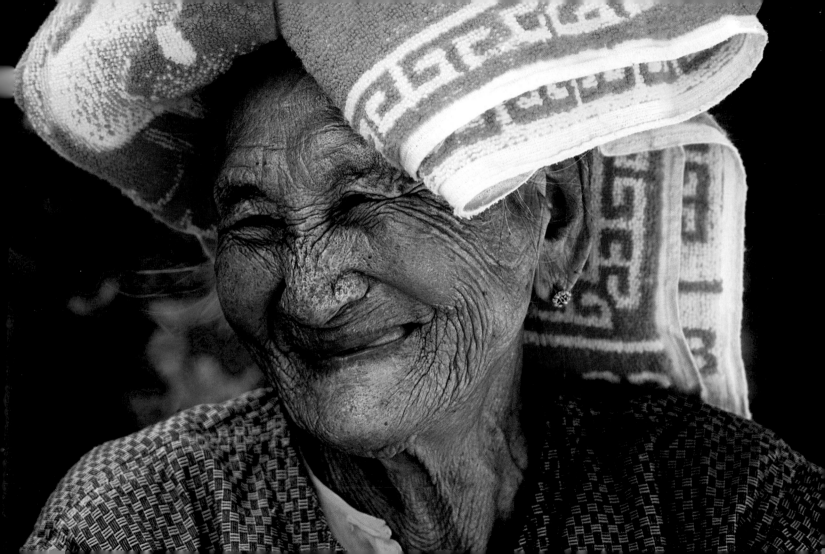

Some have an honest demeanour, yet are inclined to excess;

others seem superior but are good for nothing;

some seem docile and vague, but their minds reach far;

some seem hard but their temperament is soft;

some seem slow but are full of life.

Some seek to do what is right with a great thirst,

but then flee from it as from a fire.

Chuang-tzu

A pleasure boat takes tourists past the new district of Pudong, in Shanghai, China.

He who loves war goes to his own ruin,

but he who forgets war is in danger.

Liu Xiang

Two villagers play chess in the open air, Amarapura, Myanmar.

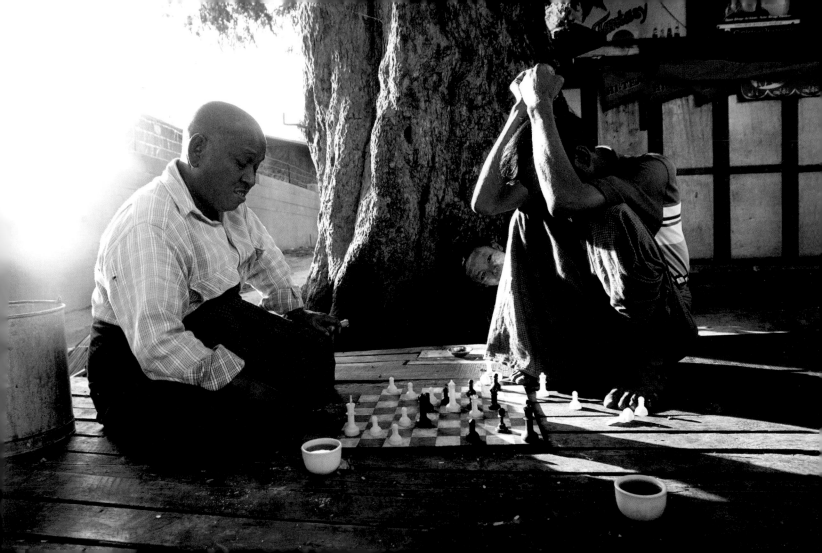

Chan* *is the heart of kung fu.*

It means constantly being cued in to the present, here and now.

Chan suggests the need to look at issues or situations from all angles.

Steve DeMasco, Kung Fu Master

* *The most ancient sacred text of Zen.*

Frescoes at Borobudur, Indonesia, a true wonder of the world.
Overleaf: Sunrise on the shores of Lake Taungthaman, Myanmar.

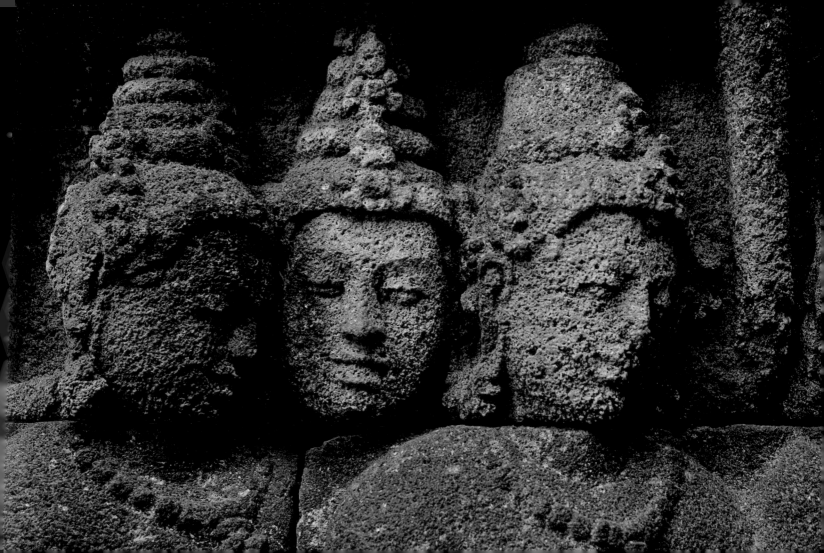

The legs of a duck, although short, cannot be lengthened without hurting the duck.

And the legs of a crane, although long, cannot be shortened without hurting the crane.

So what is long by nature should not be shortened;

what is short by nature should not be lengthened.

All sorrow is thereby avoided.

Chuang-tzu

Such is the malady of the mind:
this struggle between the notions of same and different,
of correct and incorrect,
of true and false.

Master Taisen Deshimaru

A geisha at the festival of Jidai Matsuri, which celebrates Kyoto's former status as imperial capital of Japan.

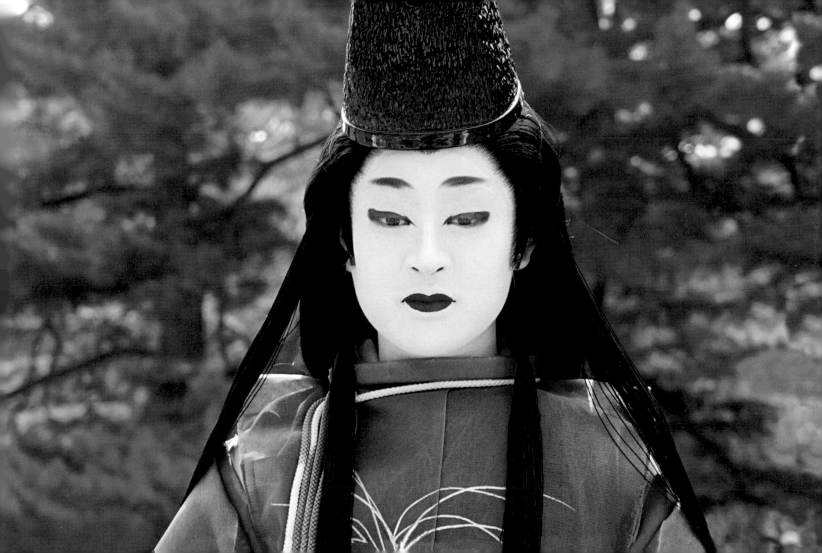

Everyone tends to think in this way:
that which is identical to my opinion, I am for,
that which is not identical to my opinion, I am against,
opinions identical to my own are true,
opinions different from my own are false.

Chuang-tzu

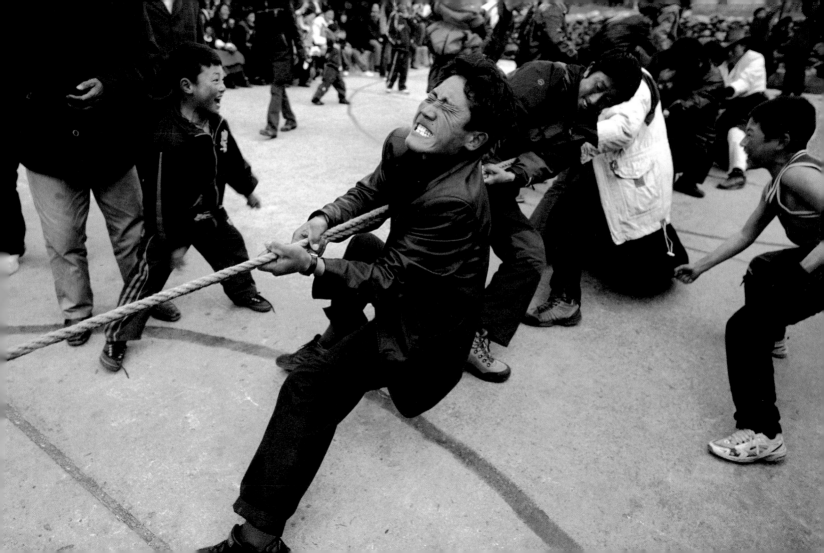

Those who do not know themselves deeply

criticize others from the point of view of their uneducated ego.

They admire things that flatter them and detest things that they do not agree with.

Because of their prejudices, they eventually become irascible, consumed by troubles,

prisoners of the suffering that they inflict upon themselves.

Suzuki Shosan

Detail of the façade of the Buddhist temple of Haeinsa, one of the three Jewel Temples of Korea, built in the 9th century on Mount Kaya, South Korea.

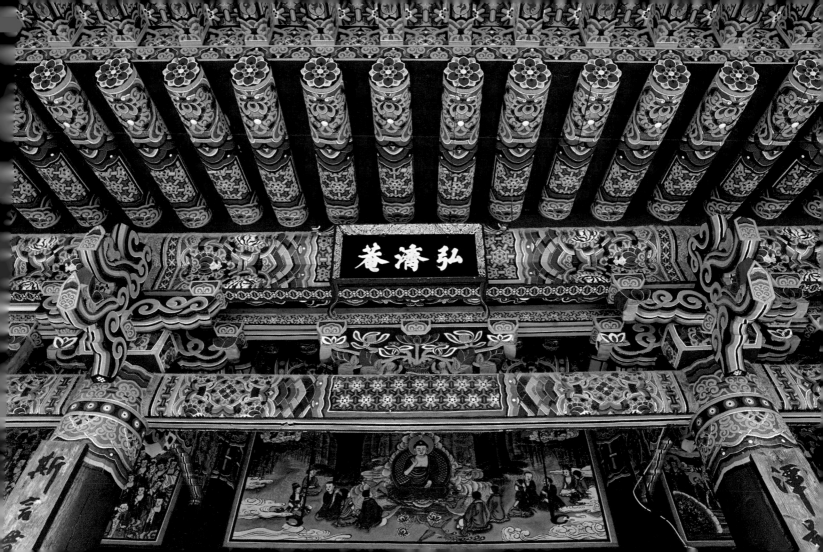

Long and short come together.

High and low lean together.

Voice and sound ring out together.

Back and front follow each other.

Lao-tzu

Passing in front of the temple of Wat Sensoukharam, the monks go to collect the food offered to them every morning by the people of Luang Prabang, Laos.

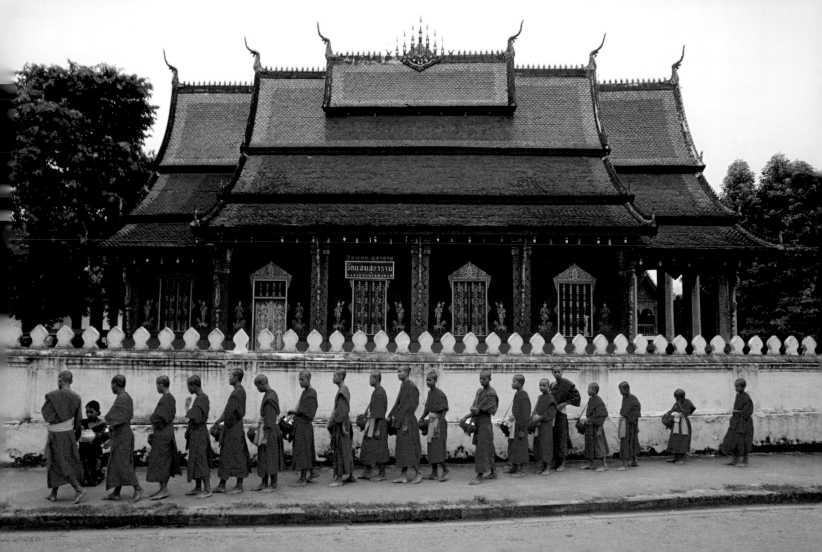

Do not search for the truth,

Just do not have any prejudices.

Master Taisen Deshimaru

Detail of the statue of a reclining Buddha in the Shwedagon pagoda, Yangon, Myanmar.

In darkness, light exists,

do not gaze with darkened vision.

In light, darkness exists,

do not gaze with bright vision.

Light and darkness

create an opposition,

but depend upon each other,

like one step going forwards, another going backwards.

Sekito Zenji

Interior of the U Ponya pagoda on the hill of Sagaing, one of the major Buddhist centres in Myanmar.

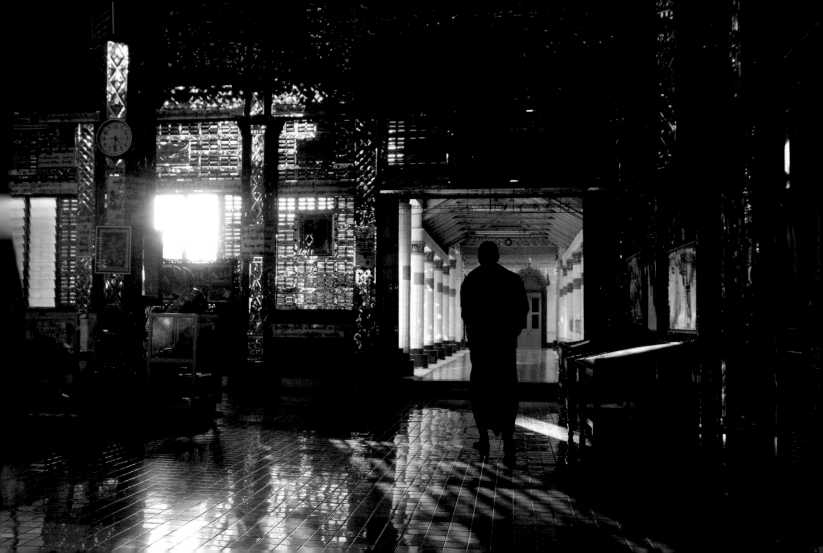

Human life is the concentration of breath:

when it is concentrated, there is life,

when it is dispersed, there is death.

Chuang-tzu

The track leading from Hualoy to the river, where the villagers fish. Thailand.

Everyone in the world knows that beauty is beauty

and yet ugliness exists.

Everyone knows that good is good

and yet evil exists.

So existence and non-existence create each other.

Difficult and easy are the same thing.

Lao-tzu

A musician from Jianshui, Yunnan province, playing in the town square where people congregate every evening. China.

Man is man,

woman is woman,

a mountain is a mountain,

a flower is a flower.

Everything is distinct.

But all things are connected, they follow the cosmic order.

'One thing is one thing, but one thing is everything.'

Master Taisen Deshimaru

Boatmen watch the ducks on Lake Taungthaman, Myanmar.

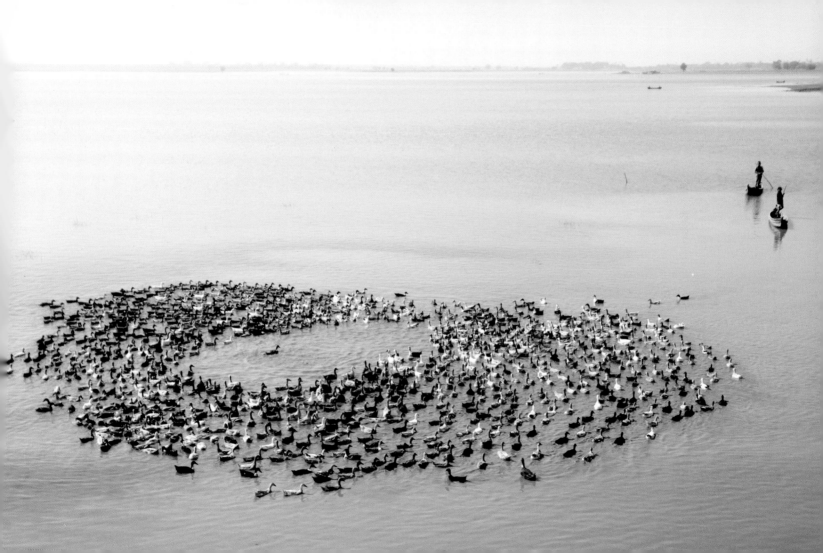

He who succeeds in seeing
that his own truth is partial, subject to error,
and that the errors of others often imply
a truth that is instructive in many ways,
shall willingly give up his own truth
and will respect others.

Liou Kia-hway

Miss Nay, aged 18, during her first year as a primary school teacher in the village of Ben Sop Jam, Laos.

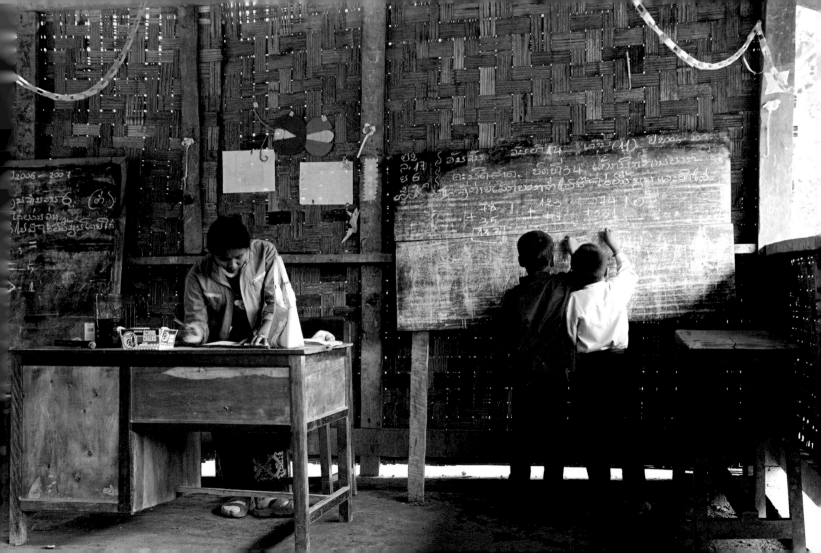

The thousand pink blossoms of the peach tree fade away in spring.

But their colour is One.

Keizan Zenji

The flowering of the cherry trees is an occasion for national celebration in Japan.

If you wish to attain the One,
this is only possible within the 'Not-Two'.

Master Taisen Deshimaru

A monk meditates outside the Shwedagon pagoda, the most venerated Buddhist shrine in Myanmar.

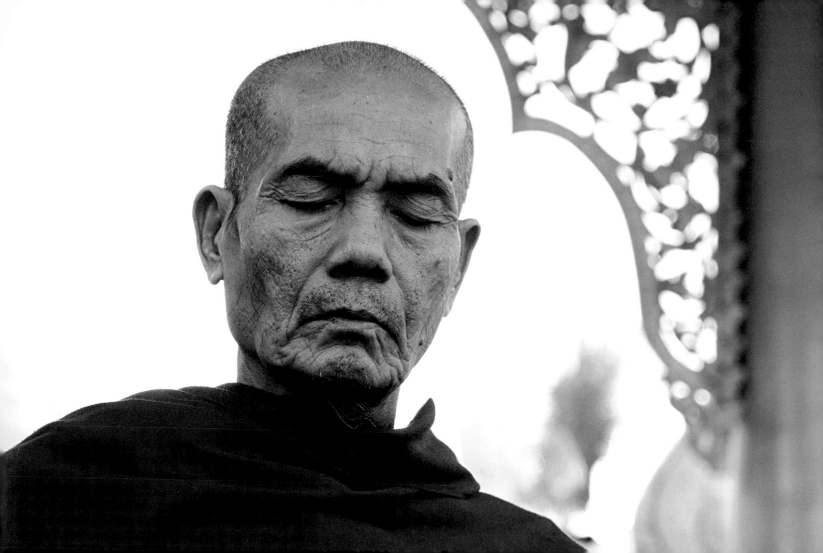

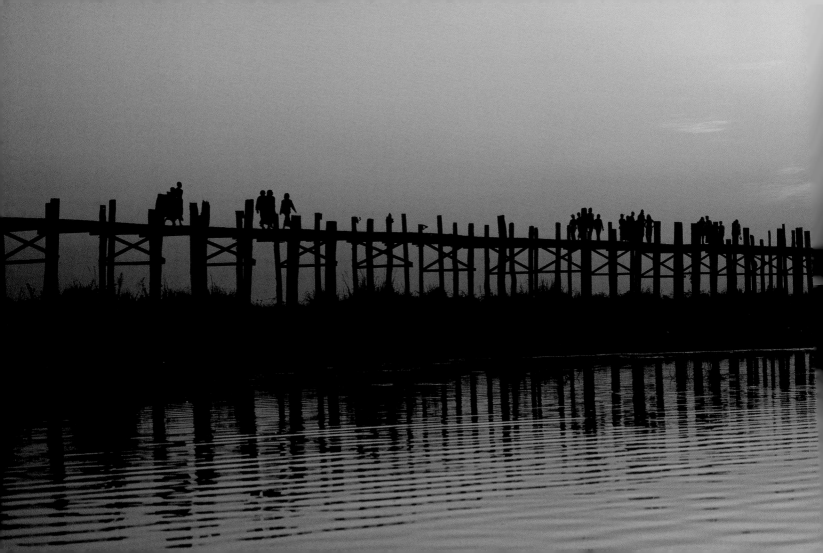

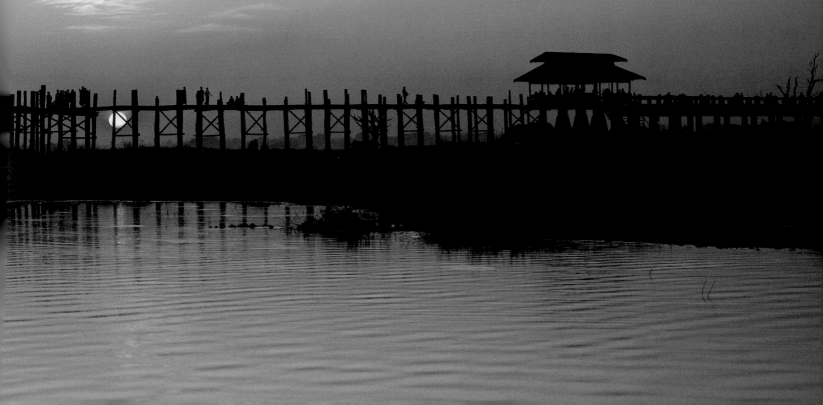

We must find the Middle Way, without going to one side or the other, but bringing the two together.

Master Taisen Deshimaru

If we retain even the smallest notion of truth or falsehood,

our minds sink into confusion.

Master Taisen Deshimaru

Ma Than Myint, a seller of amulets, relaxes near the monastery of Nat Htaung Tike in Bagan, Myanmar.
Previous pages: Sunset over the bridge of U Bein, 1.5 km (1 mile) in length, Amarapura, Myanmar.

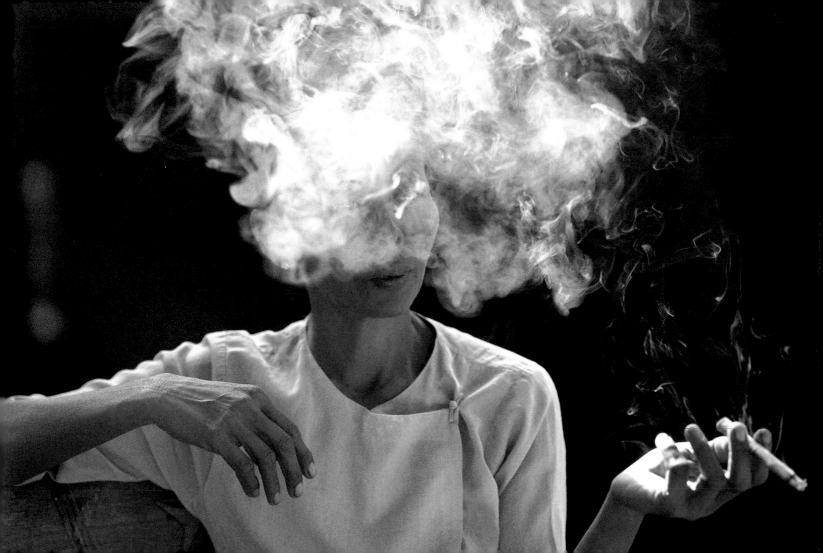

The mountains are constantly at rest and constantly walking.

We should pay close attention to the walking of the mountains.

The walking of the mountains is just like the walking of mankind.

Do not doubt that the mountains walk, just because their walk does not resemble our own.

Dogen Zenji

The village of Shiden nestles in the Mekong gorge in the Kham region of China.

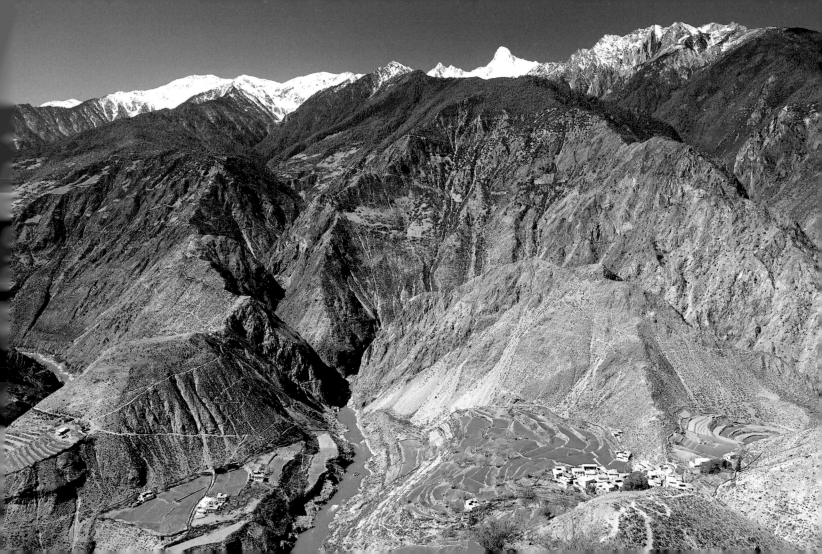

The source of human suffering
is that everyone chooses one side
and refuses to see the other side,
so reality becomes an alternating sequence of opposites
with one leading invariably to the other.

Liou Kia-hway

Kin San Nwe, aged 27, and her two sons in the countryside near Bagan, Myanmar.

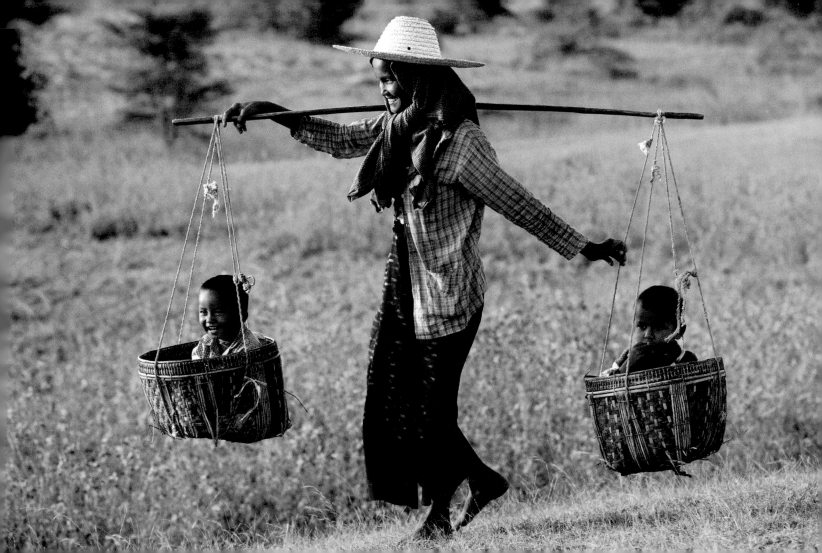

As we slowly give up all notions of taking and giving,
everything becomes clear before us.
Our consciences are pacified
and our minds remain at ease,
without duality, beyond relativity.

Master Taisen Deshimaru

Inside the Buddhist temple of Sensoji, founded in AD 628, Tokyo, Japan.

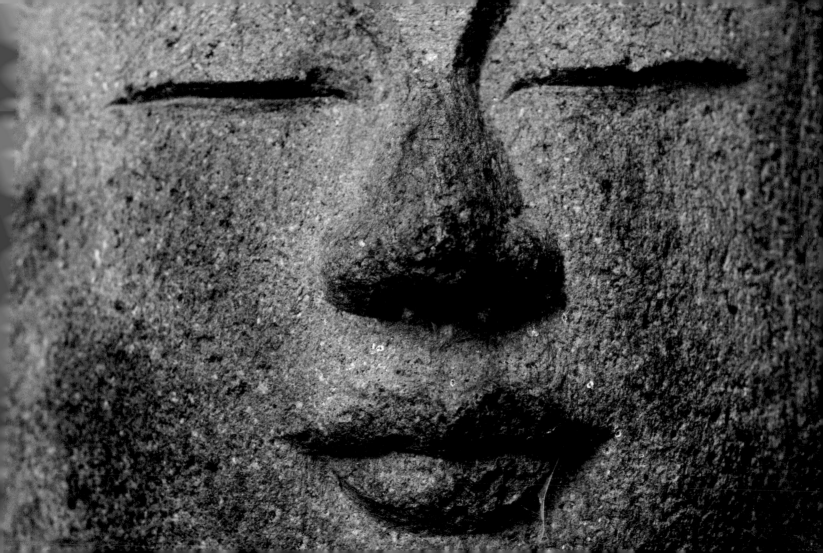

If others become righteous through my virtue,

it is because it does not offend them.

If it offends them, it must distance them from their innate nature.

Chuang-tzu

Liao Li Zhou, a 10-year-old pupil, in the Longji region, China.

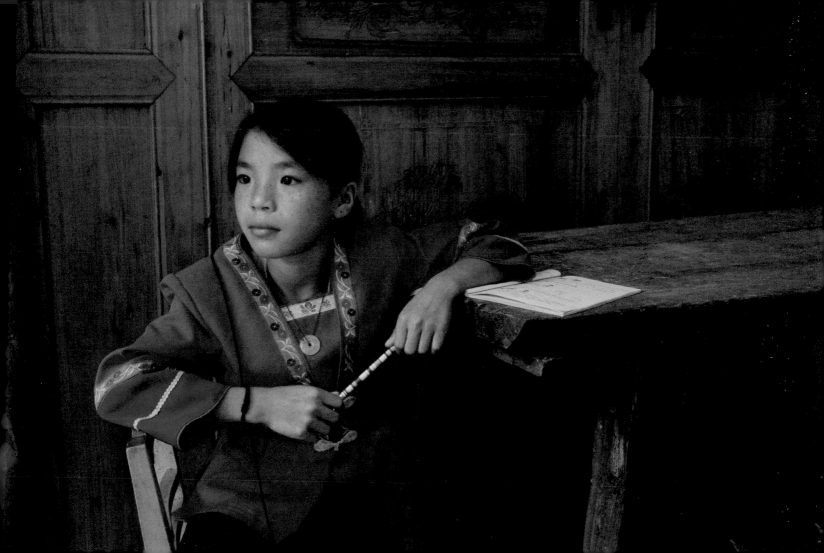

Although they are not the same, they are not different.

Although they are not different, they are not identical.

Although they are not identical, they are not multiple.

Therefore in life there are a multitude of phenomena

which make up the dynamic totality of existence.

Dogen Zenji

A centre for the Shingon school of esoteric Buddhism, Koyasan is also a huge cemetery with nearly
200,000 graves of samurai, famous figures and ordinary people amid a forest of hundred-year-old cedars. Japan.

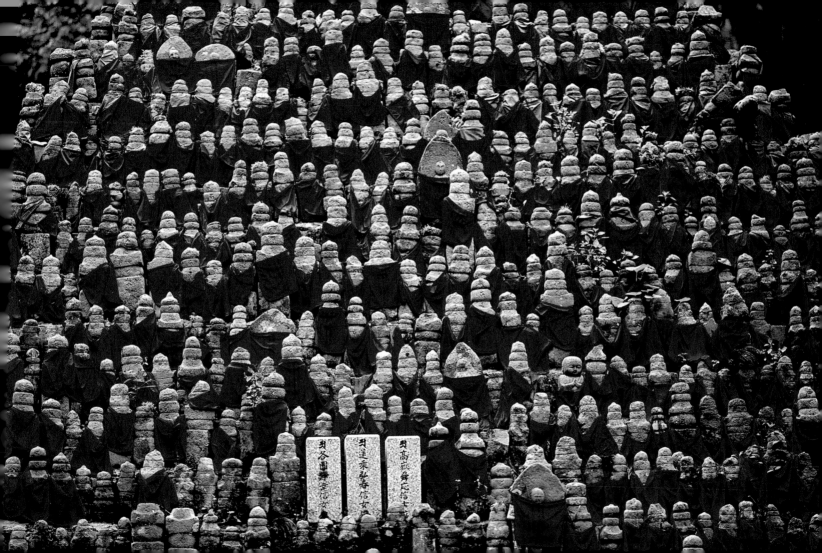

Since wars begin in the minds of men,

it is in the minds of men that defences of peace must be constructed.

Ananda W.P. Guruge

The temple of Jikjisa, one of the oldest in Korea, is the centre of the Jogye order of Korean Buddhism.

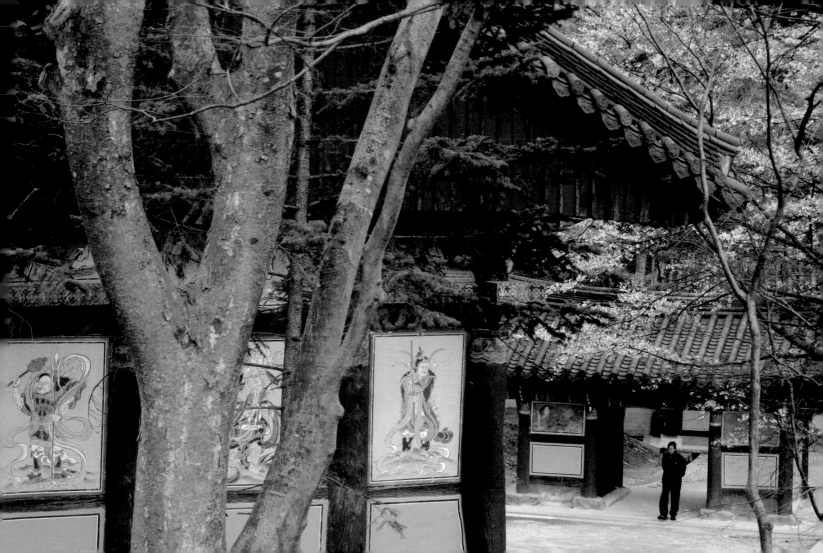

*Within the concept of 'Not-Two',
all things are identical, similar,
tolerating contradictions.*

Master Taisen Deshimaru

At sunrise, a peasant makes his way to the flooded terraces of Bada, in the province of Yunnan, China.

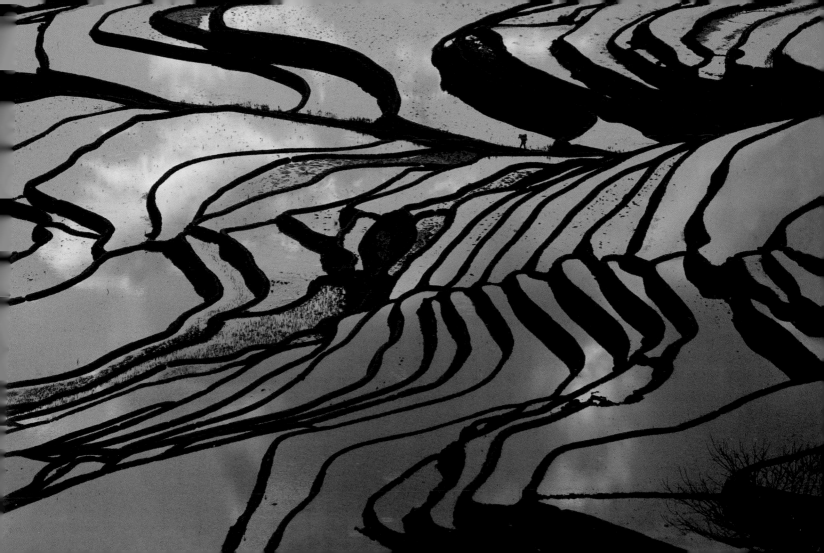

To make oneself forget the distinction between for and against

is to demonstrate the perfect adaptation of the human mind.

Never undergoing any inner change, never letting oneself be led by the outer world,

this means always being able to adapt in every situation.

It means possessing an ability to adapt without thinking about it.

Chuang-tzu

A villager enjoys a bowl of noodle soup in a tavern in Zhouzhuang, China.

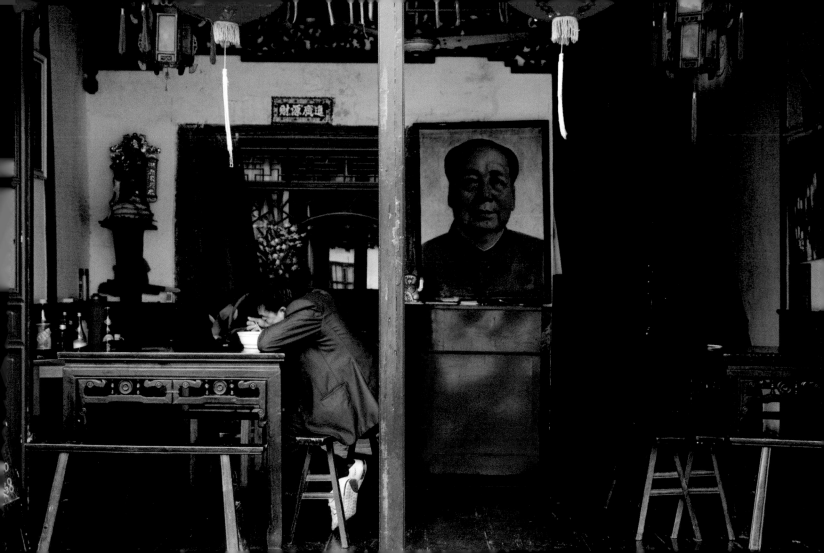

All things in the world are one.

Things that are thought beautiful are considered miraculous and marvellous,

things that are thought ugly are considered rotten and repulsive.

The truth is that rot and repulsion can transform into miracles and marvels,

and that miracles and marvels can transform into rot and repulsion.

Chuang-tzu

Floral decorations can be seen on doorways all over Myanmar.

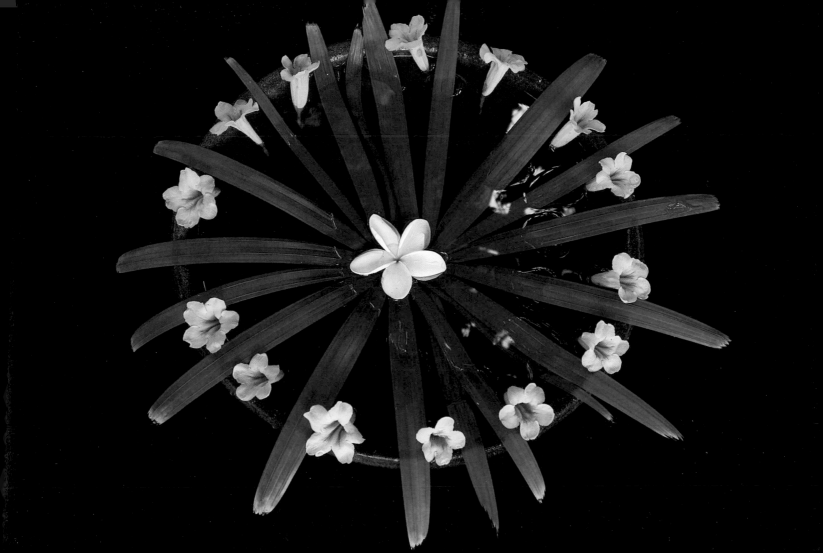

Great unity connects all things,

great darkness dissolves all things,

great vision penetrates all things,

great equality emcompasses all things,

great law rules all things,

great trust earns all things,

great balance sustains all things.

Chuang-tzu

Fishermen in the morning on Lake Taungthaman, Myanmar.

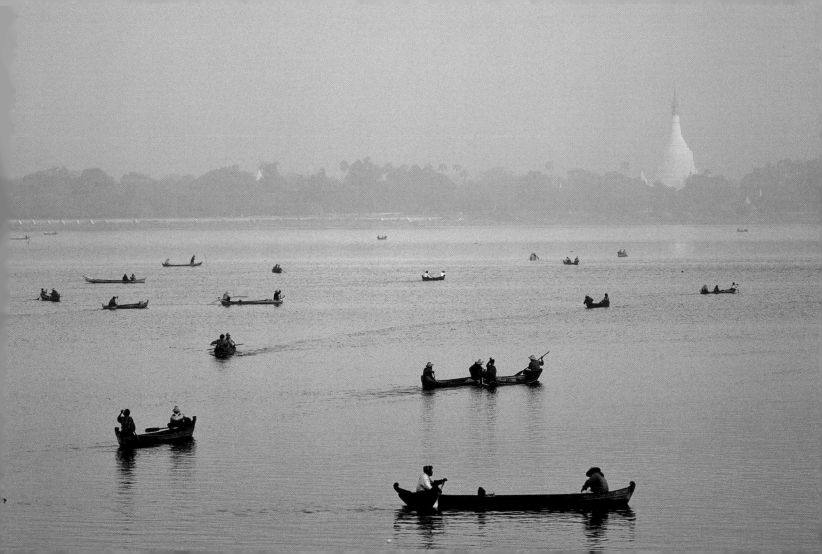

Hatred keeps on increasing to a point where both
you and I burn ourselves in our mutual hatred,
and to the Buddha the only way to solve it is that one party must stop.
Because without one party, or better still both parties,
trying to conquer hatred with friendship, hatred with non-hatred,
this sequence of hatred would never cease.

Ananda W.P. Guruge

Mahaiyan, aged 2, and younger brother Mayan, aged 1, wearing traditional Hani costume in the province of Yunnan, China.

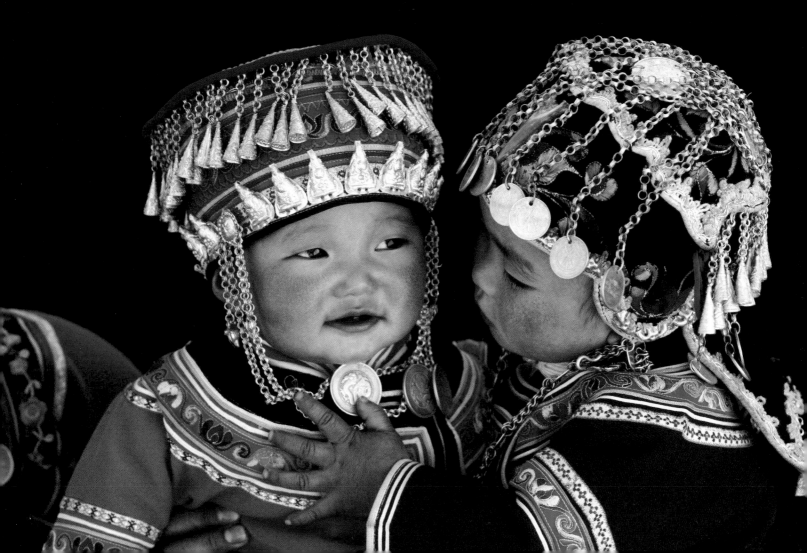

Wherever you choose to be mindful, you may acquire wisdom.
Whenever clear understanding and mindfulness act together,
wisdom, their companion, will always be found.

Ajahn Chah

Near the temple of Nong Bua, villagers from Tai Lue weave cotton shawls to sell to visitors. Thailand.

To become enlightened means a change of values.

This is enlightenment.

Master Taisen Deshimaru

Flowering cherry trees in Shinjuku Gyoen Park, Tokyo, Japan.

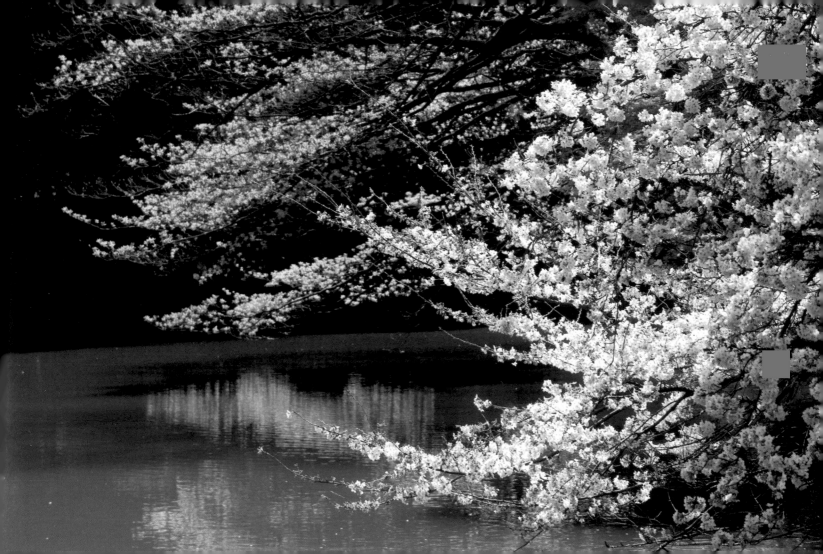

Like a great mountain, simply welcome rain, snow and ice,
and become changing, formless,
a spring of living water.

Master Taisen Deshimaru

Fields of ripe barley and wheat ready for harvesting on the plains of Zanskar in India, at an altitude of 3,500 metres (11,500 ft).

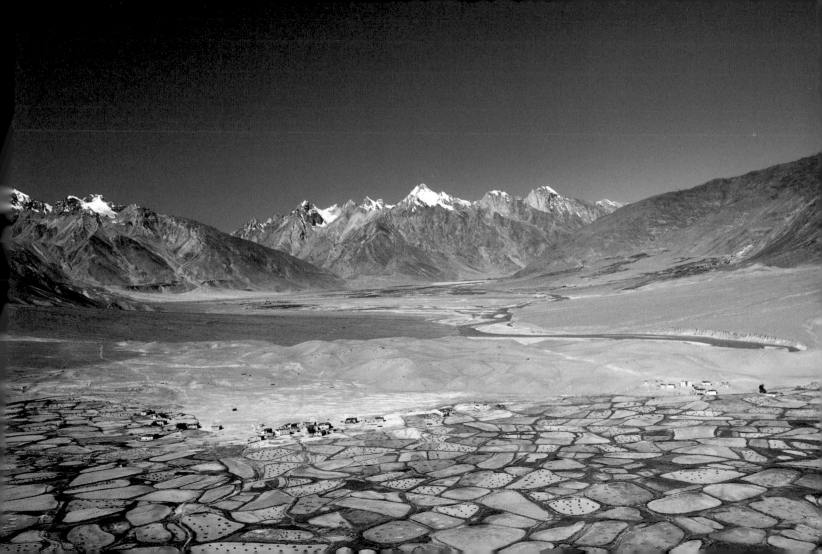

The good man is the shaper of the bad man.
The bad man is the raw material of the good man.
If the latter does not revere his master,
if the former does not care for his material,
even the cleverest will go astray.
This is the essential secret.

Lao-tzu

Traditional gardens recreate nature in miniature, to celebrate the union between mankind and heaven. Suzhou, China.

Let us not be too severe in reprimanding others for their faults,
let us think of what they can withstand.
Let us not be too ambitious, exhorting others to be good,
let us think of what they can achieve.

Hong Zicheng

Many Burmese daub their faces with the crushed bark of the thanaka tree, which serves as makeup, sunscreen and perfume. Myanmar.

Nothing in the world is softer and weaker than water.

However, when attacking that which is hard and strong,

nothing can surpass it and no one can equal it.

Weakness may overcome strength,

softness may overcome hardness,

everyone knows it

but no one puts this knowledge into practice.

Lao-tzu

A fisherman returns to his village on the banks of the Nam Ou, Laos.
Overleaf: Every morning, the monks leave the monastery to collect food given to them by ordinary people. They eat only once a day at 11 a.m. Myanmar.

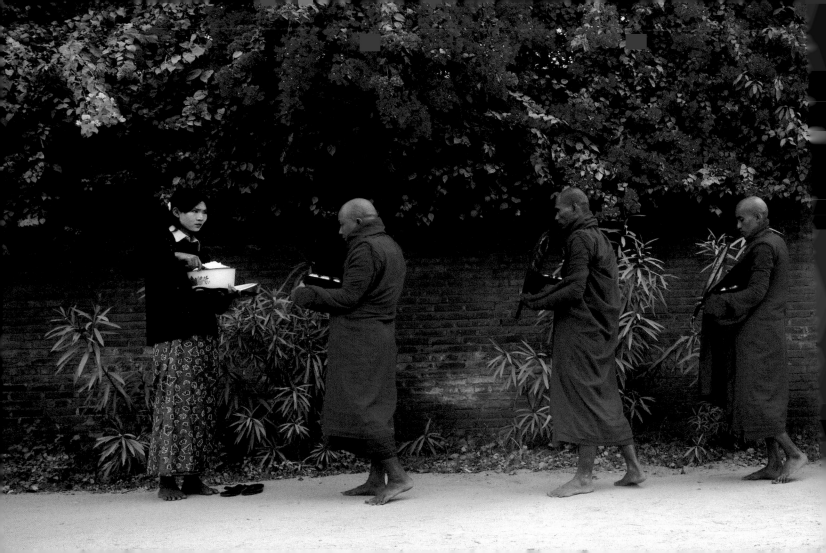

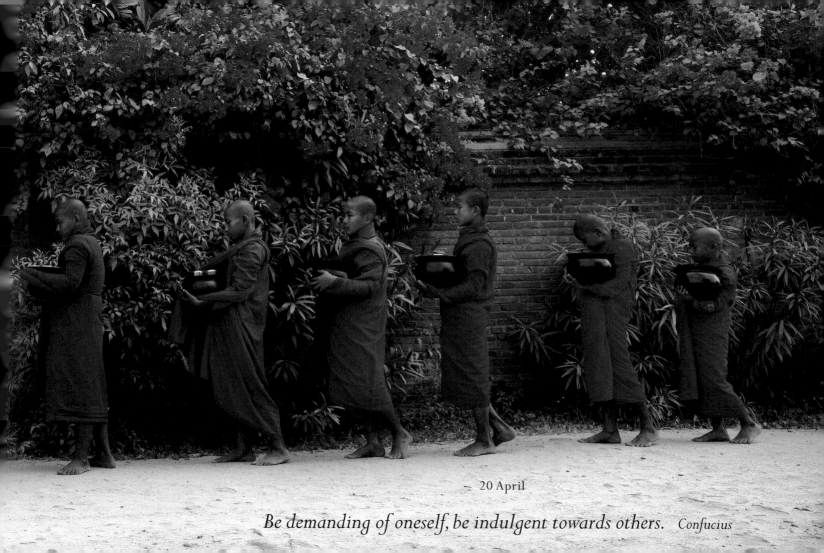

20 April

Be demanding of oneself, be indulgent towards others. Confucius

Fold yourself in two and you remain whole
Bend yourself and you can be straightened
Be empty and you will be filled again
Grow old and you will be reborn
Possess little and this little will grow
Possess much and it will be lost.

Lao-tzu

Acrobats performing at the Shanghai Centre Theatre, China.

Letting go
means accepting life just as it is:
elusive, free, spontaneous and without limits.

Zen practice

Camp in the massif of the Upper Altai, Mongolia.

Learn to stop and you will learn stability,

once stable, you will learn to rest,

in rest, you will learn serenity,

in serenity, you will learn to reflect,

and through reflection you will succeed.

Tseng-tzu

The floating market of Phong Dien in Can Tho, in the Mekong Delta, Vietnam.

I do not act,

people change by themselves.

I like to remain quiet.

Lao-tzu

In the temple of Jikjisa, centre of the Jogye order of Korean Buddhism, South Korea.

The aim of the victory that the wise man seeks is not to dominate,

but to pacify and achieve balance,

to find a total harmony

in which weakness and renunciation

act as a counterweight

to dominating power and violence.

Lao-tzu

The gesture of this modern statue suggests protection and benediction, as well as faith in the teachings of the Buddha. Myanmar.

He who learns to give way is the master of strength.

Lao-tzu

A monk praying in the pagoda of Shwedagon, the most venerated shrine in Myanmar.

Letting be, letting grow
Letting be, not hoarding
Maintaining, not subjugating
Overseeing life, not causing death.

Lao-tzu

A young mother cradles her baby in the village of Ben Sop Jam, Laos.

If we stop all movement,
our minds will become tranquil,
and then this tranquillity
will bring movement once more.

Master Taisen Deshimaru

Khoeun Khon, a young monk at the temple of Ta Phrom in Angkor, Cambodia.
Overleaf: Reclining Buddha in the temple of That Luang in Vientiane, Laos.

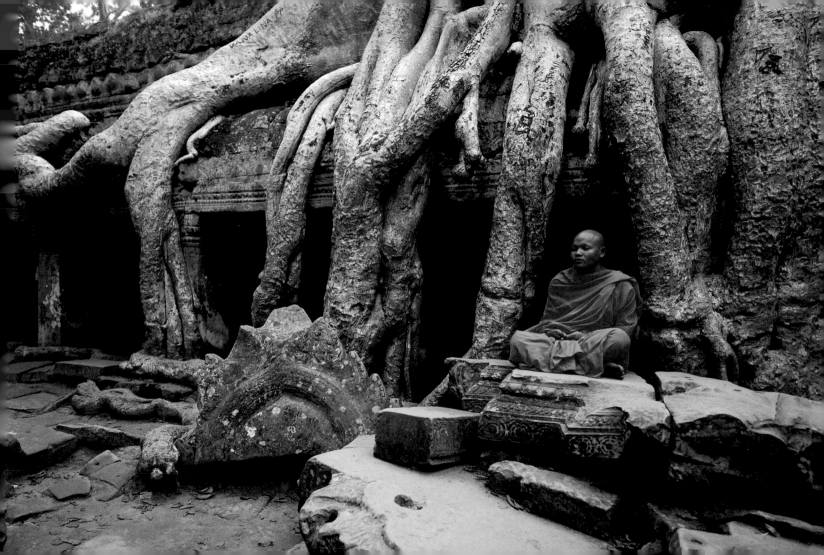

29 April

Through non-doing, nothing is left undone. To give up everything is to gain the universe.

Lao-tzu

Before you say hateful or angry things, stop for a moment.
As a thinking person, you have a choice to consider what you are going to say
— not yell, hit, defend, or accuse — before you say it.

Steve DeMasco, Kung Fu Master

An old lady smoking a traditional cigar, Myanmar.

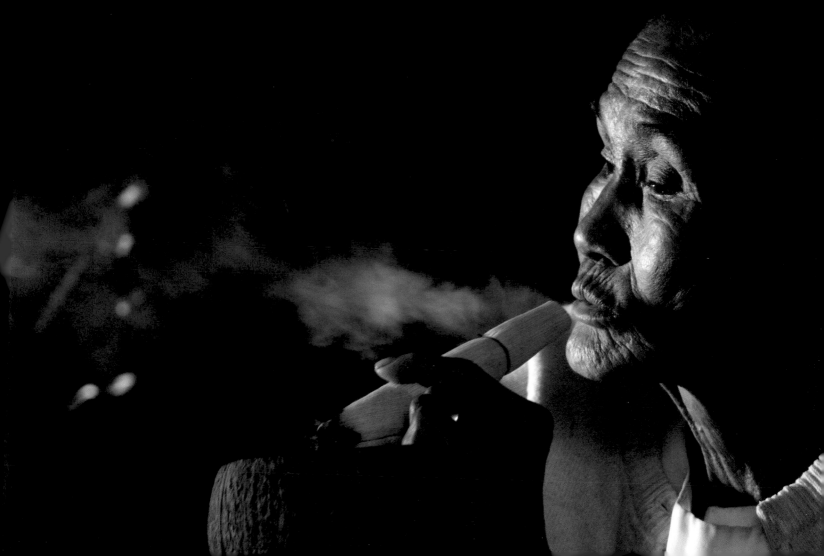

Where is what you call the Tao?

— It is everywhere.

Where is it?

— In this ant.

And lower?

— In this blade of grass.

And lower?

— In this clay tile.

And lower still?

— In this dung.

Chuang-tzu

A 'yai de lum' tree, covered with climbing vines, at the temple of Bua De Nong, Thailand.

*Anger is rooted in the lack of self-knowledge
and in the causes, both deep and immediate,
that have led to this unpleasant situation.*

Thich Nhat Hanh

A young woman selling statuettes of the Buddha in Bagan, Myanmar.

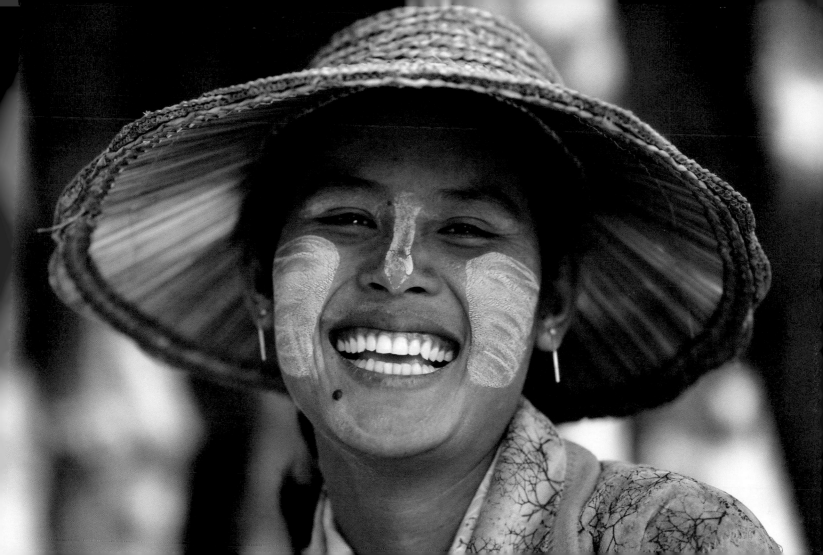

If others seem disagreeable to you,

by what miracle do you wish to appear agreeable to them?

Shosan Suzuki

Ko Khant and Nandar, among the water containers sold by their parents in Bagan, Myanmar.

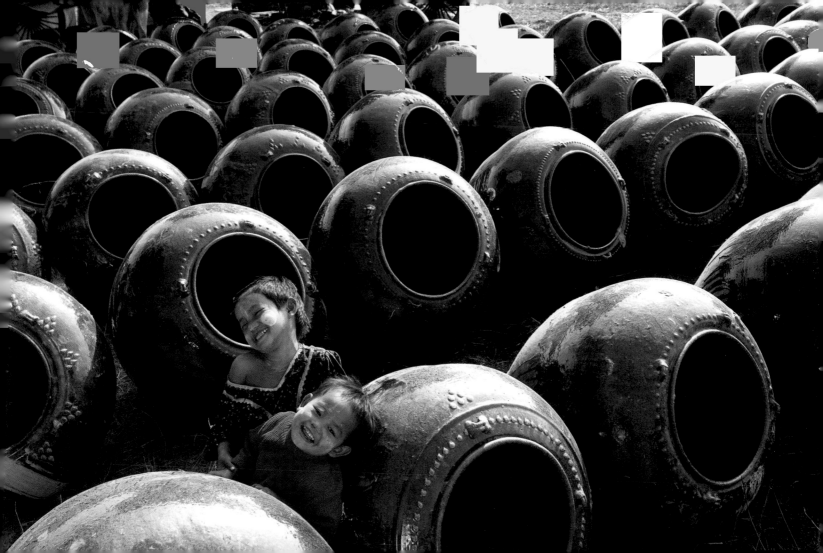

*Every decision we make and
every action we take has meaning,
and affects everything else — now and always.*

Steve DeMasco, Kung Fu Master

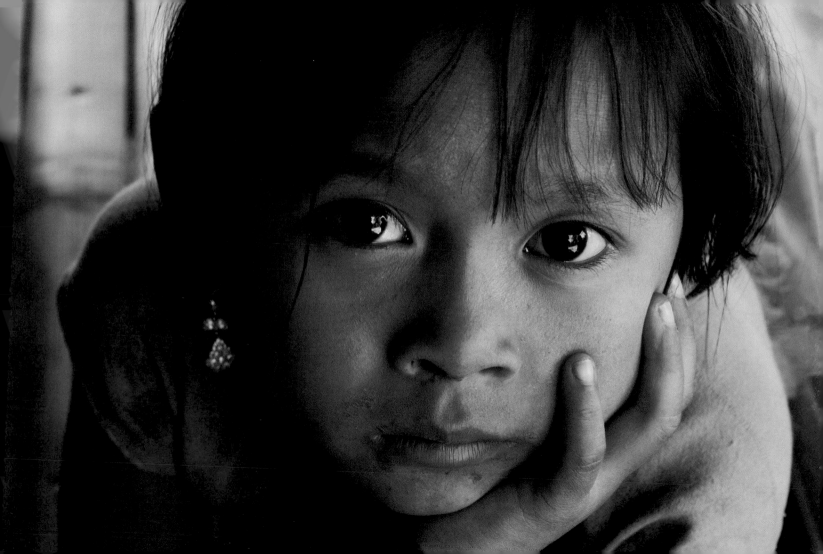

If I hurt you, it's going to come back to me.

Steve DeMasco, Kung Fu Master

Statue of the Buddha at the temple of That Luang in Vientiane, Laos.
Overleaf: Sunrise over the fishing boats on Lake Taungthaman, Myanmar.

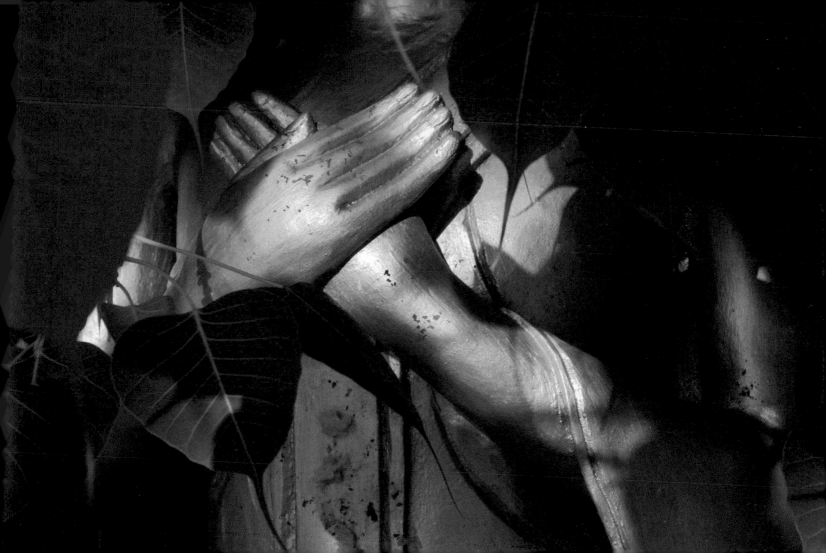

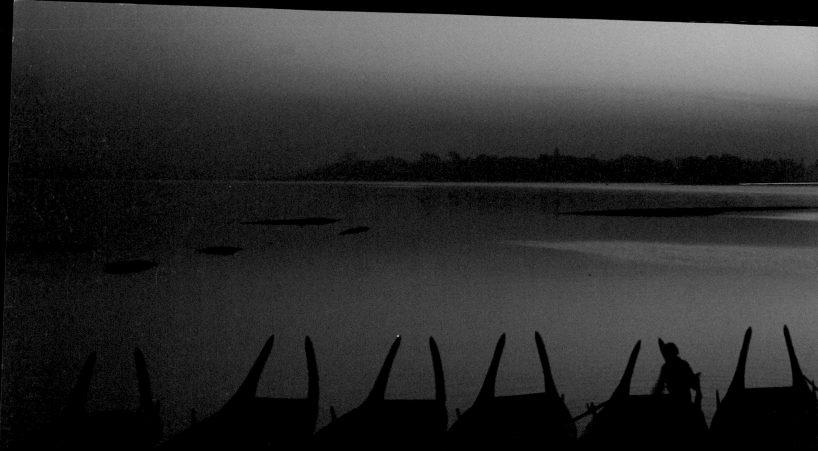

Words are as noisy as the song of the frog in the mating season.

Master Taisen Deshimaru

Every obstacle we have to climb over in our lives

can be considered a battle in itself.

One of the keys to overcoming weakness

lies in understanding what kind of war we're fighting,

and what we don't often realize is that

the scariest player in the war is you or me.

Sun Tzu

The temple of Borobudur, which is in the shape of a Tantric Buddhist mandala, representing Buddhist cosmology and the nature of the spirit. Indonesia.

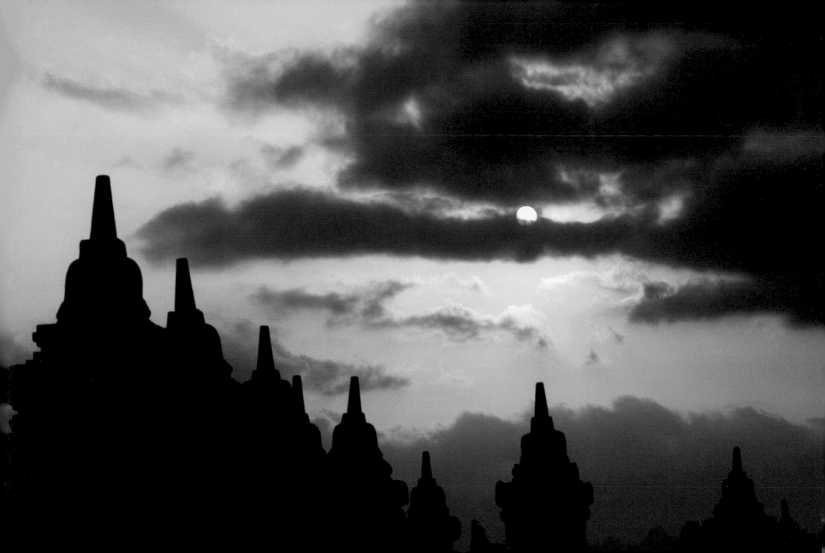

The heart is made from the same substance as the heavens.

Joyful thoughts are like the Star of the Just or a happy omen.

Angry thoughts are like storms and tempests.

Kind thoughts are like the breeze and the dew.

Harsh thoughts are like the burning sun or the autumn frost.

All of these aspects alternate; it is enough to watch them appear and disappear

to feel as free as the universe, made from the same substance as the heavens.

Hong Zicheng

At dusk a rider returns to camp in the massif of the Upper Altai, Mongolia.

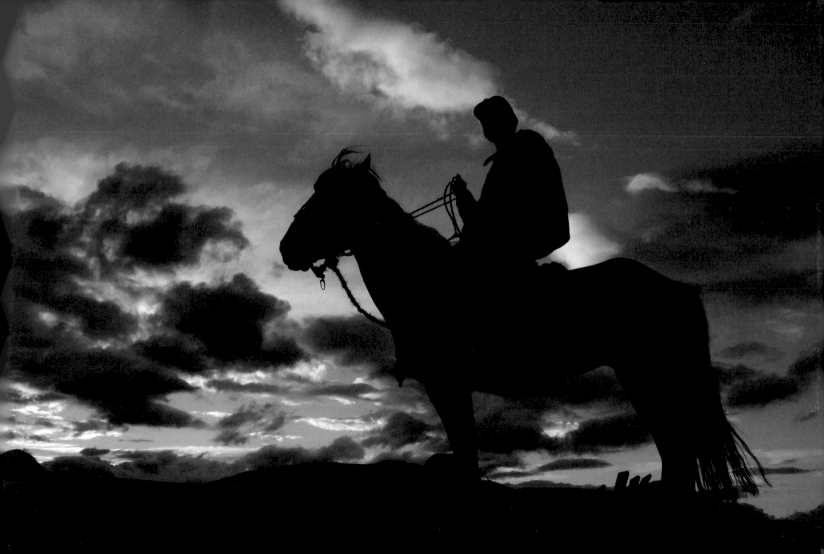

Happiness is lighter than a feather,
no one can grasp it.
Suffering is heavier than the earth,
no one can let it go.

Chuang-tzu

Mashumei, aged 2, reaches out affectionately. Yunnan, China.

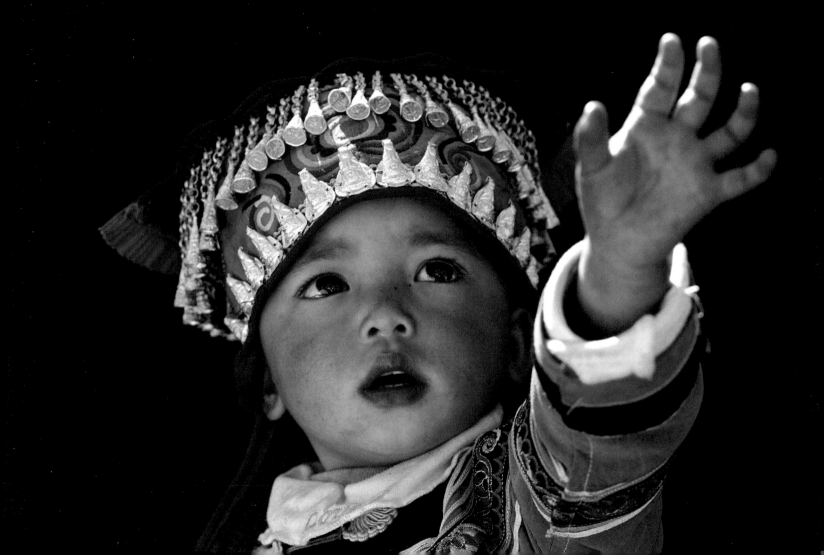

The path to enlightenment is an easy one:

do no harmful actions,

do not become attached to the cycle of death and rebirth,

show kindness, respect the old and have compassion for the young,

do not have a heart that rejects or a heart that covets

and have no worry or sadness in your heart.

This is what is called enlightenment.

Do not seek it elsewhere.

Dogen Zenji

Two young nuns return to their convent in Sagaing, one of the principal centres of Buddhism in Myanmar.

Heaviness is the root of lightness,
calm is the master of agitation...
too light and the root will be lost,
too agitated and mastery will be lost.

Lao-tzu

A villager comes to draw water for his kitchen garden from the Li river, China.

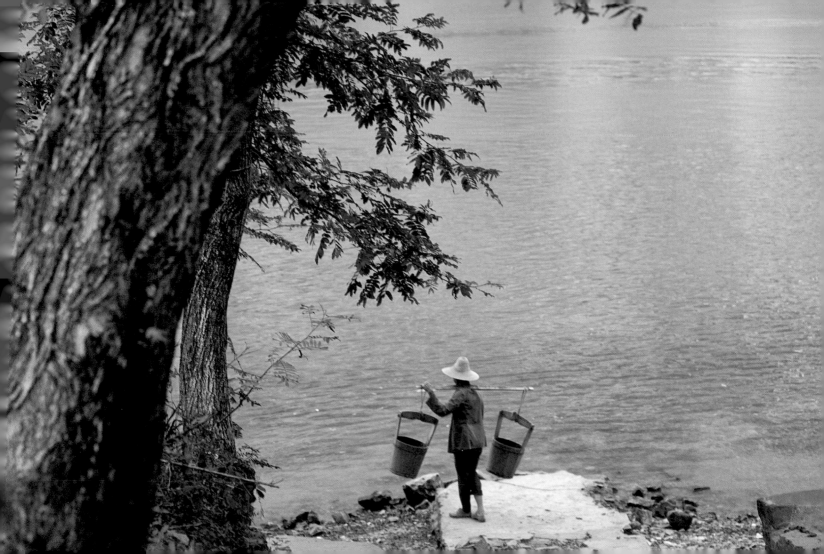

To adapt to things by creating harmony:

this is virtue.

To cope with things by bringing them together:

this is the Tao.

Chuang-tzu

Terraced paddy fields in the region of Longji (the dragon's spine), China.

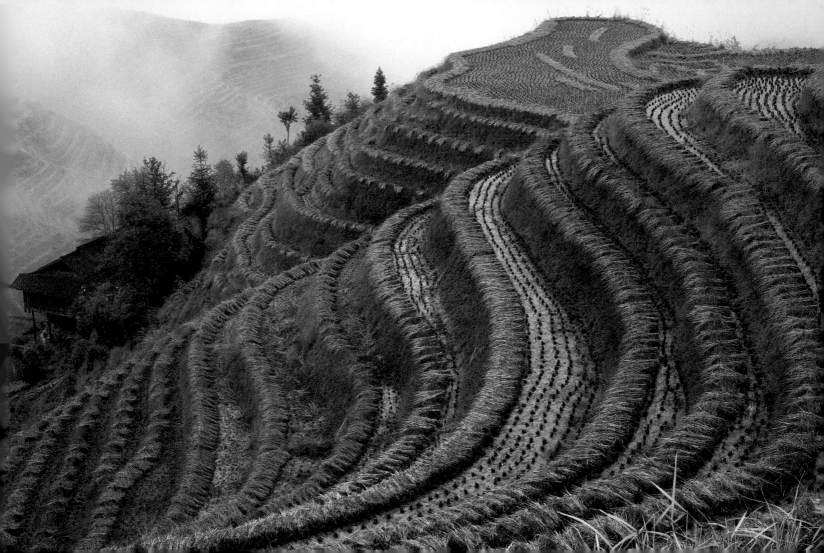

Every day I examine myself on these points.

In looking after the affairs of others, have I been loyal?

In my relationships with friends, have I been sincere?

Tseng-tzu

Lin Aung with little brother in the market of Than Iwin, Mawlamyine, Myanmar.

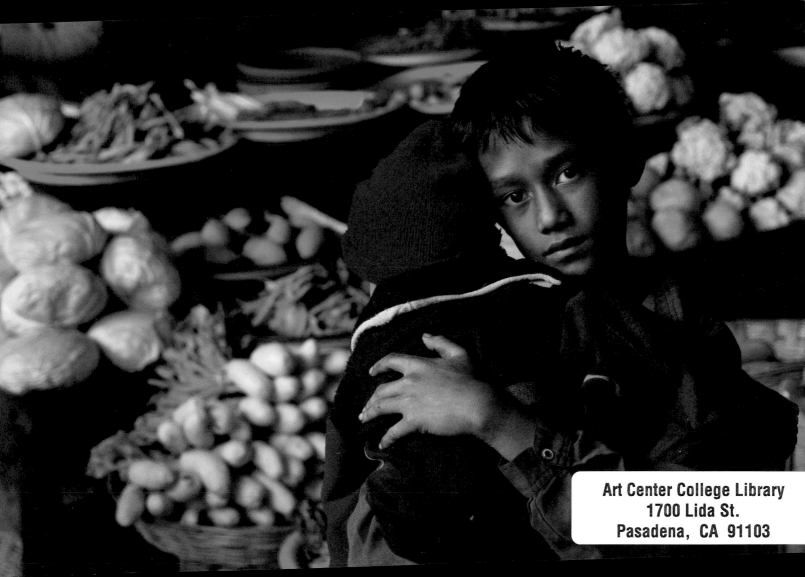

Art Center College Library
1700 Lida St.
Pasadena, CA 91103

Greater than a thousand meaningless words
is a single reasonable word
that brings calm to those who are listening.

Buddha

Three friends beside the Irrawaddy river, Myanmar.

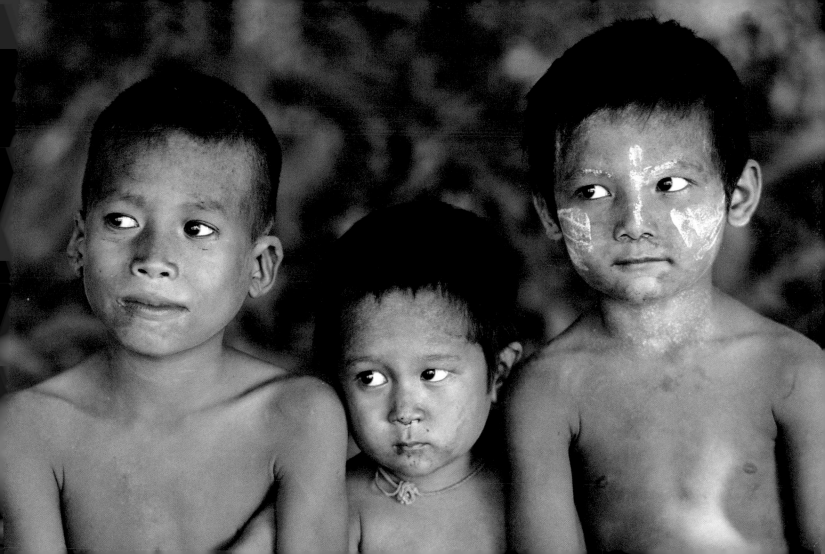

It is not power that corrupts, but fear.

Aung San Suu Kyi

In the region of Kham, the village of Yugong nestles in the gorge of the Mekong, China.

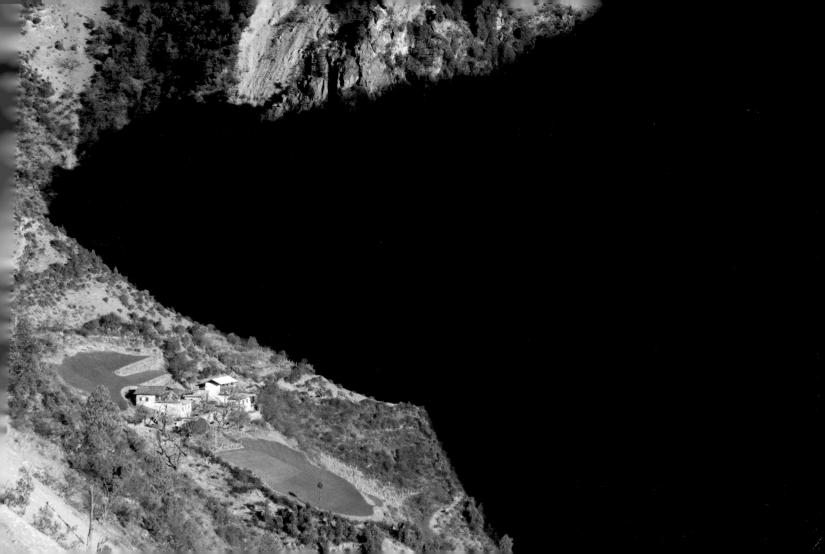

A true warrior is not warlike,

a true fighter is not violent,

a true victor avoids combat,

a true leader remains humble before his men.

Lao-tzu

The engineer aboard the Irrawaddy ferry, Myanmar.

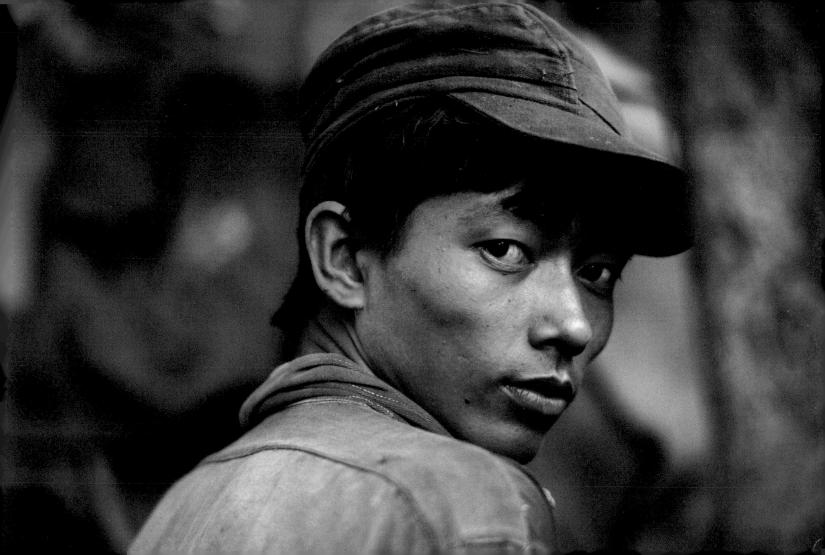

When we understand that we cannot be destroyed,

we are liberated from fear.

Thich Nhat Hanh

The unfinished pagoda of Mingun, which fell victim to an earthquake in 1838. Myanmar.

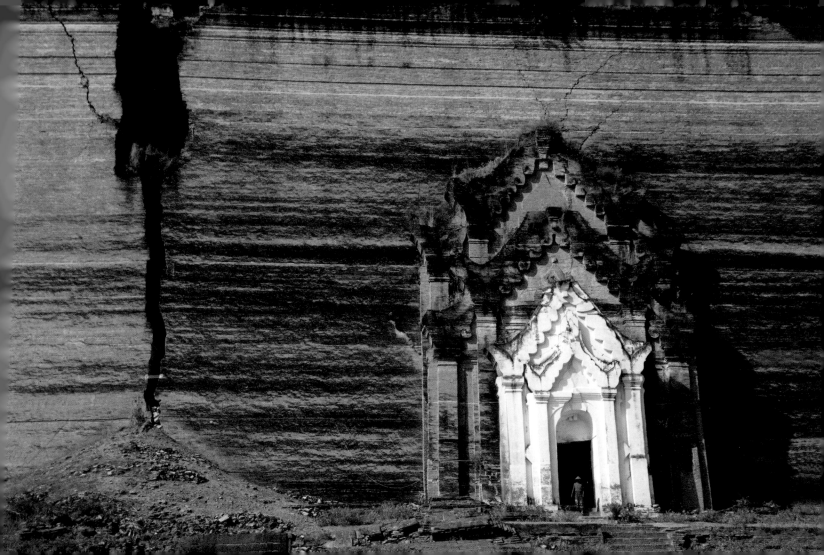

Through courage we do not reduce our fear,

we go beyond it.

Chögyam Trungpa

Bridge spanning a canal in the Mekong Delta, Vietnam.

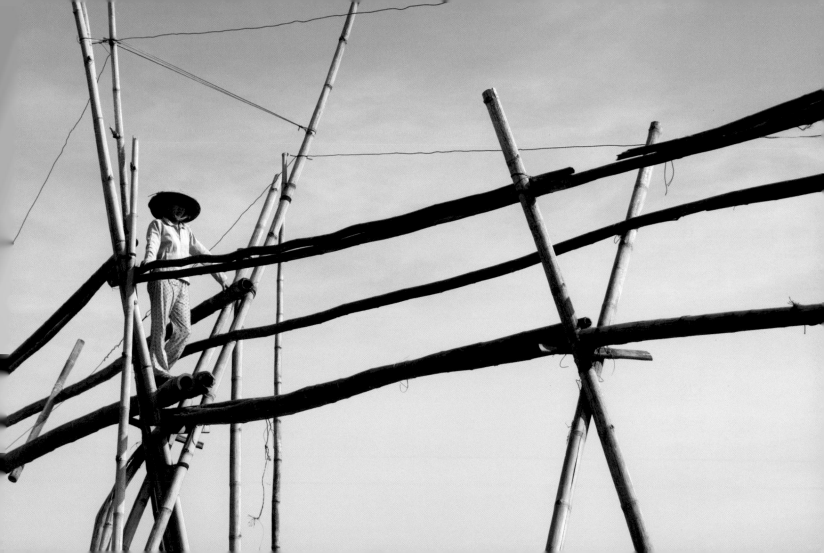

One act can save a life
or help to seize a rare opportunity.
So may one thought,
because thoughts lead to words and action.

Thich Nhat Hanh

Ma Ei Pone, aged 25, rocks her 4-month-old son in the village of Minnanthu, Myanmar.

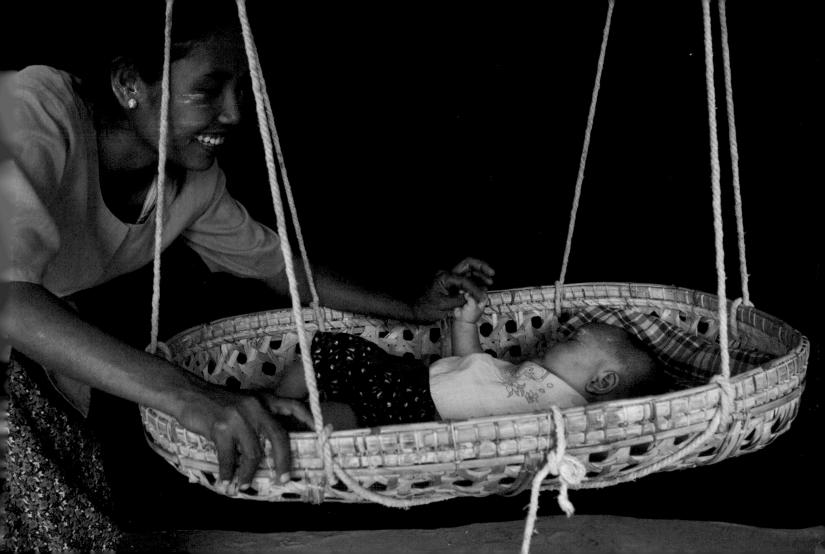

Great perfection seems flawed
but does not decay.
Great fullness seems empty
but does not fail.
Great truth seems false.
Great cleverness seems clumsy.
Great eloquence seems awkward.

Lao-tzu

Primary school pupils in the village of Ben Sop Jam wait for their first exam results, Laos.

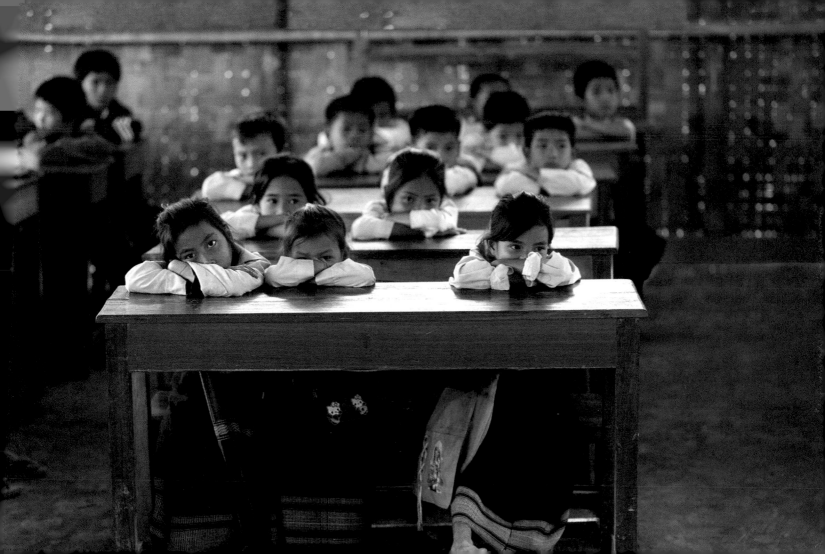

Heaven and earth, day and night, yin and yang, subject and object,

life and death, right and wrong, love and hate,

before and after, above and below…

We always find two sides, two aspects to everything.

We must always keep going beyond that point.

And in the end, everything will return to its own single essence.

Master Taisen Deshimaru

A ridge lit by the setting sun seems to be radiating out of a little Buddhist *chorten* in Shadi in the mountains of Zanskar, India.

If I know that love is myself

and that pain is also myself,

that understanding is myself and suffering too,

then I will be mindful.

I will not suppress my own suffering

because I know that I can transform it into a flower...

The flower exists because suffering exists.

Thich Nhat Hanh

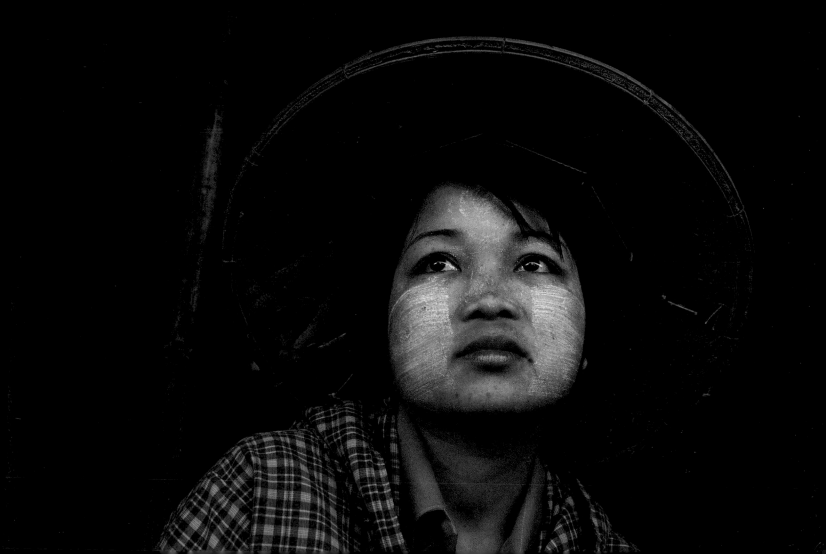

Even if our words are just,
even if our thoughts are precise,
that is not the same as the truth.

Master Taisen Deshimaru

Sake-Daru, casks of sake to be offered to the deities, are sold near tombs. Japan.

Strive for detachment,
concentrate in silence,
conform to the nature of things,
be without ego.
Then mankind will be at peace.

Chuang-tzu

The temple of Wat Xiengthong, built in 1560, Luang Prabang, Laos.

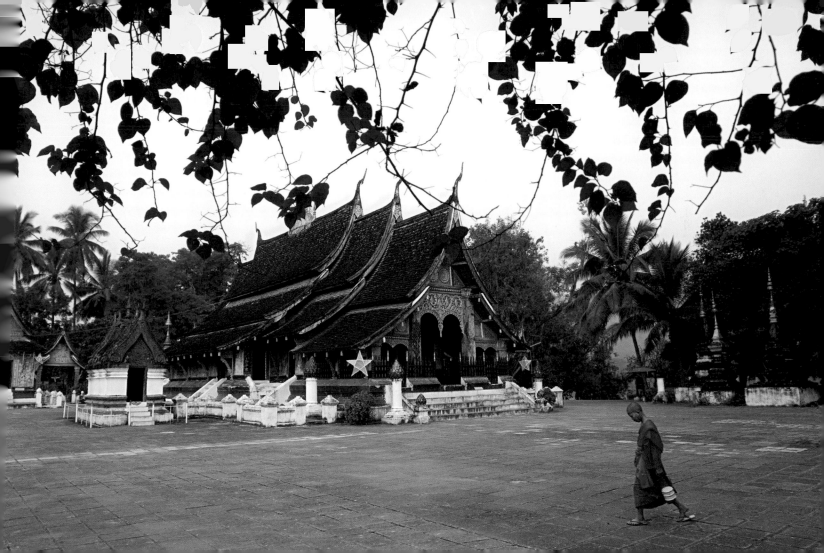

For someone who knows how to manage their free time, one day may last a thousand years.

For someone whose heart is great, a hut may be the size of the universe.

Hong Zicheng

An elderly couple relax in the shade under the canopy of their home in Suzhou, China.
Overleaf: A boat transports goods from one village to another along the Irrawaddy river, Myanmar.

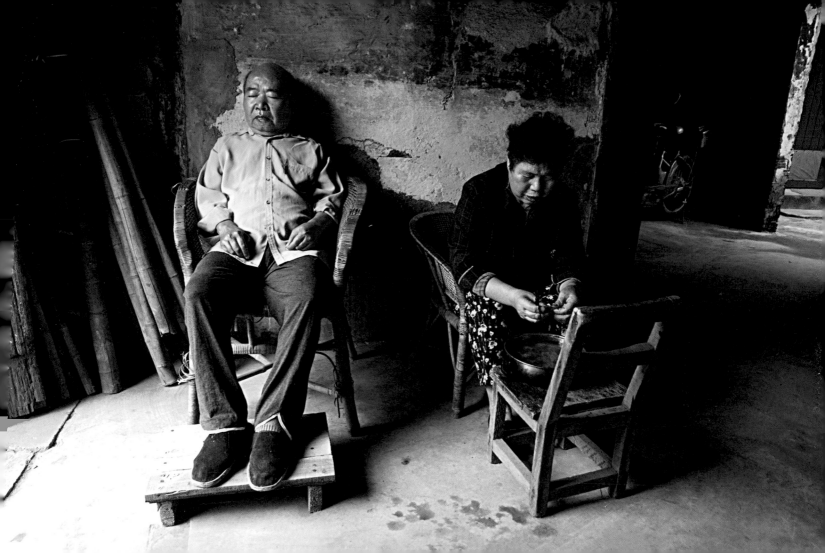

26 May

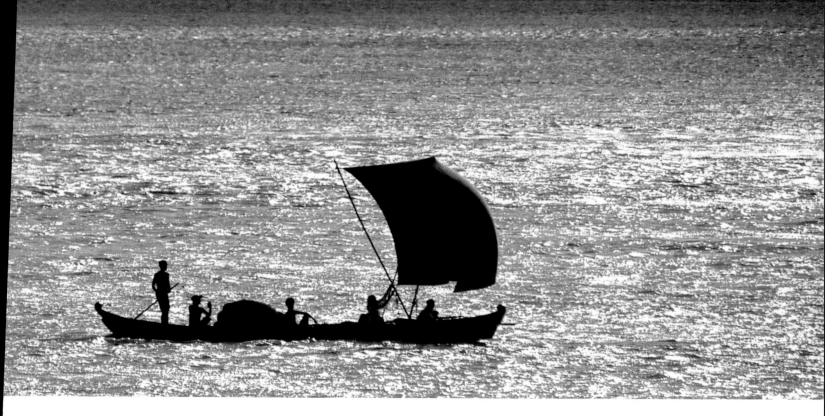

To act with the minimum of effort and obtain the maximum results, such is the way of the wise man.

Chuang-tzu

The blazing plains cannot make a wise man feel the heat;
the frozen streams cannot make him feel the cold;
the lightning that splits the mountains, the hurricane that raises the sea,
these things cannot frighten him.
In this way he rules the clouds, harnesses the sun and moon,
and travels beyond the seas.

Chuang-tzu

The ruined temple of Ta Phrom in Angkor, Cambodia.

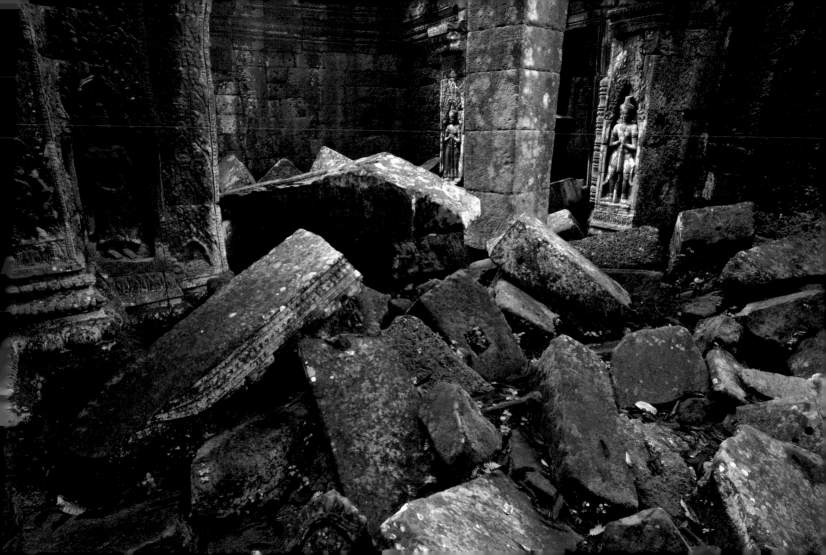

He who moves does not know what to do.

He who knows what to do does not move.

Feng Menglong

A Naxi peasant woman from Yunnan at the weekly market in the region of Dali, China.

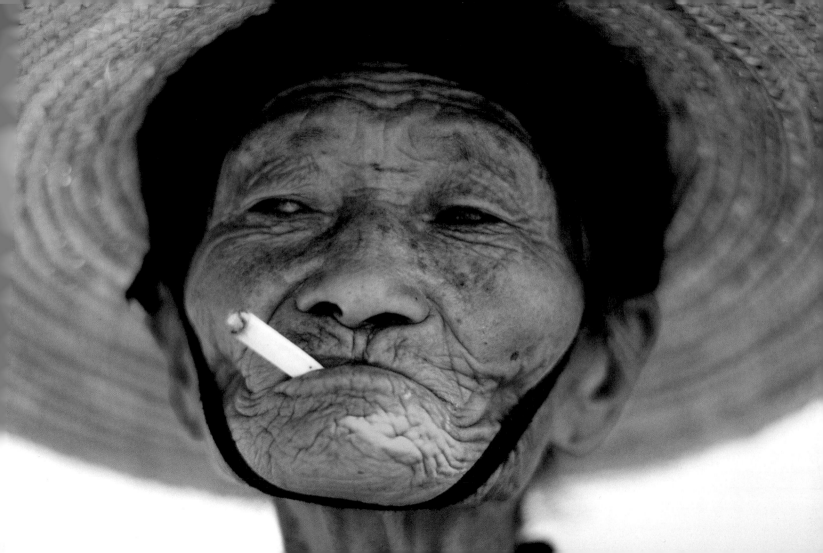

Words and thoughts are limited and relative, while truth is without limits.
Words find their truth in the heart of silence,
and thoughts when they rise from the depths of non-thought.

Master Taisen Deshimaru

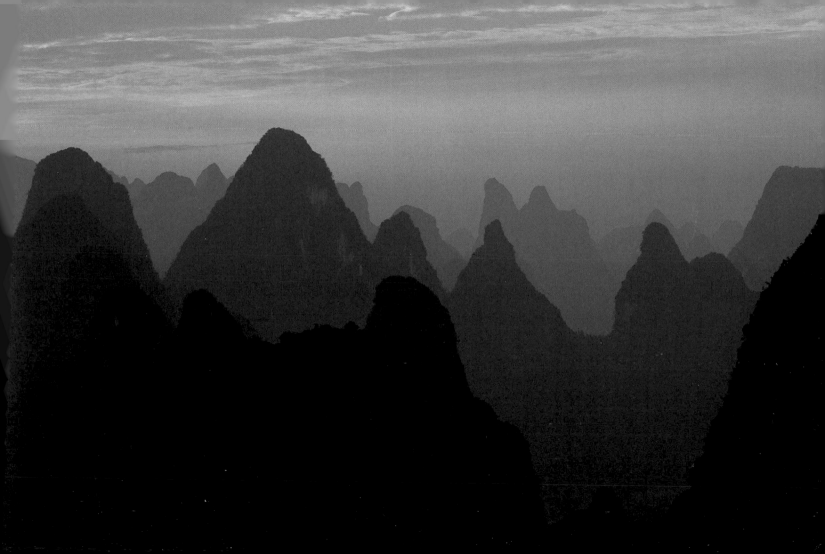

Those who know quiet, alone,

are as carefree as the flowers in the breeze,

as pure as the snow in the moonlight.

Those who know leisure, alone,

may watch the changes in the water and the trees,

the bamboo and the stones.

Hong Zicheng

Fishing in the morning on Lake Taungthaman, Myanmar.

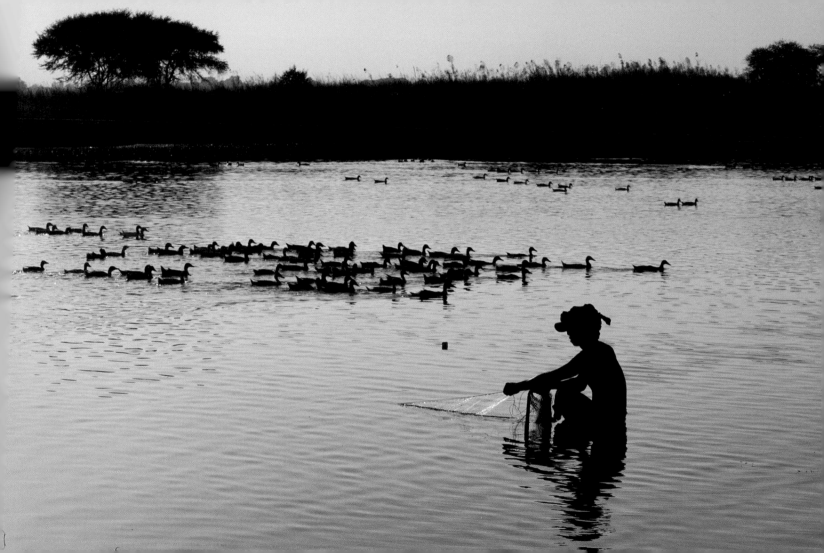

He who knows does not speak.

He who speaks does not know.

Lao-tzu

A village woman near a pagoda in Bagan, Myanmar.

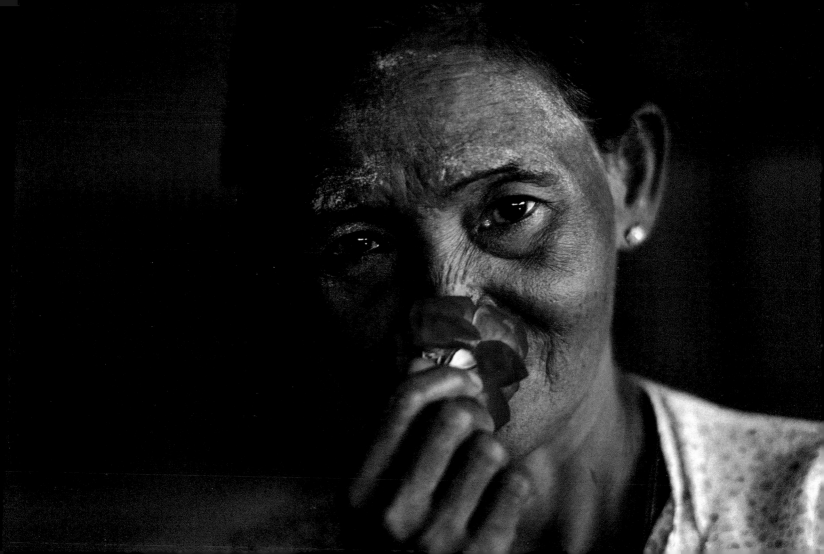

*The songs of the birds and insects wordlessly transmit
the law of the universe.
The colours of the flowers and leaves wordlessly teach
the truth of the world.*

Hong Zicheng

Autumn in Koyasan, a centre of the Shingon school of esoteric Buddhism, Japan.

The wise man governs by non-doing.

He teaches by non-saying.

Lao-tzu

A young nun prays at Sagaing, one of the major Buddhist centres in Myanmar.
Overleaf: Storm on the island of Koh Lipeh in the Andaman Sea, Thailand.

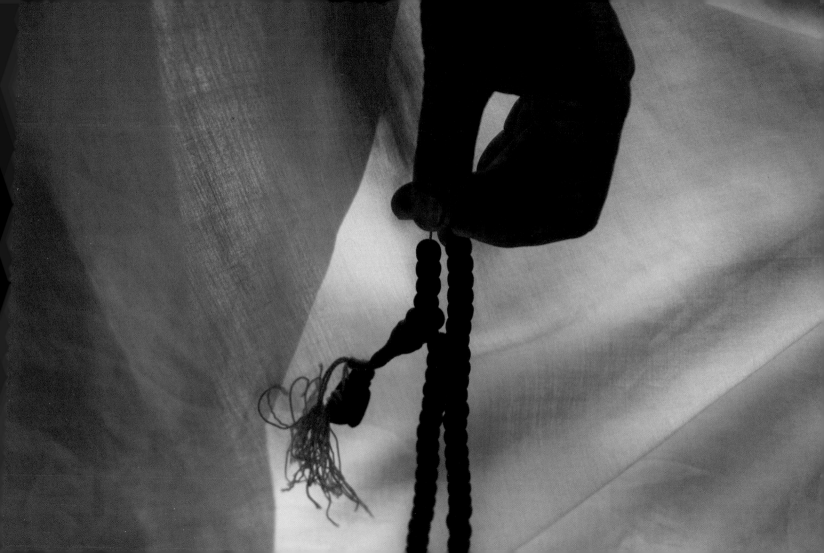

A gust of wind does not last for a morning.

A shower of rain does not last for a day.

What produces them?

Heaven and earth.

If heaven and earth

do not produce anything that lasts,

how can a human being?

Lao-tzu

Knowing what we can do nothing about
and accepting it as our destiny,
this is supreme virtue.

Liou Kia-hway

Camp in the massif of the Upper Altai, Mongolia.

The entire cosmos is our own body.

Life and death are merely the coming and going of the real human body.

Master Taisen Deshimaru

A child from the village of Ban Houey Ko, on the banks of the Mekong, Laos.

Our mother the Earth once brought us into life,
and she will bring us into life a hundred times more,
and we will know neither fear nor suffering
when she opens her arms to welcome us again.

Thich Nhat Hanh

Every morning a worker collects the leaves that have fallen from a banyan tree in the gulf of Yogyakarta, Indonesia.

Growing and subsiding, filling and emptying, ending and beginning again,
this is the cycle of the world.
This is how we must understand the great duty that falls to everyone,
and the universal order that governs all things.

Chuang-tzu

A peaceful afternoon with a grandfather and grandson from the Karen people of southern Myanmar.

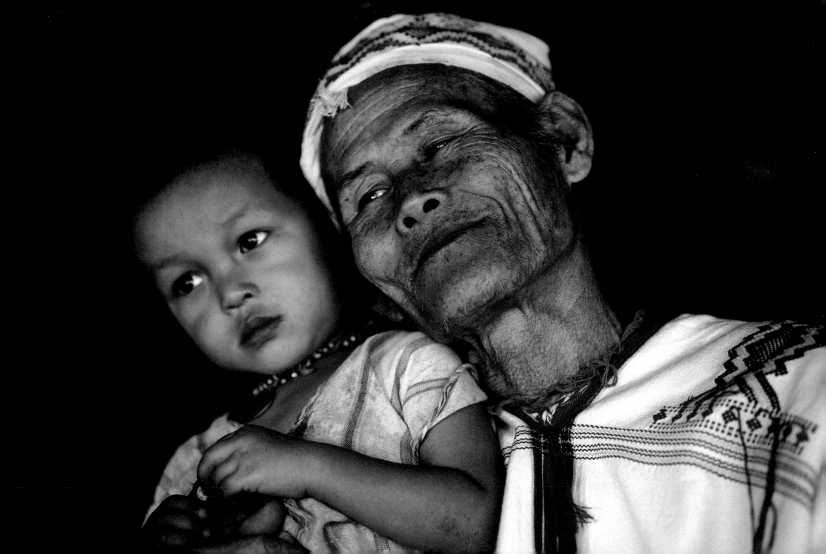

Death and life are part of Destiny, as are day and night.
All that mankind cannot change is part of the intimate substance of things.

Chuang-tzu

At dusk, a fisherman returns to his village on the banks of the Nam Ou, Laos.

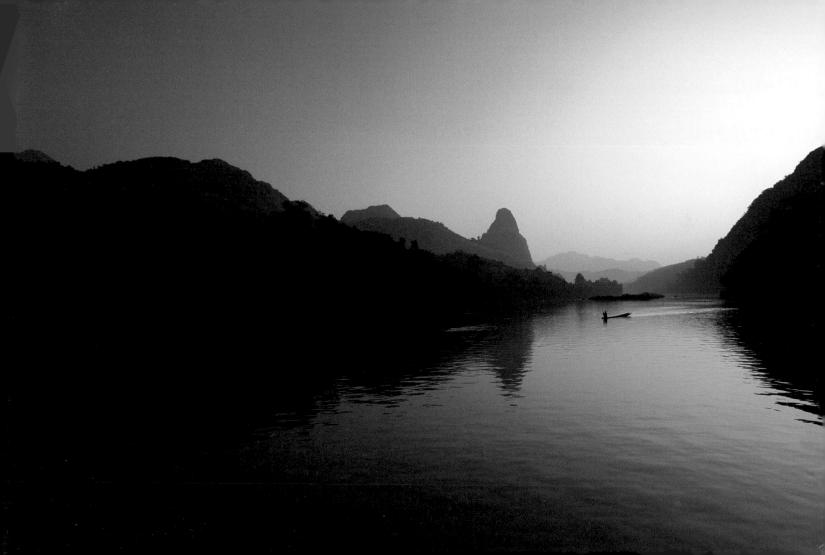

'Now' is primordial

and contains the entire universe, changing and impermanent.

Master Taisen Deshimaru

In September, at 3,500 metres (11,500 ft), thermal winds become violent on the plains of Zanskar, India.

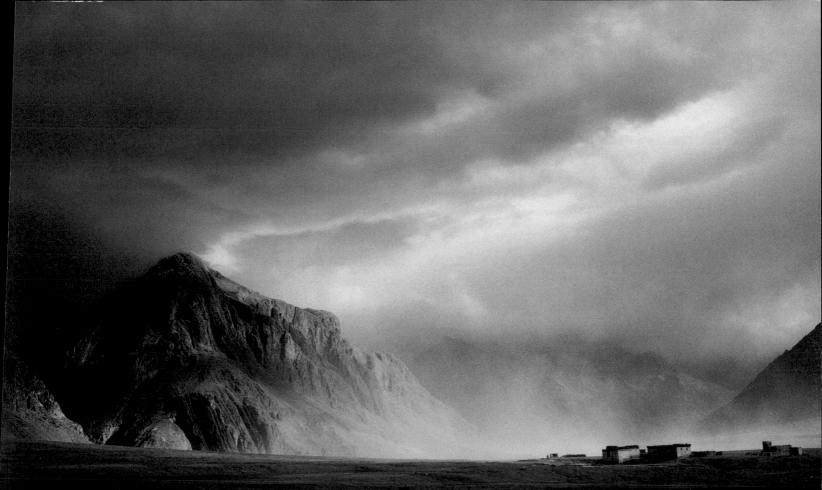

All things that have flowered return to their root.

This returning to the root has a name:

Quiet.

Lao-tzu

Floral decorations are to be seen on entrances all over Myanmar.

All things appear or disappear like the sound of an echo:

the clouds in the sky

the moon on the water

the lightning, the sea foam,

the trail of a bird as it flies

or the visions of dreams after waking.

Master Taisen Deshimaru

Morning mists of autumn in the valley of Gangten, Bhutan.

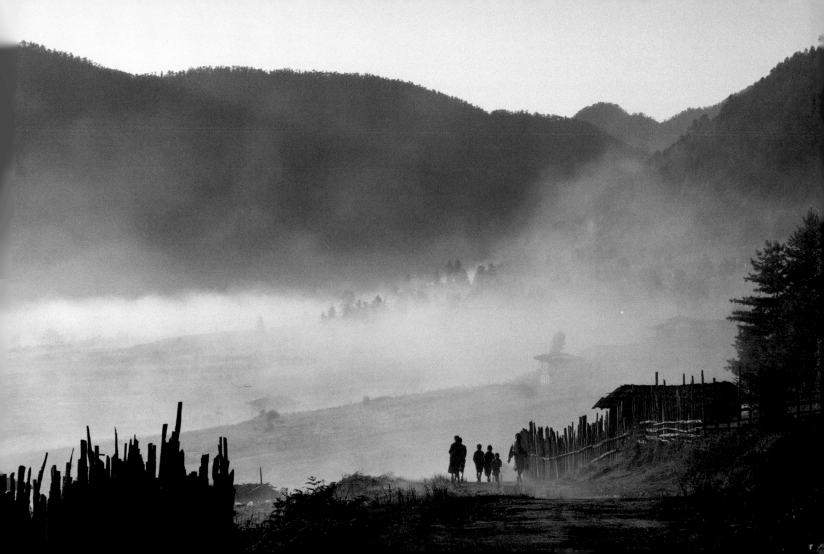

The lives of all beings are like a galloping horse.

In every movement, it adjusts,

in every moment, it moves.

You ask me what you should do and what you should not do?

Just allow yourself to change naturally.

Chuang-tzu

In the Chinese village of Ping An, Liao Li Zhou, aged 10, is a little discouraged by all the work she has to do.
Overleaf: Sunset on the island of Koh Lipeh in the Andaman Sea, Thailand.

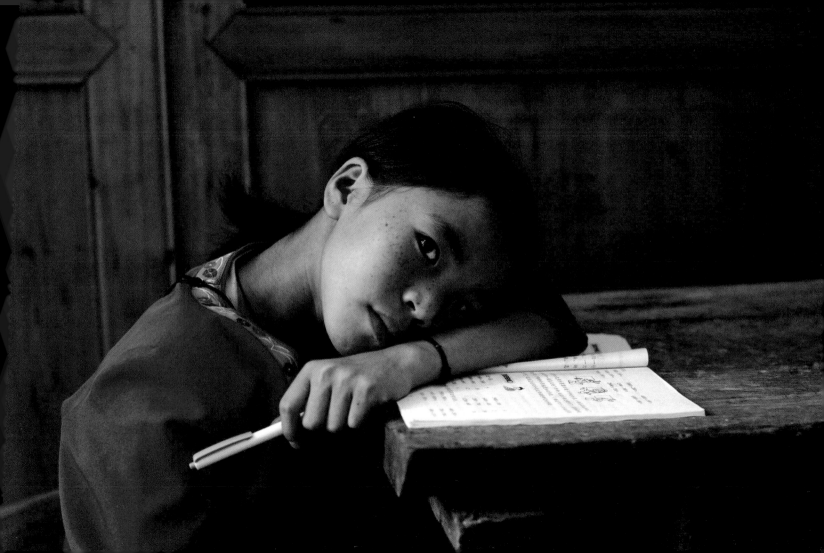

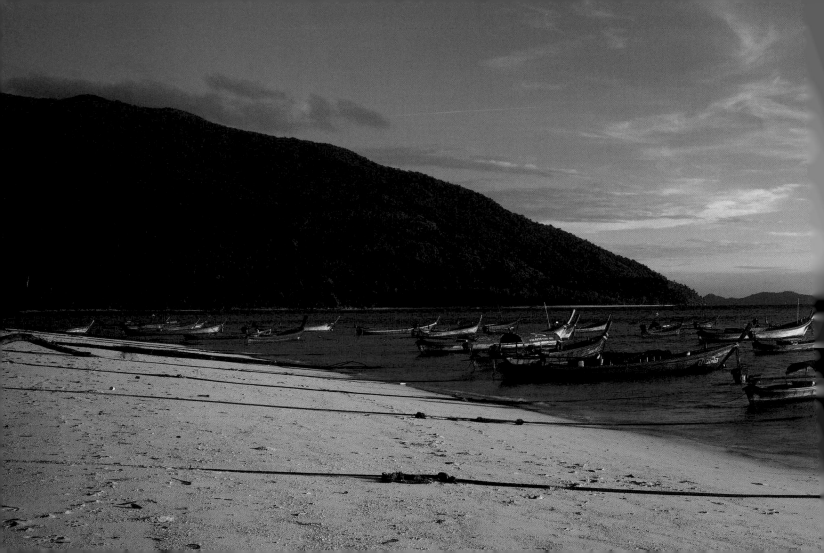

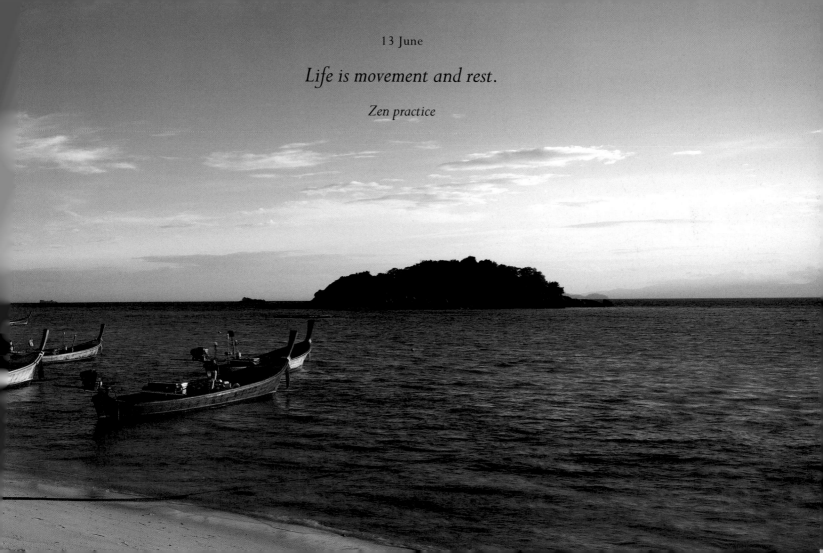

13 June

Life is movement and rest.

Zen practice

When the universe is silent

we listen with great pleasure to a bird that suddenly sings.

When the forest is dead

we understand the great power of life when we see a flower that suddenly blooms.

This shows that what comes from heaven never truly dies,

and that eternal motion can always begin again.

Hong Zicheng

Petals fall from the flowering cherries onto the waters of Tsurugaoka Hachimangu in Kamakura, Japan.

We are always at the beginning of things,
in the fragile moment that holds the power of life.
We are always at the morning of the world.

François Cheng

In the village of Nong Khiaw, a young woman comes to the river to draw water. Laos.

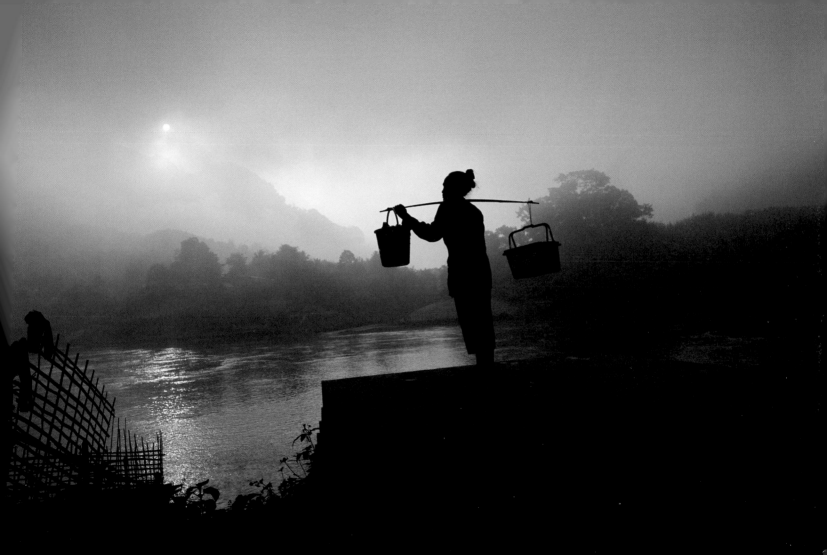

For a brief moment, the flowers flutter like jewelled insects

and dance on the crystal waters:

then, as they slip away on the laughing stream,

they seem to say:

'Goodbye, springtime! We are leaving for eternity!'

Master Okakura Kakuzo

The flowering of the cherry trees is an occasion for national celebration in Japan.

*Your ability to keep coming back and
keeping your fists raised against weakness
as you find your own personal strengths
will determine whether you win or lose.*

Steve DeMasco, Kung Fu Master

A young novice monk plays in the courtyard of Lan Tayar monastery, Myanmar.

*As greater progress is made by man,
there will be a greater need for him to assert
that he is the master of himself.*

Ananda W.P. Guruge

Like many Chinese people, this man from Beijing does his T'ai Chi exercises before going to work.

Recognizing the sacred begins, quite simply,

when we are interested in every detail of our lives.

Chögyam Trungpa

In the village of Guotian, a woman shells beans outside her home, on which is written 'Let us grow trees for our country'. China.

Art is the essence of life.

Our words and our actions should be filled with art.

The substance of art is complete awareness.

Thich Nhat Hanh

Phathommy weaves a shawl as her son watches, in the village of Ben Sop Jam, Laos.

*The perfection of goodness
is the ultimate degree of the coincidence of the principles of your actions
with the order of things.*

Tseng-tzu

Liao Yi Lin meditating in the Garden of the Master of the Nets, Suzhou, China.

Light must come from inside.
You cannot ask the darkness to leave,
you must turn on the light.

Sogyal Rinpoche

A gesture of homage to a Buddha, called 'Wai' in Thailand.
Overleaf: A monk studying holy texts in the monastery of Nat Htaung, Myanmar.

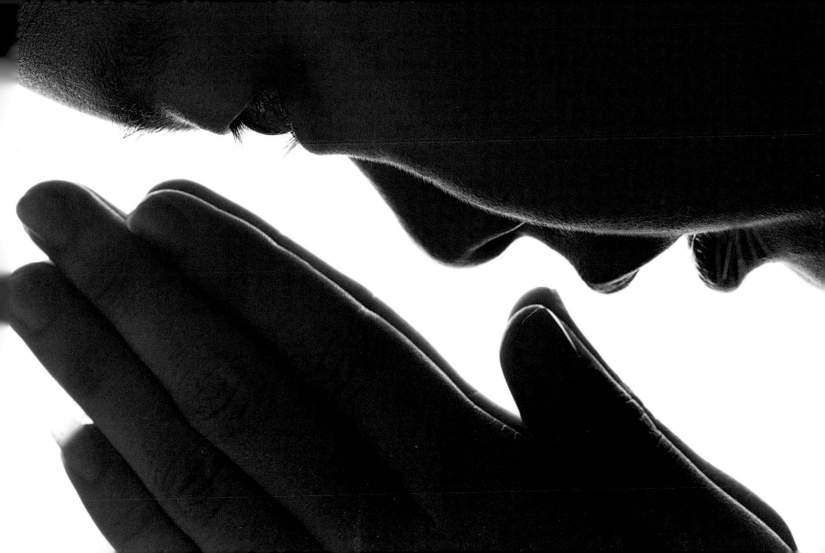

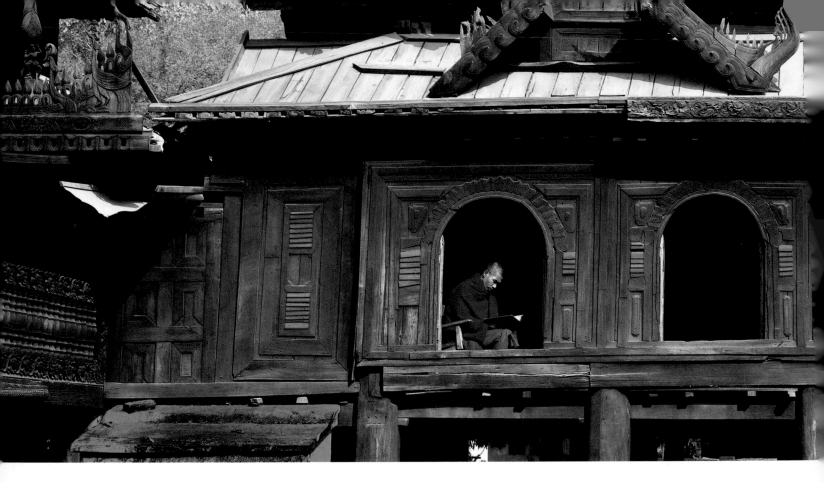

23 June

Man must let his true nature blossom, for there is inside him a light that asks only to shine.

Tseng-tzu

The truth of life is only revealed
through exchanges between many individuals.

François Cheng

A pond in the gardens of the Zhu family, constructed at the end of the 19th century, Jianshui, Yunnan province, China.

Only one who observes the evolution of the world
and adapts to it constantly can make use of it.
'To lead others, one must find one's own direction.'

Chuang-tzu

At the temple of Chionin in Kyoto, Japan, one of the faithful reads a sacred text.

What is to be closed must first be opened.

What is to be weakened must first be strengthened.

What is to be destroyed must first be promoted.

What is to be rejected must first be grasped.

The soft overcomes the hard, the weak overcomes the strong.

Lao-tzu

In the village of Yugong, Nima Lhamo, aged 6, presents a *katak* – the traditional Tibetan scarf that is a sign of welcome and respect. China.

Many are the wise men and masters who have lived on water since the distant past.

Among those who live on water, there are some who fish for fish,

there are some who fish for men, and there are some who fish for the Way.

Since ancient times, this has all been part of the way of living on water.

There are still those who fish for the Self,

those who fish for food, those who are fished for food,

and those who are fished by the Way.

Dogen Zenji

Morning fishing on Lake Taungthaman, Myanmar.

The art of living as a warrior is to express basic goodness
in its fullest, freshest and most brilliant sense.
This becomes possible when that basic goodness is not something we possess;
it is something that we are.

Chögyam Trungpa

In the Zhuang region (the 'Land of the Tribe of the Strong') a farmer returns from the fields. China.

Good to the good, good to the malicious,
because virtue is goodness.
Loyal to the faithful, loyal to the unfaithful,
because virtue is loyalty.
The life of the wise man overwhelms the minds of the people
and brings them together.

Lao-tzu

Monks head towards the Ananda pagoda, in the centre of Bagan, Myanmar, to celebrate the festival of Pyatho.

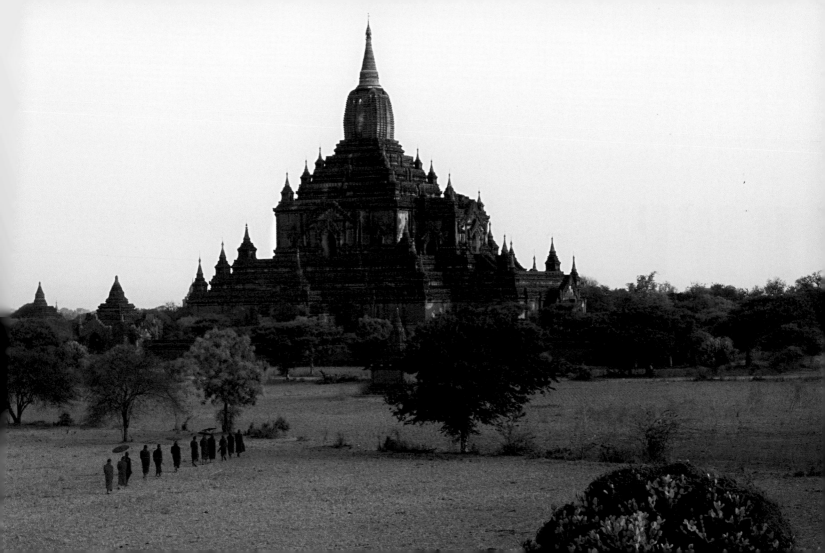

Know glory, understand misfortune, become the Valley of the World.

To be the Valley of the World is to know unchanging virtue.

It means returning to simplicity.

Lao-tzu

In the region of Kham, the village of Yugong nestles in the gorge of the Mekong, China.

However far you go,
however high you climb,
you must begin with a single step.

François Cheng

Tou, aged 1, in his wicker cradle in the village of Ban Houey Ko, on the banks of the Mekong, Laos.

You can protect yourself from misfortunes sent by Heaven;
not from misfortunes that you bring upon yourself.

Zen practice

A young souvenir vendor waits for customers in Mingun, Myanmar.

What do you want in life? That's the real question,

because once you know that, you'll have a goal,

and once you have a goal, you have a direction.

Steve DeMasco, Kung Fu Master

The gardens of Heian Jingu, a Shinto shrine of peace and tranquillity, Kyoto, Japan.

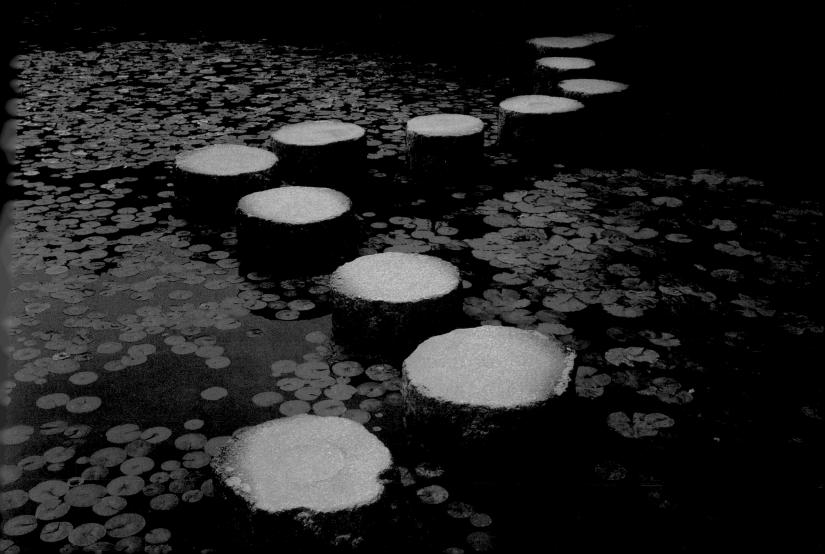

There is no shame in having many faults;

it would be more worrying if there were none to correct.

Chinese proverb

Gao Song Si, aged 72, a Hani peasant woman, returns from the fields in the evening, Yunnan, China.

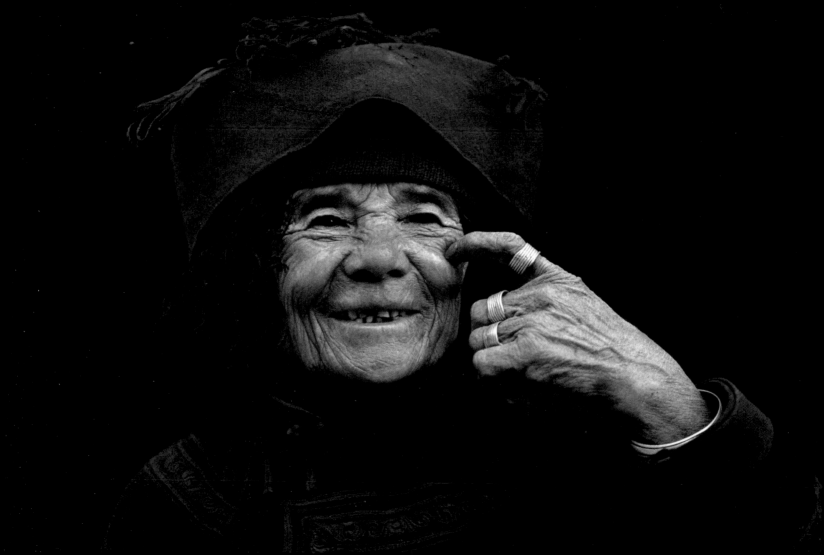

Put you in control and keep you from feeling helpless.

Steve DeMasco, Kung Fu Master

Entrance to one of the many temples of Koyasan, a major centre of spiritual life in Japan.

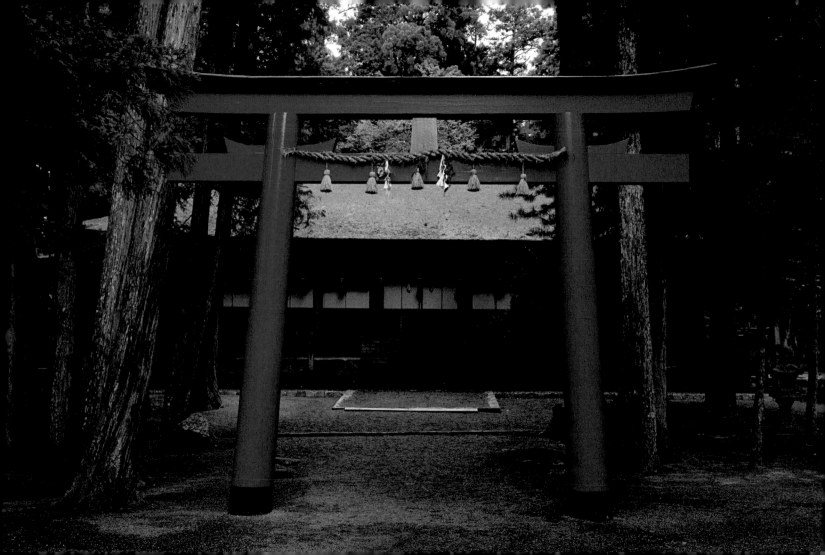

You cannot prevent the bird of sorrow from flying over your head,

but you can prevent it from nesting in your hair.

Chinese proverb

Pinkdala, aged 12, in the village of Ban Houey Ko, on the banks of the Mekong, Laos.

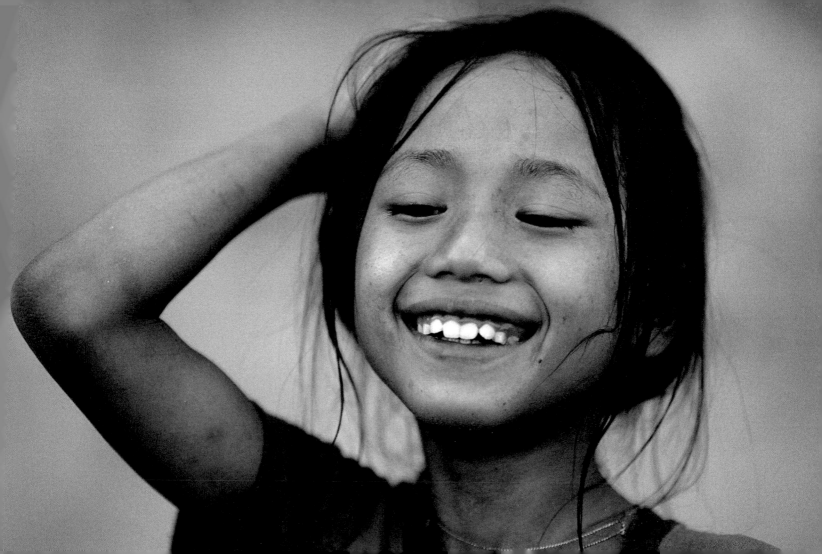

Becoming conscious of what we really are,

that is what we call enlightenment.

Zen practice

In a valley in the Zanskar mountains in India, a villager takes his goats back to their shelter to protect them from snow leopards.

A person who depends on wealth or status
and the admiration of his or her staff to feel good
can become a total crash-and-burn situation quickly.
Why?
Well... what if all that other stuff goes away?

Steve DeMasco, Kung Fu Master

Zar Zar Tun, aged 13, decorates her face with crushed bark from the thanaka tree. Myanmar.

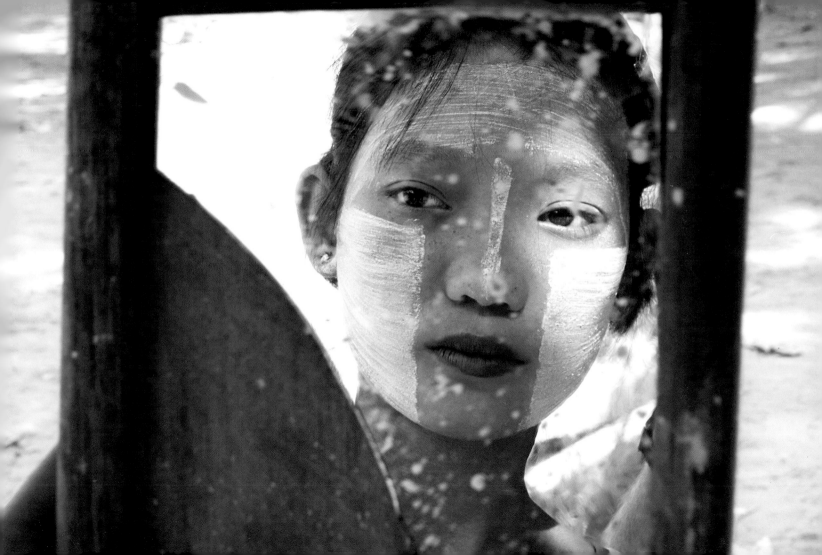

*All we own in life is
who we are,
what we say we are,
and how we choose to act.*

Steve DeMasco, Kung Fu Master

Zhouzhuang is famous for its canals and its traditional houses, typical of the Yangtze Delta, China.

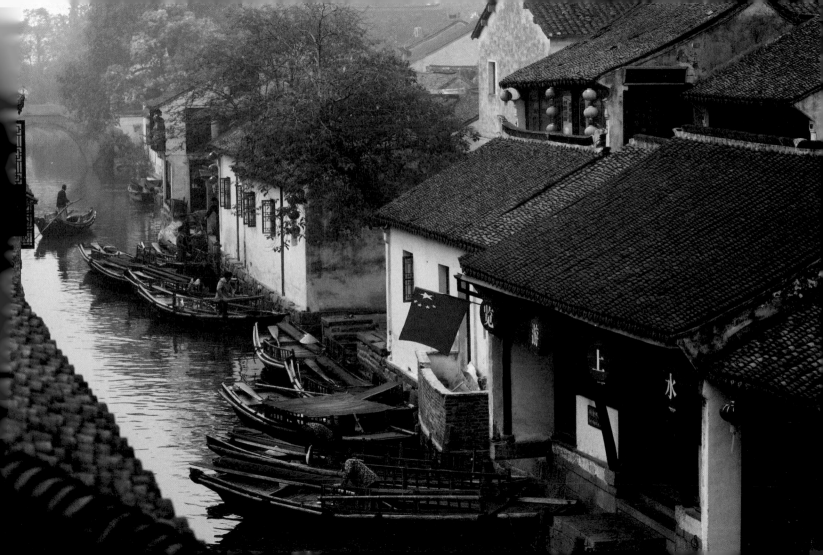

When one who is lost understands that he must turn back,

he is not far from having found the Way.

Zen practice

The mountains of Huangshan, source of inspiration for traditional Chinese painting and literature. China.

The world only becomes transparent to man
when man himself is completely transparent,
when he is what he truly is.

Chao Yong

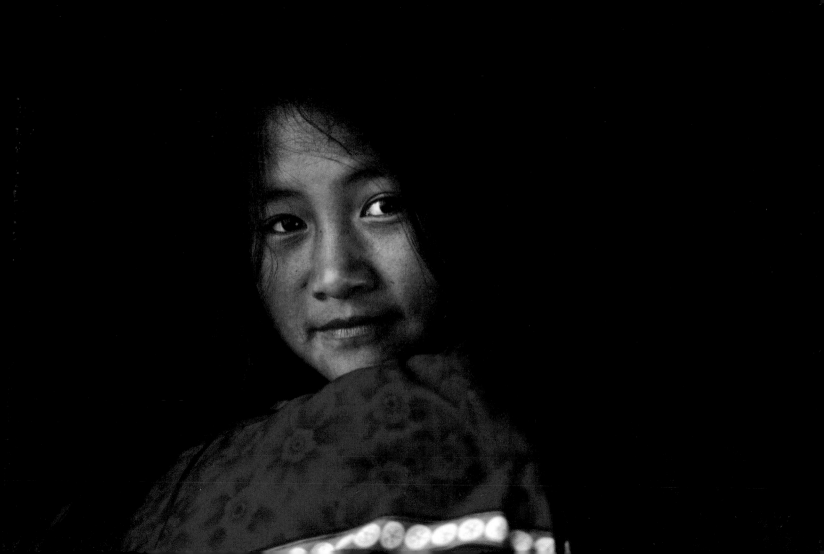

*The reason was that I kept trying
to make others see my worth
instead of seeing it for myself.*

Steve DeMasco, Kung Fu Master

The village of Zhouzhuang in the land of the Zhuang people, China.

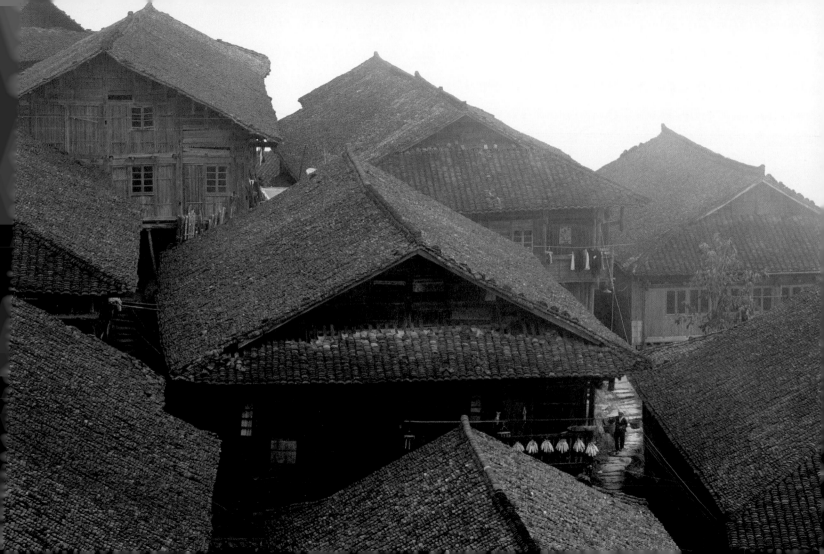

All things have their own nature,

and yet they are all equal in terms of truth.

Dogen Zenji

Villagers from Hualoy doing a traditional dance of the Lua people, Thailand.
Overleaf: Founded in the 2nd century AD, the ancient city of Bagan once contained more than 13,000 pagodas, 2,200 of which are still in use. Myanmar.

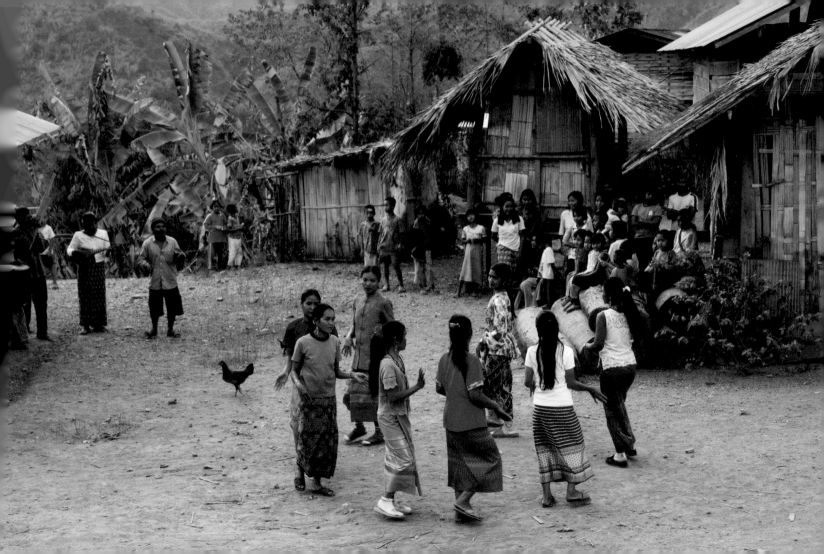

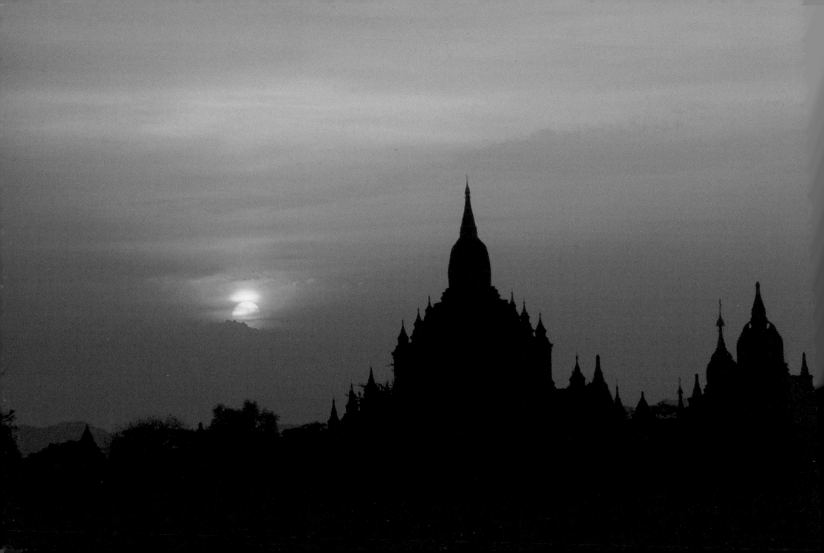

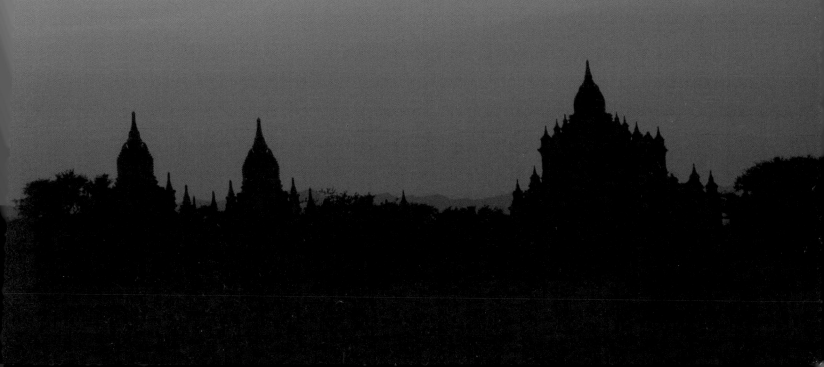

It is within ourselves that yesterday is distinguished from tomorrow.

Zen practice

When we are afraid of ourselves
and the world seems threatening to us,
we become extremely selfish.
We try to build a nest for ourselves, our own cocoon,
so we can live there alone in safety.

Chögyam Trungpa

The gardens of the teahouse at the temple of Jomyoji in Kamakura, Japan.

We can only free ourselves from the hell of unrest and dissatisfaction
by extinguishing the fire of desire.
People want to be free in hell.

Master Taisen Deshimaru

Commercial signs in Hong Kong, China.

We cannot possess the power and magic of this world.

They are always available to us,

but they do not belong to anyone.

Chögyam Trungpa

The Golden Rock, 6 metres (20 ft) high, is a major Buddhist site in Myanmar.
Pilgrims come from all over the country to bring offerings in the form of gold leaf that sticks to the rock.

If he possessed the riches of the world,

he would not consider them his personal fortune.

If he reigned over the whole world,

he would not consider it his personal glory.

His glory is to know that

all things are one.

Chuang-tzu

Camp in the massif of the Upper Altai, Mongolia.

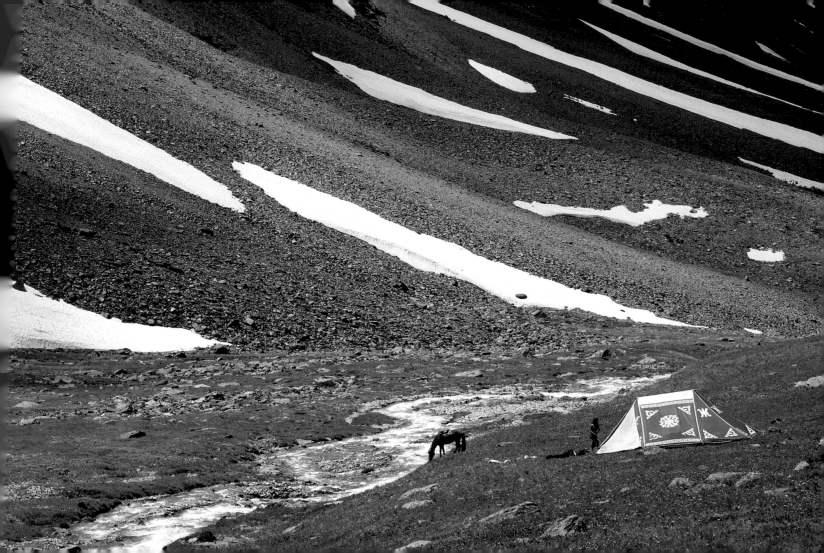

Our lives are often centred on profit,

which results in both greed and detachment from humanity.

Ironically, this pursuit that makes us believe that we will be happy, rich, famous, secure,

makes us unhappy, lonely and alienated.

Steve DeMasco, Kung Fu Master

Xi Duo Lang (meaning 'man of joy'), aged 5, cycles to market with his mother. China.

When you meet a virtuous man,

try to equal him.

When you meet a man without virtue,

examine your own shortcomings.

Confucius

The flooded, terraced paddy fields of Duoyishu, in the province of Yunnan, are the heritage of centuries of labour. China.

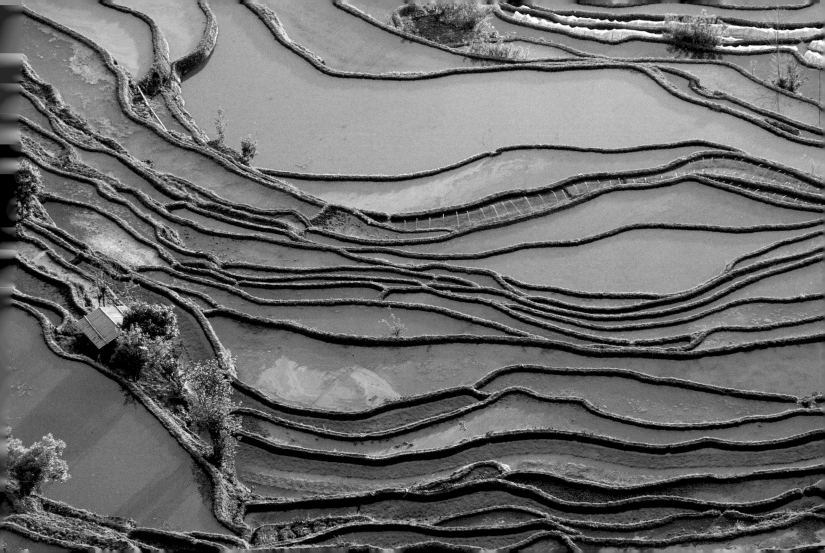

Always rid yourself of desire, in order to contemplate wonders.

Always retain your desire, in order to contemplate its manifestations.

Lao-tzu

Vendors display their wares during the New Year celebrations of the Kayin people, Myanmar.

There is no greater crime
than not being able to control your desires.
There is no greater disaster
than not knowing how to be content.
There is no greater suffering
than that caused by a covetous mind.
When we know how to be content,
we never want for anything.

Lao-tzu

A village woman in Zhuang country ('the land of the strong'), China.

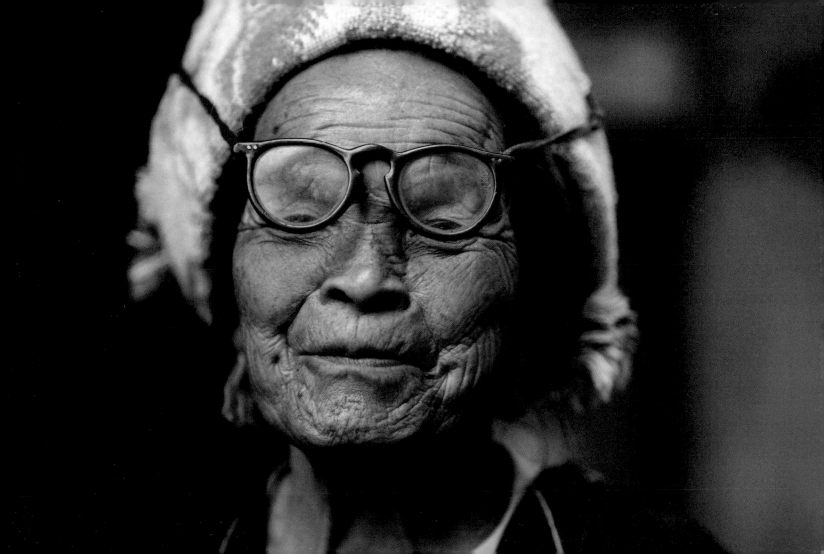

Man seeks happiness in the wrong way.

He constantly rushes to try to satisfy all his desires,

believing that this is the way to reach happiness.

In fact, happiness is not born from what we receive, but from what we give.

The more we receive, the more we demand.

Desires are unquenchable and dissatisfaction perpetual.

Master Taisen Deshimaru

The new business district of Pudong in Shanghai, China, seen from the Bund area.

No desires, no goal, no seeking, no thoughts,

neither obtaining, nor rejecting, nor grasping, nor letting go,

being free.

Master Taisen Deshimaru

A monk goes to a ceremony at the Buddhist temple of Haeinsa,
one of the three Jewel Temples of Korea, built in the 9th century on Mount Kaya, South Korea.

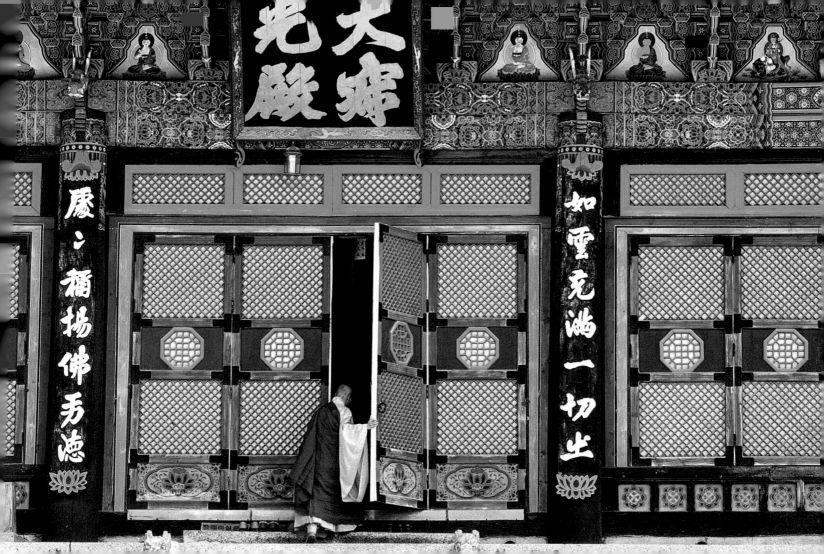

Gain, loss, truth, falsehood:

I ask you, please abandon them.

Master Taisen Deshimaru

Mask of the Buddha, sold in a shop in Mingun, Myanmar.

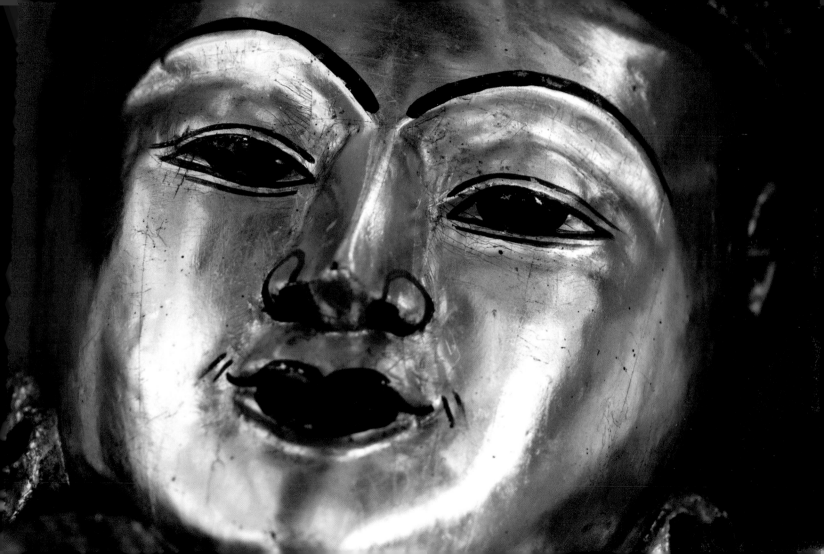

He who wishes to grasp the world and use it is bound to fail.

The world is a sacred vessel

and cannot withstand being grasped and made use of.

He who uses it will destroy it.

He who grasps it will lose it.

Lao-tzu

In Yangon, the area around the Shwedagon pagoda, the most venerated Buddhist shrine in Myanmar, built a century after the birth of the Buddha.

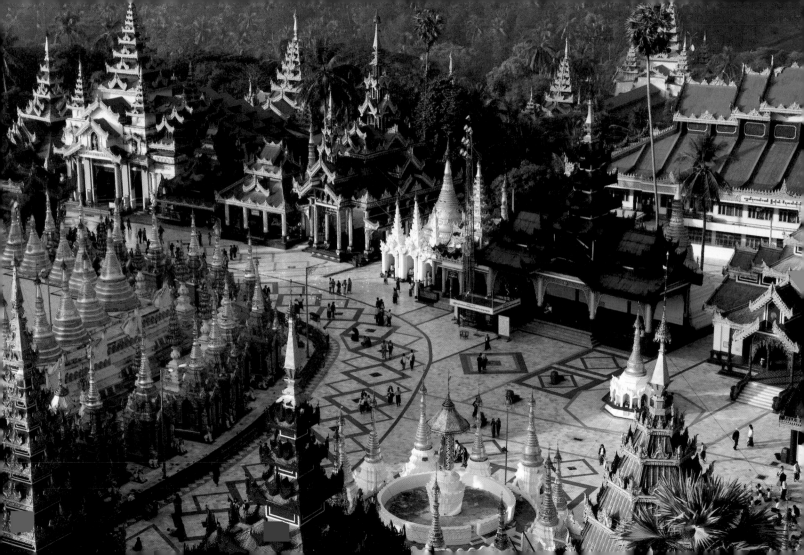

Man seeks what is good for himself, sometimes at the expense of others.

Every one of us chooses, selects, discriminates.

We love what is beautiful, rich and delicate.

But the cosmic order includes everything. The sun shines for the whole world.

We should therefore seek a deep understanding of all things,

and practise universal compassion.

Master Taisen Deshimaru

In the temple of Cao Dai of Tay Ninh, the faithful extol the virtues of a universal religion
that combines Buddhism, Confucianism, Taoism, Christianity and Islam. Vietnam.

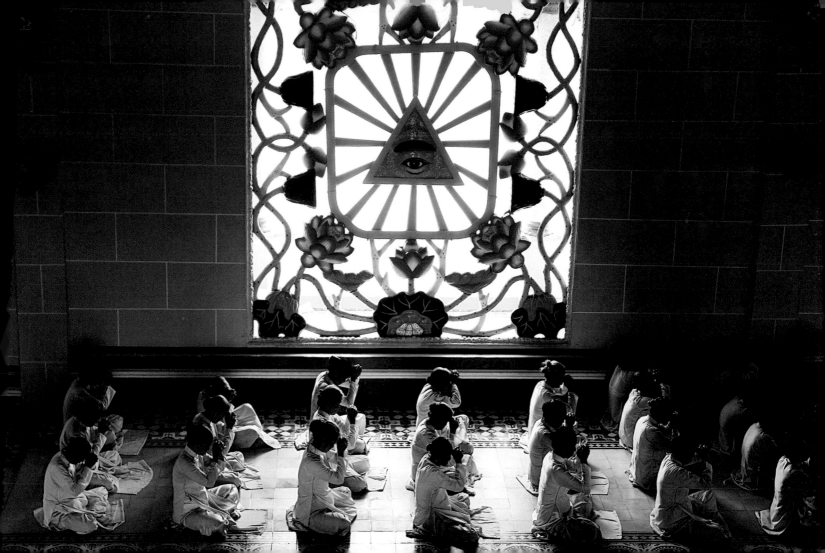

All that clings to the 'I' or 'self' is suffering.

All that does not cling to the 'I' or 'self' is freedom from suffering.

Buddhadasa Bhikkhu

Farmers go home after celebrating the festival of Pyatho in Bagan, Myanmar.

One must have a generous temperament without being excessive,
a rigorous mind without being pedantic,
pure tastes without being limited,
strict morality without being inhuman.

Hong Zicheng

A performer at the ceremony of Jidai Matsuri, which commemorates Kyoto's history
from the Heian era (794–1185) to the Meiji era (1868–1912). Japan.

Whenever a person has a mind that is truly without ego,
in which the ego itself has been completely rejected,
this person has developed perfect altruism.

Buddhadasa Bhikkhu

At dawn every morning, the monks of Luang Prabang go to collect the food offered to them by the people of the town. Laos.

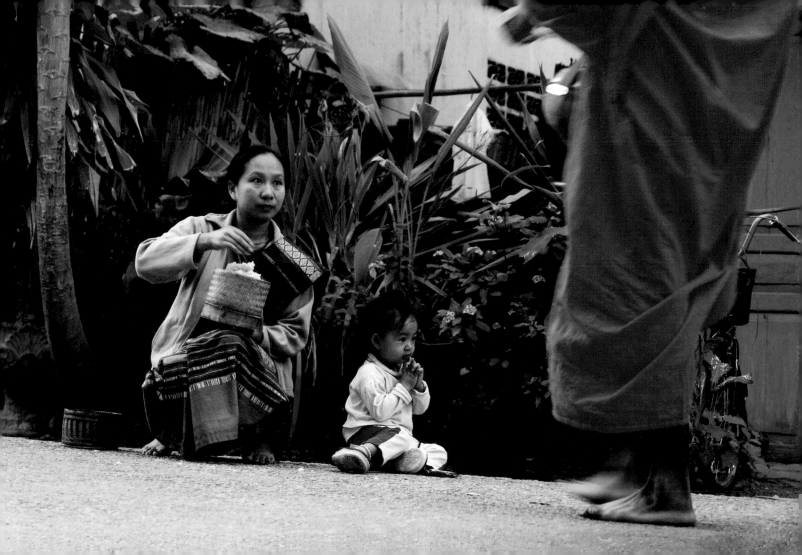

Who can take what they have in excess and give it to the world?

Only those who possess the Way.

Lao-tzu

Herds of goats and yaks return to their pens in the massif of the Upper Altai, Mongolia.

Giving is non-attachment:
simply to be attached to nothing
is to give.

Master Shunryu Suzuki

A young monk carries water from the well. Myanmar.

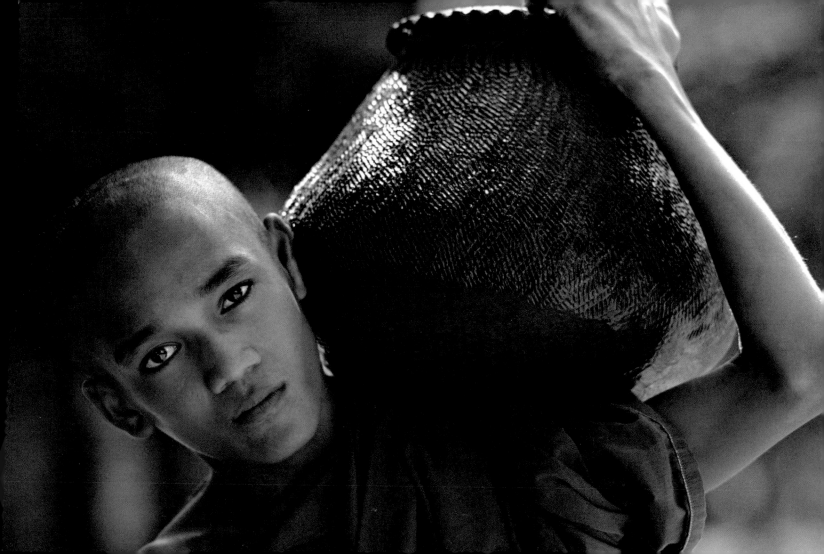

Jump into the dangerous current of the river, into civilization.

Do not run away or hide in the mountains.

Withdraw, but know how to return to others.

Master Taisen Deshimaru

A villager crosses the Mekong river by a suspension bridge that is under repair in the region of Kham, China.

It is the way of heaven to take from those who have excess
and give to those who are in need.
The way of man is the opposite:
it takes from those who have little
and gives to those who have too much.

Lao-tzu

Fishermen at dusk on the Mekong, Vientiane, Laos.

Art Center College Library
1700 Lida St.
Pasadena, CA 91103

Let us look at a humble virtue, that of gratitude.

With this virtue alone, the world could be at peace.

We need to recognize that everybody in the world is the benefactor of everybody else.

Not only people: even cats and dogs are benefactors of mankind, even birds.

If we remain aware of the debt of gratitude that we owe to these things,

we will be unable to act in any way that hurts or oppresses them.

With the power of the virtue of gratitude, we can help the world.

Buddhadasa Bhikkhu

The venerable Maha Pinn Bhutawiriyo, a Buddhist monk, practising profound 'vipassana' meditation, Thailand.
Overleaf: The gorges of the Li river, in the Guangxi region, source of inspiration for traditional Chinese painters. China.

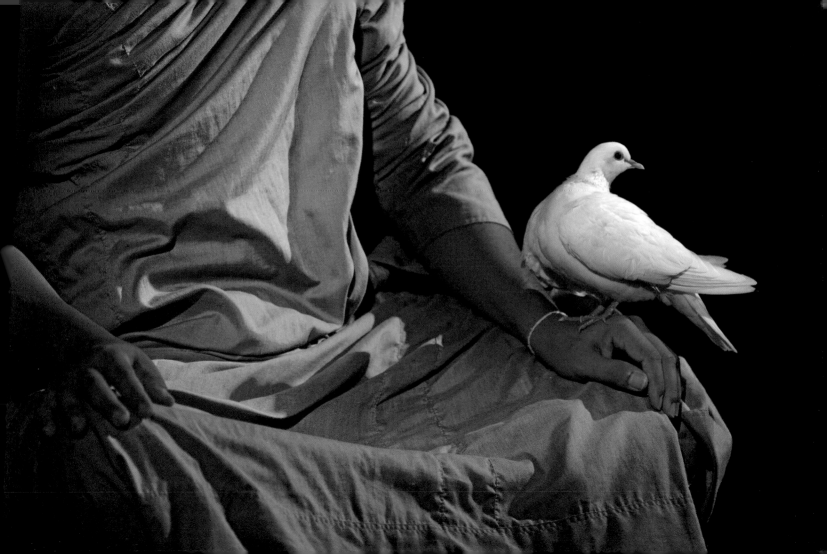

Know honour, preserve humility,
and in this way be the Valley of the World.

Lao-tzu

He who stands on tiptoe will quickly lose his balance.

He who takes too many steps will not last the distance.

He who wants to shine will shed no light.

He who wants to be valued will go unnoticed.

Lao-tzu

Four children with their faces painted with the crushed bark of the thanaka tree, Bagan, Myanmar.

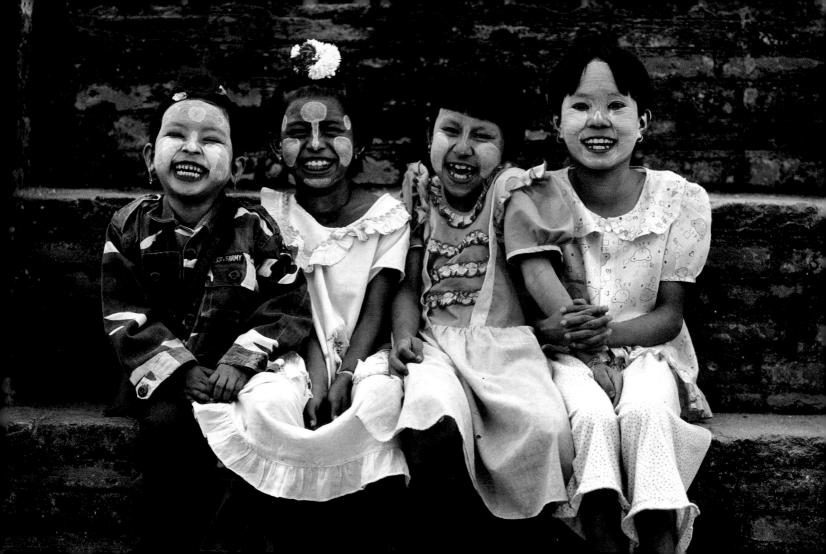

If the whole world praises him, he is not elated.

If the whole world condemns him, he is not beaten.

In a word, praise and blame cannot change his conduct.

Such a man possesses true virtue.

As for myself, I am still among those who are influenced

by the opinions of others, like the wind moves the waves.

Chuang-tzu

Chortens (Tibetan Buddhist stupas) and a retreat in the steep-sided Mekong Valley in the region of Kham, China.

If you are listened to, be content.

If you are not listened to, be even more content.

Meng Zi

A performer takes a break during the ceremony of Jidai Matsuri, commemorating the history of Kyoto, Japan.

A deed as great as the Earth is effaced by a single word:

pride.

A crime as huge as the heavens is effaced by a single word:

repentance.

Hong Zicheng

A monk prays in the Shwedagon pagoda in Yangon, the most venerated Buddhist shrine in Myanmar.

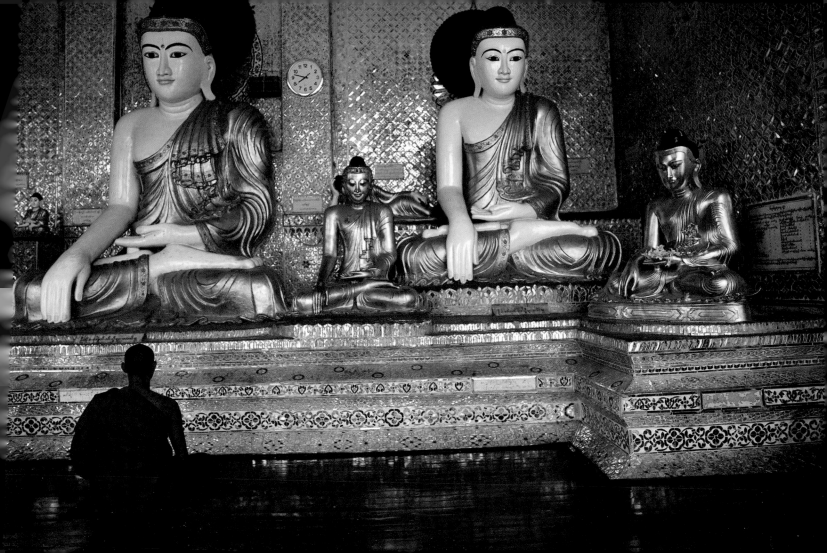

Of all the things in the world,
the heavens and the earth are the greatest, and do nothing to achieve it.
He who possesses greatness seeks nothing, loses nothing and regrets nothing.
He does not allow himself to be influenced by the world.

Chuang-tzu

After the Pyatho festival, a monk returns to his monastery near Bagan, Myanmar.

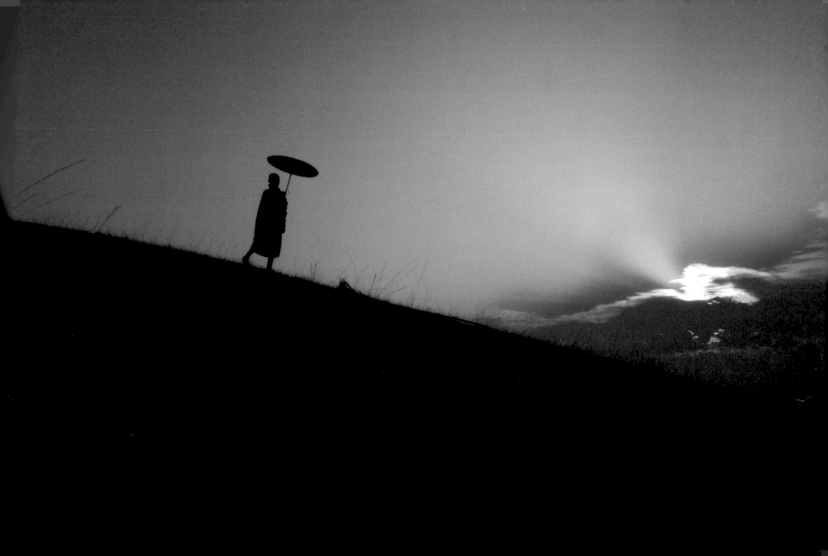

*Dignity is the state of a man who is well prepared
and who is not troubled by the actions of others.
It does not change according to the outside situation.*

Master Kenji Tokitsu

Shin Yay Wata, a young novice monk at Sagaing, one of the principal Buddhist centres in Myanmar.

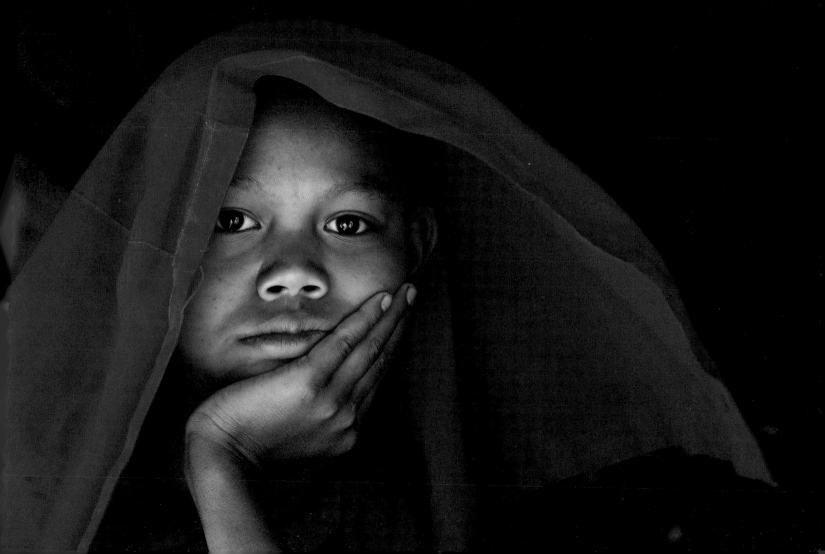

We leave this world with nothing.

No medals, no rewards,

no success, no failure.

Nan Huai Chin

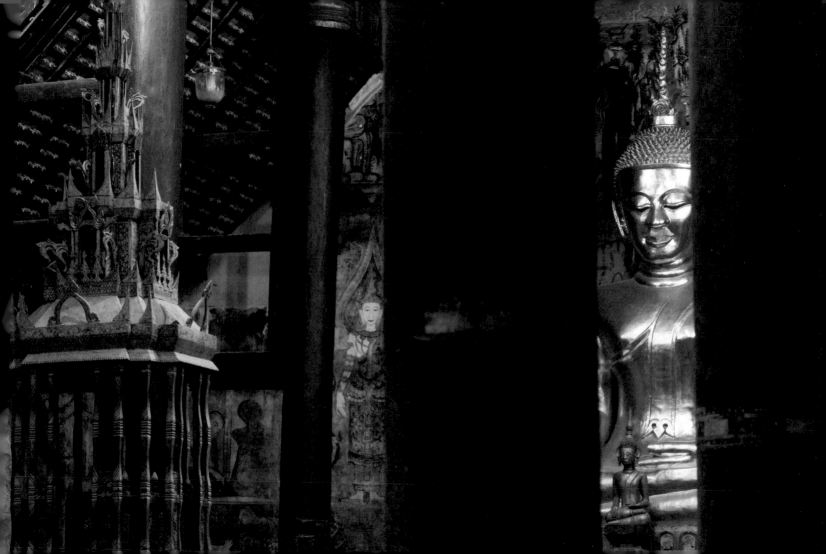

Move always towards greater simplicity.

Zen practice

Su Su Htwe, aged 10, painted with the crushed bark of the thanaka tree, Amarapura. Myanmar.
Overleaf: Monks head for the Ananda pagoda, in central Bagan, Myanmar, for the Pyatho festival.

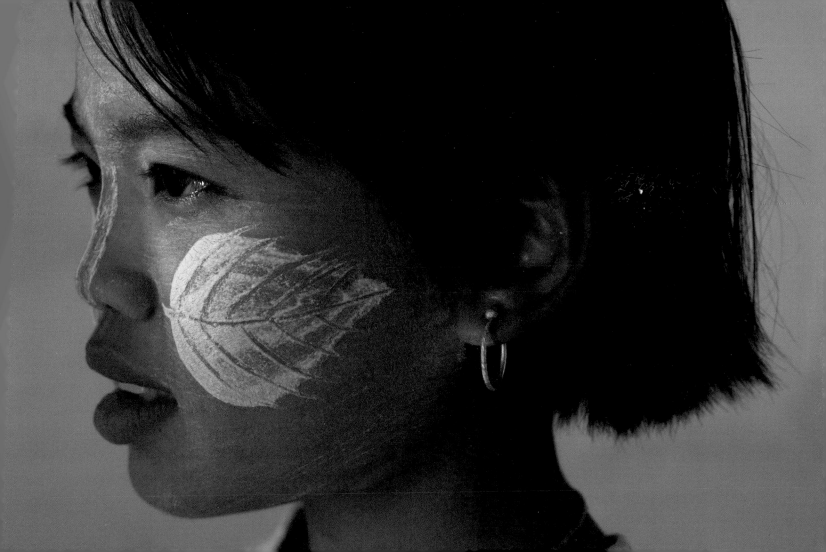

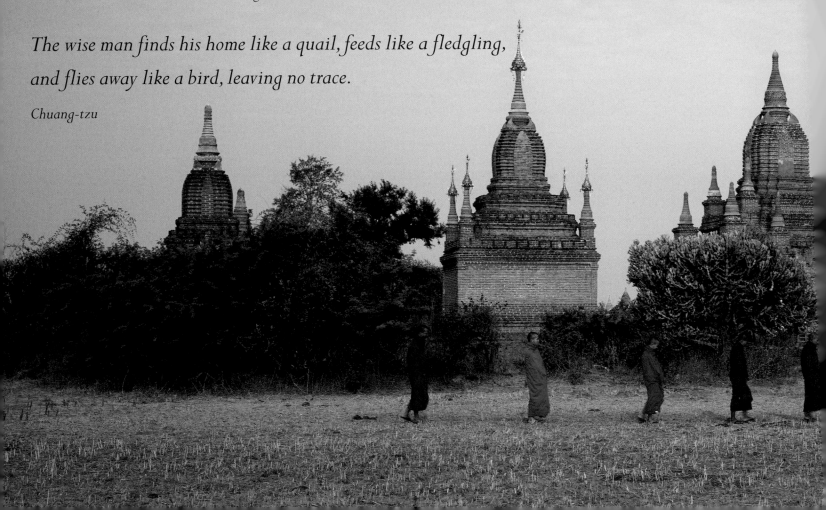

The wise man finds his home like a quail, feeds like a fledgling, and flies away like a bird, leaving no trace.

Chuang-tzu

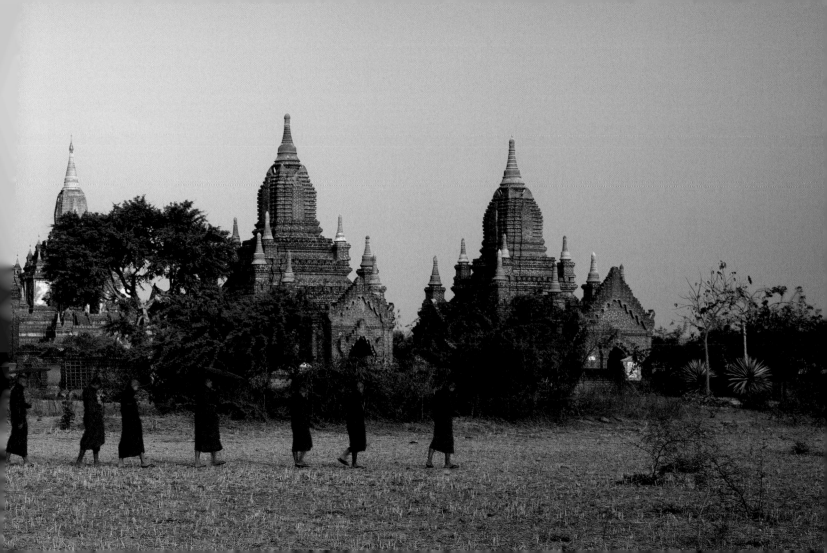

There are three treasures that I keep and cherish.

The first is love,

the second simplicity,

the third humility.

Those full of compassion may be generous.

Those who are humble may govern others.

Lao-tzu

Ma Hu Jiao, a Hani woman aged 65, returns from the fields carrying wood to use for cooking in the evening. Yunnan, China.

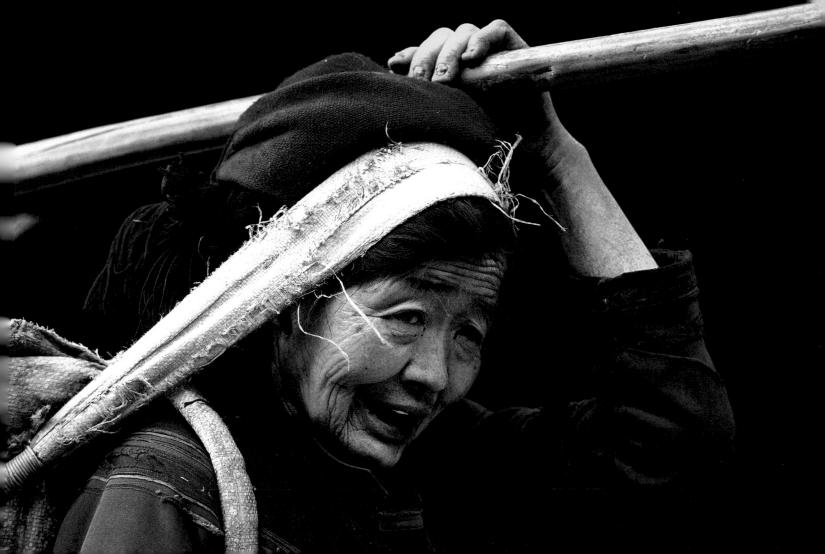

There is no true abundance without moral perfection.

Li Ru Hang

Market in front of the Ananda pagoda during the festival of Pyatho. Bagan, Myanmar.

Do not go!
Although your song is humble,
you are my nightingale.

Issa Kobayashi

After a hard day's work in the fields, a family returns to the village. Myanmar.

Dig a hole for your pond
without waiting for the moon.
When the pond is finished,
the moon will come by itself.

Dogen Kenji

Two riders return to their yurt in the massif of the Upper Altai, Mongolia.

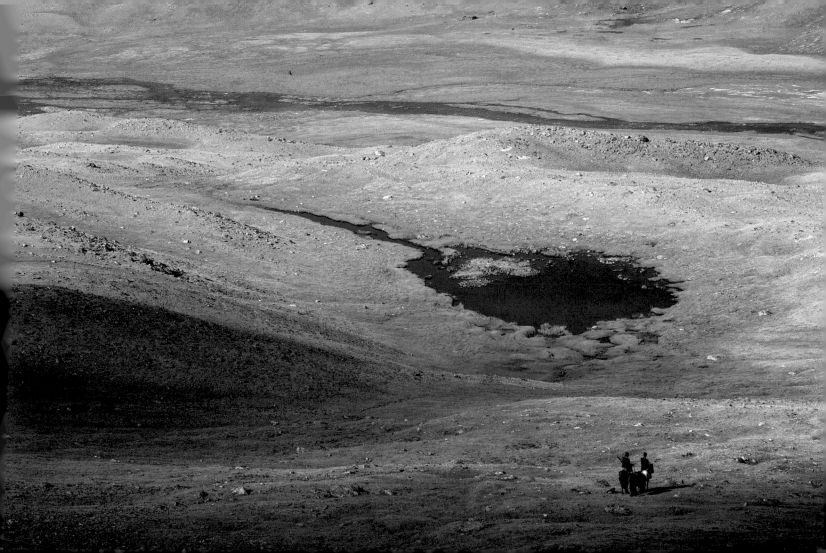

Throw away your wisdom and intelligence,
and people will be a hundred times happier.
Throw away your justice and morality,
and the love of a father for his son will flourish once more.
Throw away your cunning and hunger for profit,
and there will be no thieves or swindlers.

Lao-tzu

Teera Uhpadee, aged 40, proudly shows off his first son, aged 7 months, Thailand.

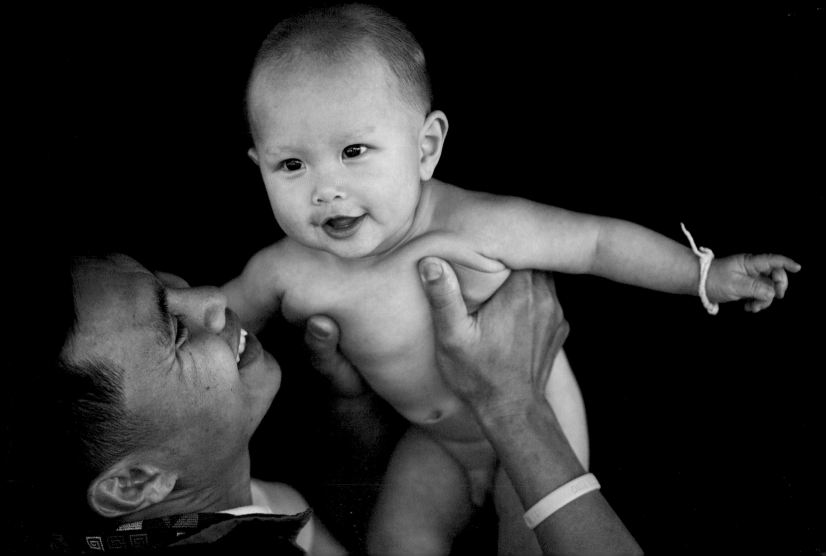

He who uses machines and mechanics will become mechanical in his mind.
He who has a mechanical mind no longer has the purity of innocence
and loses the peace in his soul.

Chuang-tzu

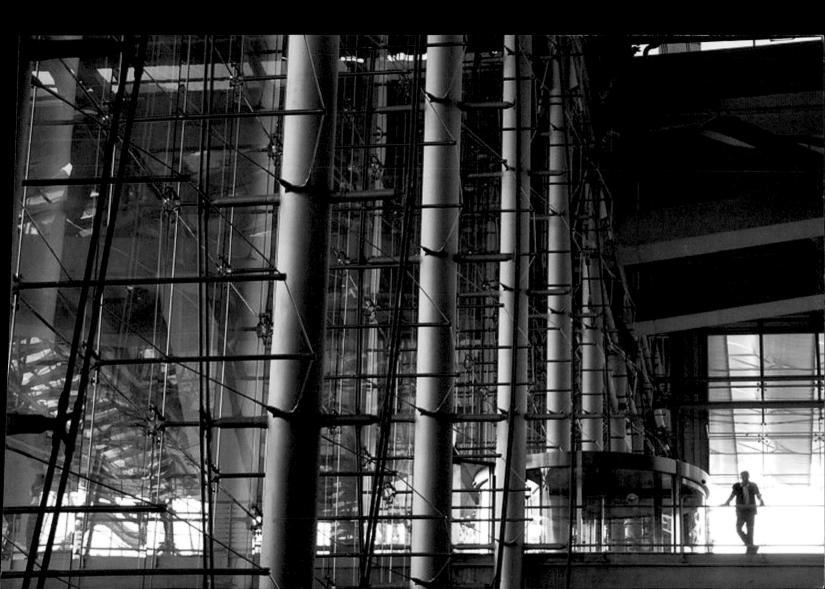

He who looks only as far as his eyes can see,

who listens only as far as his ears can hear,

and who imagines only as far as his mind can reach:

such a man has achieved ideal balance and dynamic adaptation.

Chuang-tzu

Ngwe Lar in his wooden house in the village of Yay Tagon Taung, Myanmar.
Overleaf: Borobudur is a place of worship and pilgrimage, constructed around the 9th century, and it is the largest Buddhist monument as well as being a true wonder of the world, Indonesia.

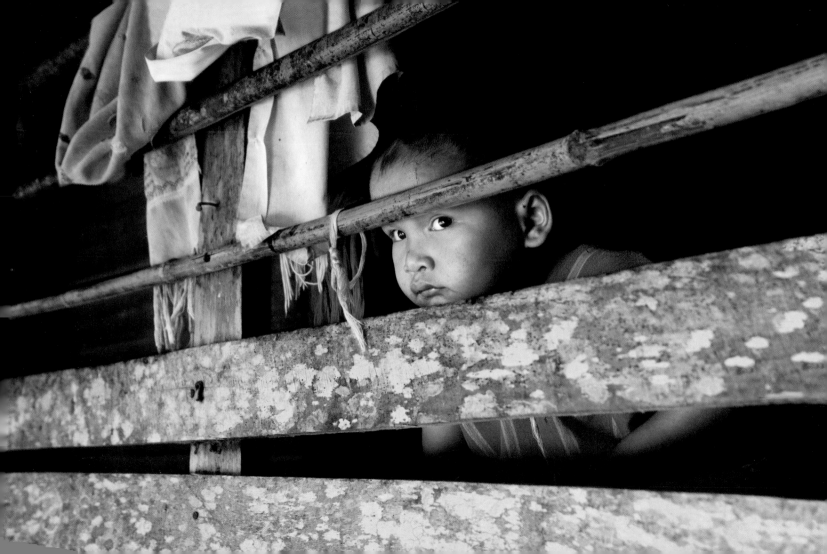

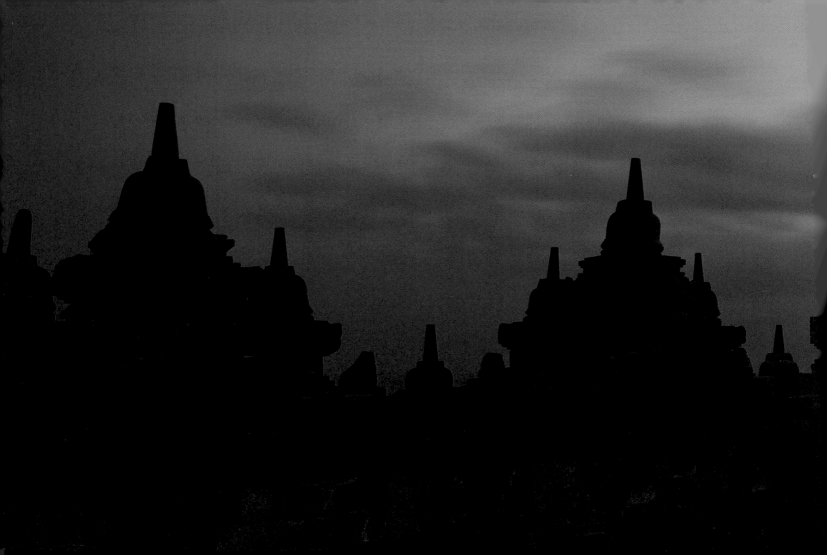

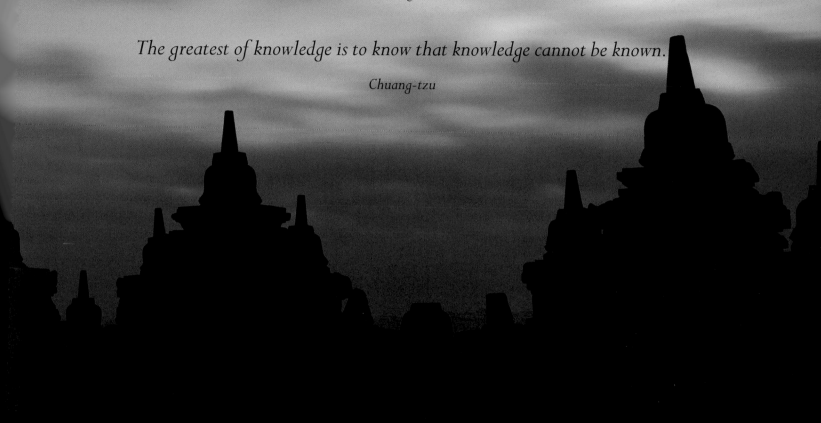

The greatest of knowledge is to know that knowledge cannot be known.

Chuang-tzu

The knowledge of the small cannot compare to the knowledge of the great;

a short life cannot compare to a long one.

How do we know that this is so?

The mushroom that lives only for a morning will never know when evening comes;

the short-lived cricket will never know how spring follows autumn.

Chuang-tzu

The village of Ben Sop Jam, on the banks of the Nam Ou, Laos.

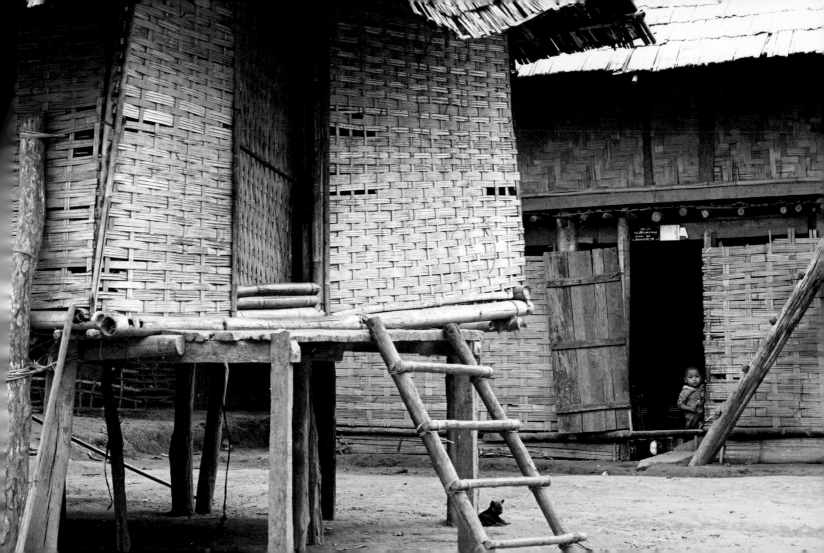

Thinking means dividing into neat and incompatible ideas the complexity of the real, whose essence is utter indivisibility.

Liou Kia-hway

Two monks visiting the temple of Ta Phrom in Angkor, Cambodia.

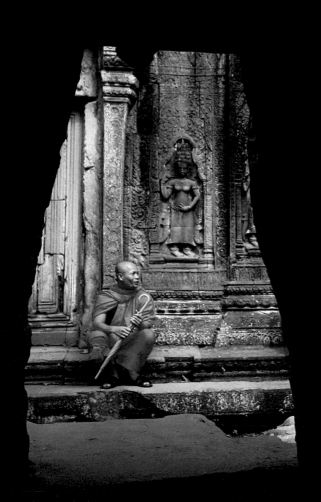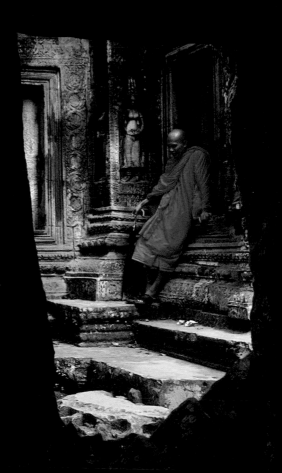

Pursue thought;

Put on a lined cape

And go outside

Far from the silent houses, lit by lamps...

Along the path, the gaze of the moon follows you.

The tangled branches

There on the snow

Mark out the signs

Of your thoughts.

François Cheng

First snows of autumn in a remote valley in Bhutan.

Greater than heaven and earth together,
the mind fills all places and leaves no trace.
It is absurd to want to look inside one's own mind,
like measuring the void or capturing the wind.

Hamwol

The Li river, in the Guangxi region, is a major source of inspiration for Chinese painters.

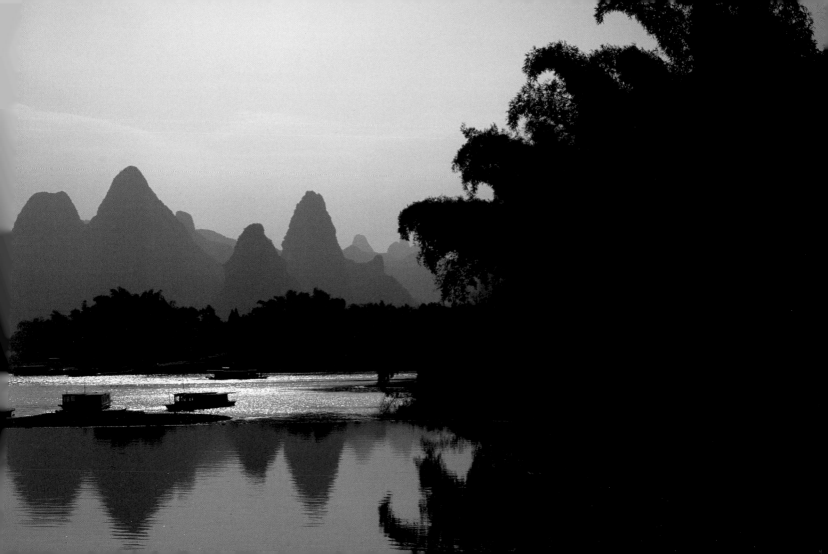

The force of the cosmos is unlimited, infinite, eternal.
If human beings give up their ego,
they come back to cosmic action in the here and now,
becoming energy.

Master Taisen Deshimaru

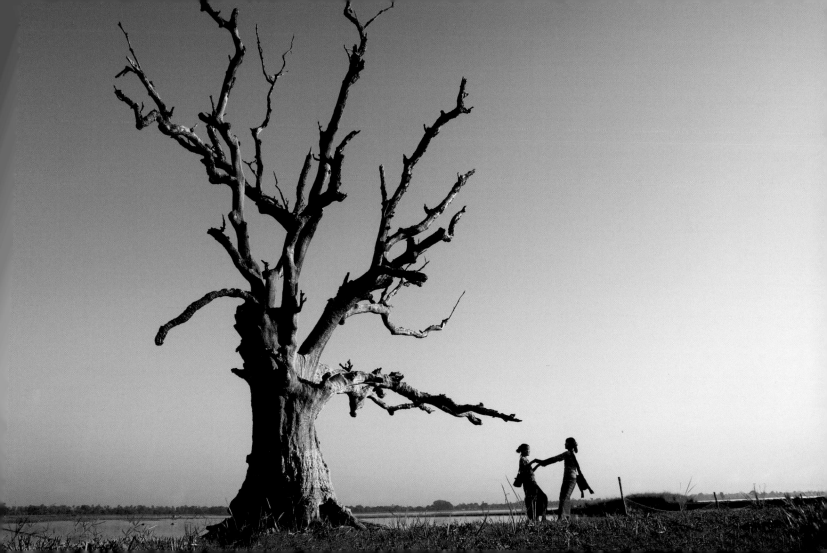

It is not difficult to become a Buddha...

One single, straightforward method: harmony with the cosmic order.

Rejecting and destroying our personal consciousness

and attaining a state of mindfulness.

Master Taisen Deshimaru

The temple of Beng Meala, hidden in the jungle of Angkor, Cambodia.

The essence of Zen resides in the absolute negation of our ego and in the complete penetration of the affirmation of this ego.

Master Taisen Deshimaru

Tinh Xan May, aged 65, wearing traditional costume in the village of Ta Phin, Vietnam.

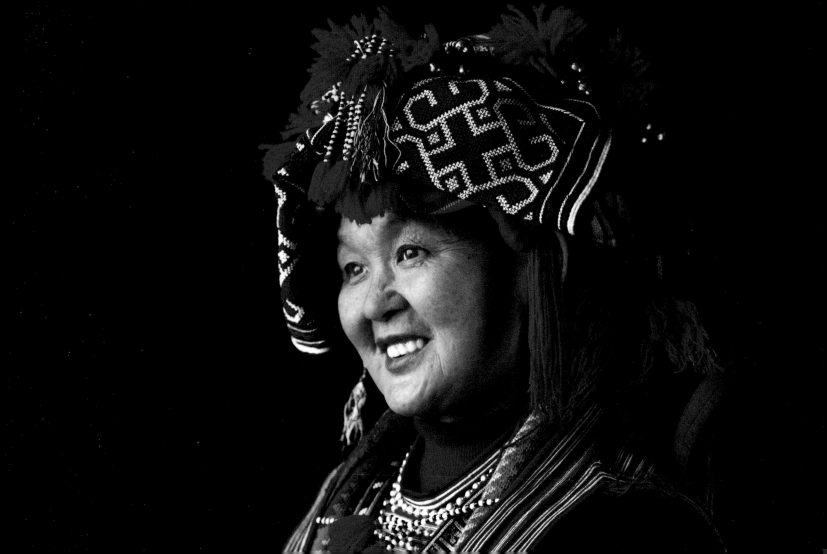

The perfect man has no self.

The inspired man has no body of work.

The wise man leaves no name.

Chuang-tzu

At the temple of Nanzenji, the stone gardens of Tenjuan were designed at the beginning of the 14th century, Kyoto, Japan.
Overleaf: Angkor Wat – the largest temple in the monumental complex of Angkor in Cambodia – was built in the 12th century, in honour of the Hindu god Vishnu.

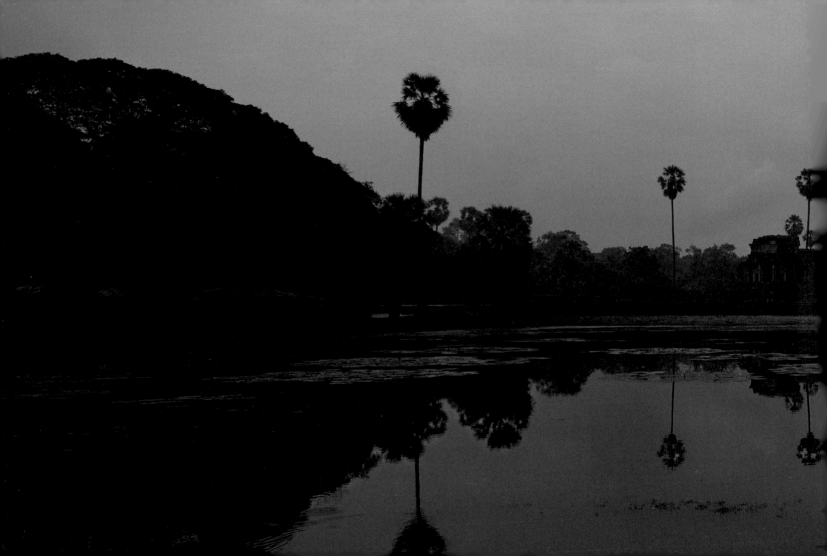

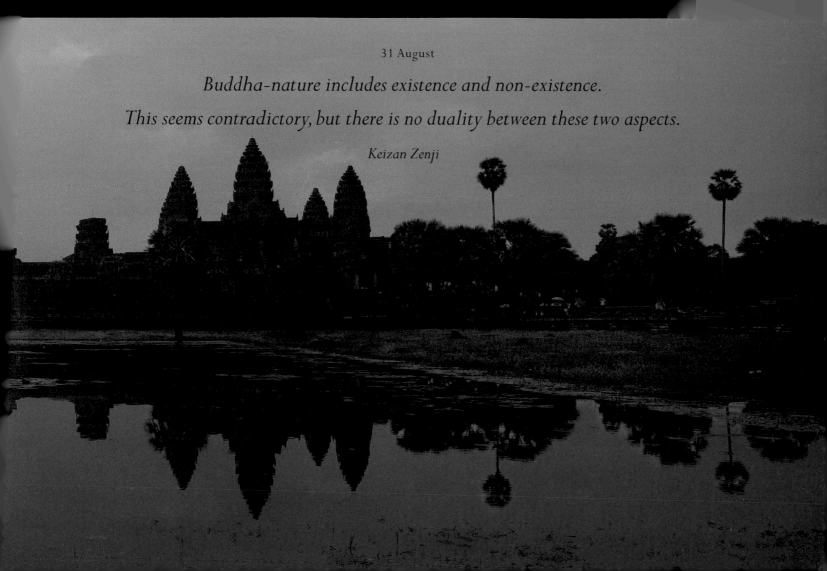

31 August

Buddha-nature includes existence and non-existence.

This seems contradictory, but there is no duality between these two aspects.

Keizan Zenji

'*Me, me again, me always!*'
This thought lies at the deep root of our misery.

Shosan Suzuki

Ha, aged 12, in the village of Lao Chai, Vietnam.

To study the way of Buddha is to study oneself,
To study oneself is to forget oneself,
To forget oneself is to find oneself in unity with all things.

Master Taisen Deshimaru

Become aware of yourself.

Learn to discover yourself.

Whatever the extent of your knowledge,

if you do not know yourself, you can know nothing about the world.

Reflect on this.

Shosan Suzuki

Phyu Phyu Lin, aged 25, who sells souvenirs in Bagan, made up with the traditional crushed bark of the thanaka tree, Myanmar.

There is nothing else you can do but burst out laughing.

Zen practice

Children from the village of Ban Hat Ya, on the banks of the Nam Ou, Laos.

Before they become a tangible reality, all phenomena are seeds.

The wise man takes great care of seeds.

Han Fei Zi

The fertile shores of Lake Taungthaman and its fish-filled waters give sustenance to the people who live all around it. Myanmar.

You must personally accept the responsibility of improving your own life.

Chögyam Trungpa

A young woman meditates at the Shwedagon pagoda of peace in Yangon, Myanmar.

Along the path, one must turn back in order to seek oneself.

Meng Zi

Luoxiaoli, aged 20, a Hani from the village of Pugaolaozhai, with her first child, Yunnan province, China.

The mountains in spring are surrounded by a garland of clouds and mist,

man feels joyful.

The mountains in summer are rich with shady greenery,

man is at peace.

The mountains in autumn remain serene as the leaves fall,

man seems serious and solemn.

The mountains in winter are heavy with thick dark clouds,

man remains silent and distant.

François Cheng

The peak of Shenny is one of the summits of Mount Meili (6,740 m or 22,100 ft), and is sacred to the Tibetan people. China.

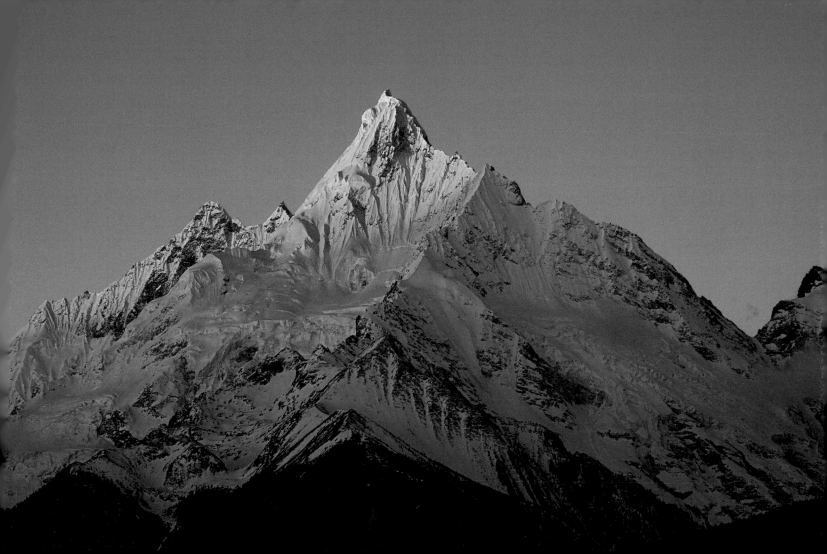

If you cannot find truth in yourself,

then where do you hope to find it?

Zenrin Kushu

A monk meditates at the Shwedagon pagoda of peace, the most venerated Buddhist shrine in Myanmar.

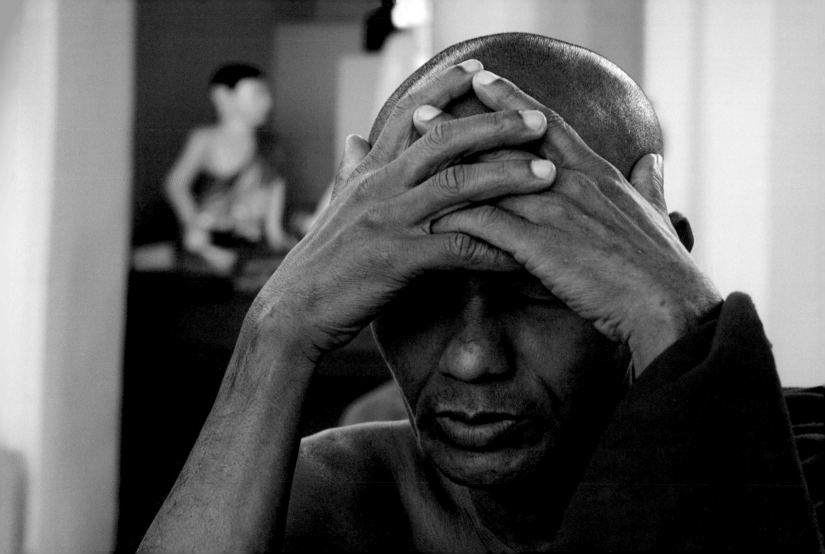

If you open your hand, you may receive everything.

If you obtain one thing, you may lose another.

If you lose one thing, you may obtain another.

Suffering may become happiness, and vice versa.

The complete negation of the ego becomes its greatest affirmation.

Dogen Zenji

· The village of Ben Sop Jam specializes in making shawls. Laos.

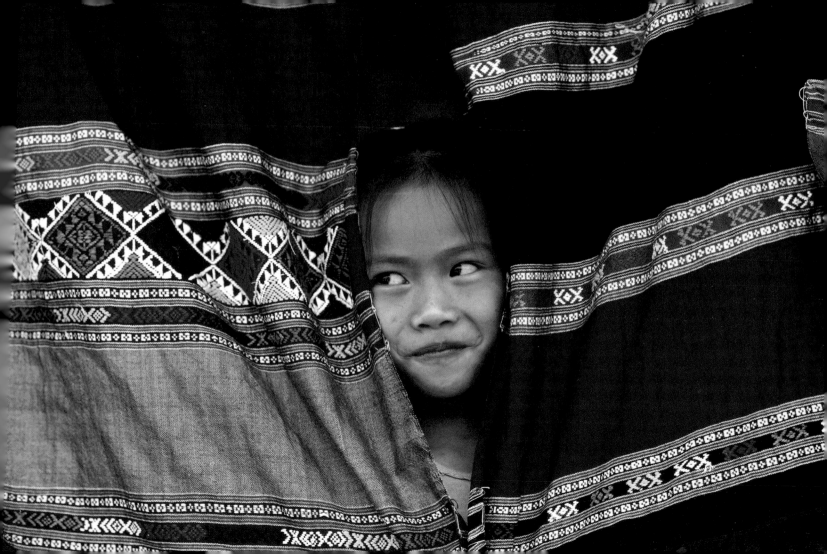

All things under Heaven are made of visible and invisible.

The visible is the outer aspect, their Yang;

the invisible is the inner aspect, their Yin.

Yin and Yang together is the Tao.

Pu Yen-T'u

A rice farmer finishes his day's work in the flooded terraces of the paddy fields, Bada, Yunnan province, China.

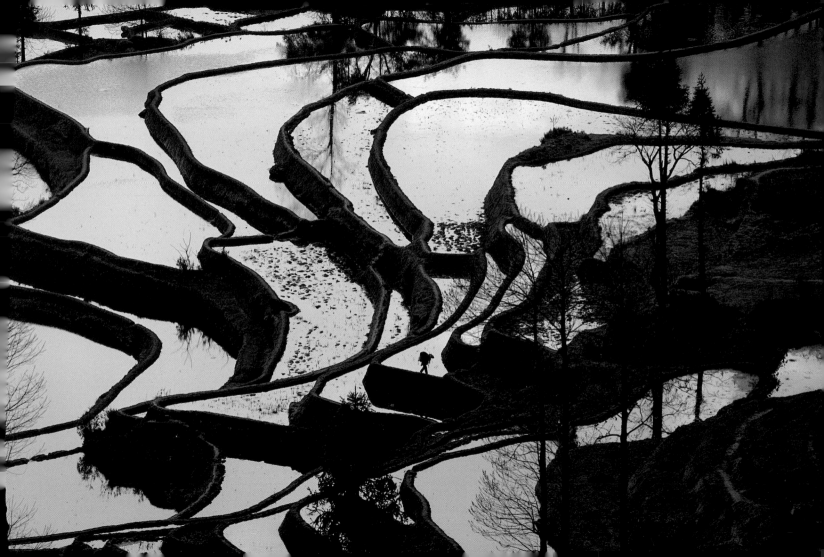

To cultivate the art of the warrior,
is to learn to come to rest in basic goodness,
in a state of total simplicity.
In Buddhist tradition, this state of being is called
the 'non-self' or 'non-ego'.

Chögyam Trungpa

Mayan, aged 1, asleep on the back of his Hani mother, Yunnan province, China.

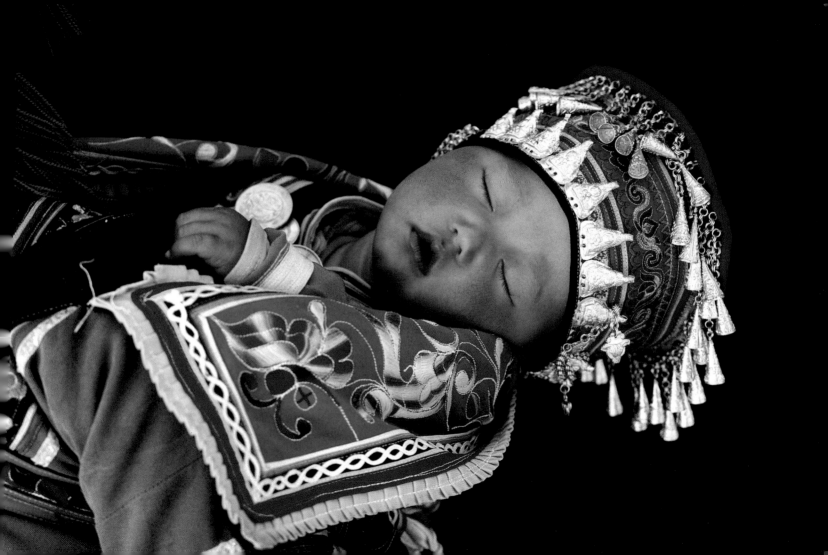

It is pointless to fight or to flee from anything.

It is also futile to run after anything.

Master Taisen Deshimaru

After celebrating the Pyatho festival, monks return to their monastery near Bagan, Myanmar.

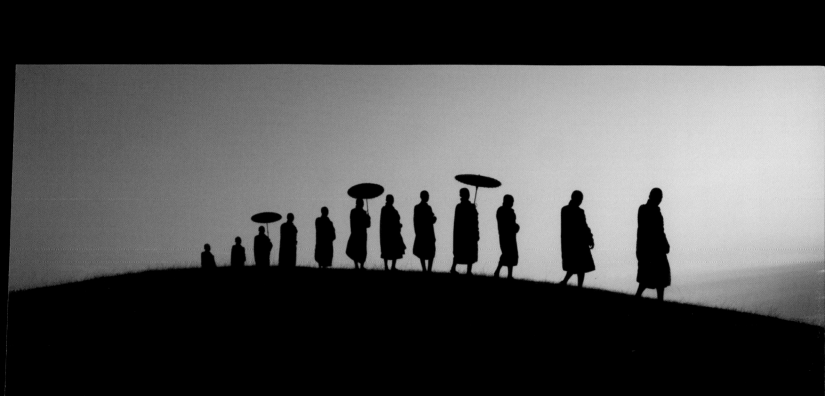

It is the self that creates life,

and it is life that makes the self what it is.

Dogen Zenji

Hnin Hnin Myint, aged 8, helps her parents to sell statuettes at the pagoda of Shwe Sandaw in Bagan, Myanmar.

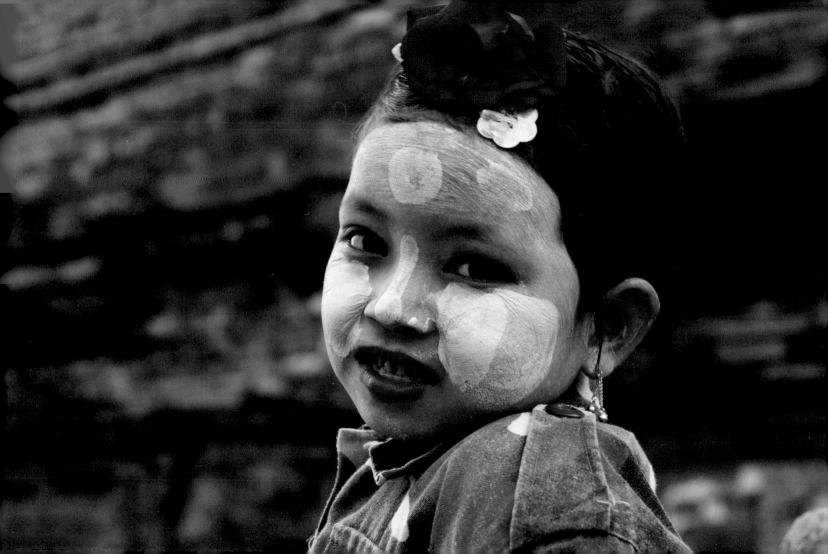

Zazen consciousness is infinite,*
like boats following the motion of the sea,
neither seeking it nor fleeing it.

Master Taisen Deshimaru

** The Zen practice of sitting and opening the hand of thought.*

Fishing boat from the island of Koh Lipeh in the Andaman Sea, Thailand.

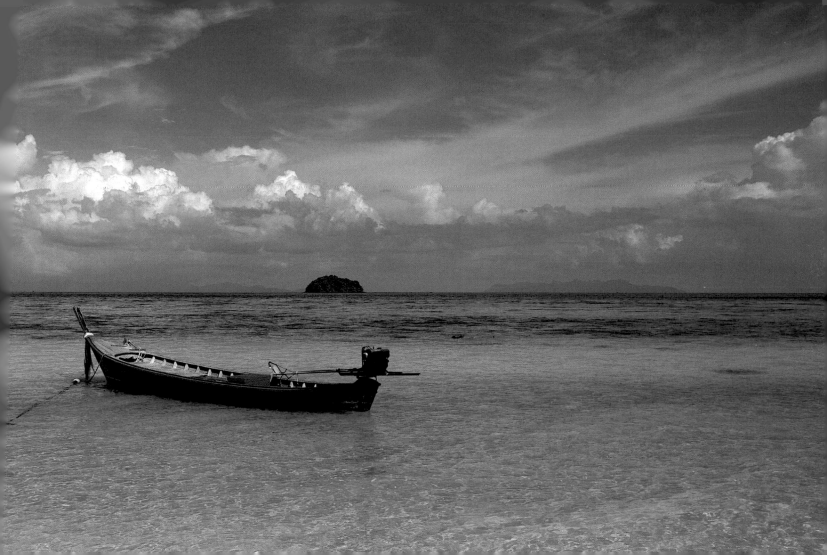

He who knows a thing is worth less than he who loves a thing.

He who loves a thing is worth less than he who rejoices in it.

Confucius

Ei Ei Phyo, aged 13, has decorated her face with the crushed bark of the thanaka tree. Myanmar.

Dive into reality to reach its most secret heart,

and capture within it the echo of the universal order.

Tseng-tzu

Meiji Jingu, the most famous Shinto shrine in Japan, is surrounded by a man-made forest of 120,000 trees from 365 different species. Tokyo, Japan.

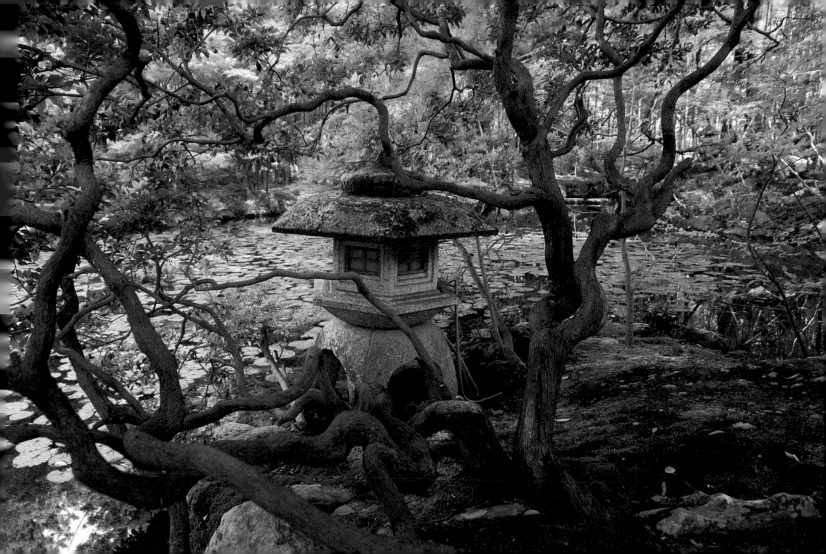

Am I dreaming that I am dreaming?

Chuang-tzu

A little girl waits for her mother, who is praying in the Shwedagon pagoda, Yangon, Myanmar.

Chuang Chou once dreamed that he was a butterfly, fluttering and happy,
and unaware that he was Chuang Chou.
He woke up suddenly and realized he was Chuang Chou once more.
He did not know if he was Chuang Chou who had dreamed he was a butterfly,
or a butterfly who had dreamed he was Chuang Chou.
Between Chuang Chou and a butterfly there must be a difference.
This is called the transformation of things.

Liou Kia-hway

Moe Pwint Pho, aged 2, watched over by his grandfather in the village of Naung Bo, Myanmar.

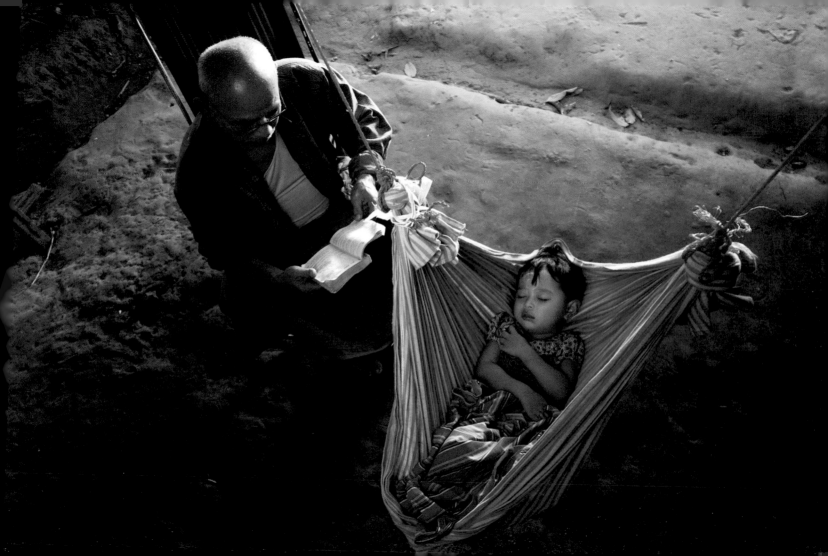

The messages of our ears and our eyes are our external enemies.
Our feelings and our thoughts are our internal enemies.
One must master oneself and remain seated, with an enlightened mind,
in the middle of the main room of the house.
The enemies will then be transformed into family members.

Hong Zicheng

Shin Nya Na, aged 7, a novice monk at Sagaing, one of the most important Buddhist centres in Myanmar.

The Zen seated posture means intimacy with oneself.
In this Zen posture,
automatically, naturally, unconsciously,
we know the cosmic order.

Master Taisen Deshimaru

The gardens of Hakusasonso, created by the Japanese painter Kansetsu Hashimoto in 1916 for his home in Kyoto, Japan.

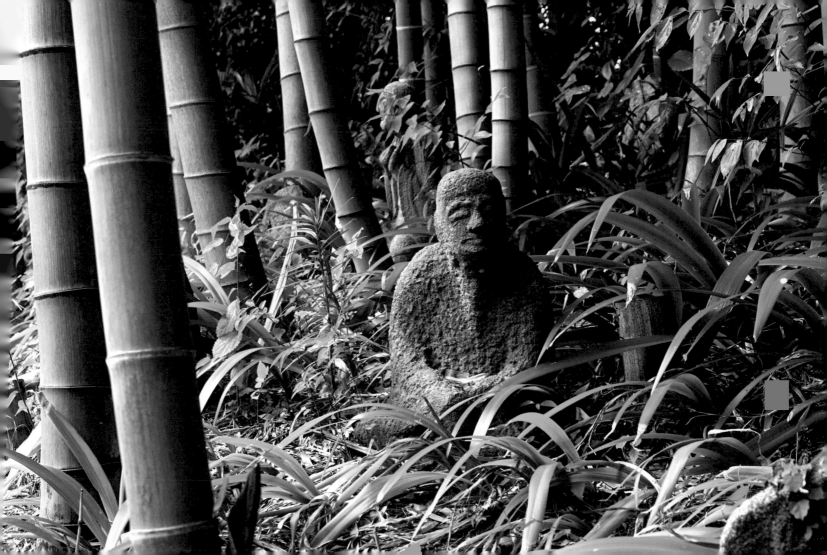

It is our way of seeing the world
that determines the nature of our feelings.

Thich Nhat Hanh

A geisha during the festival of Jidai Matsuri, which commemorates Kyoto's history, Japan.

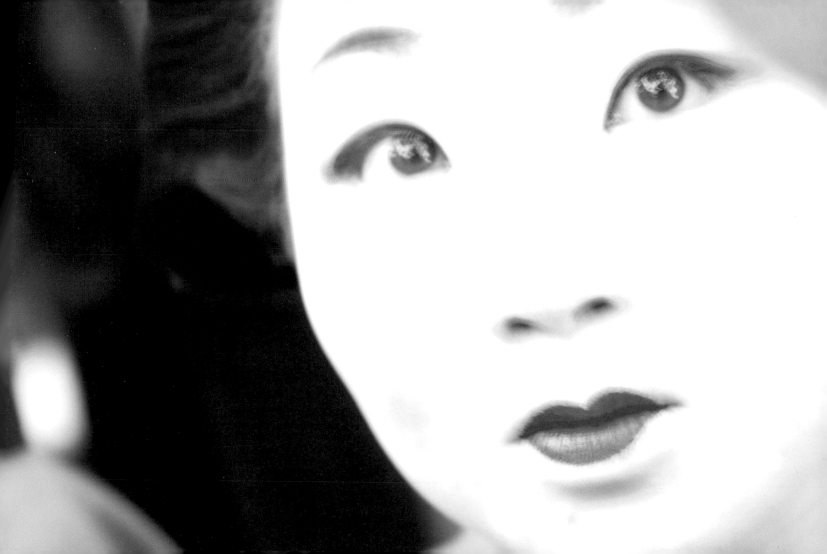

The drops of dew fall one by one.

This world is perfect.

Issa Kobayashi

The flowering of the cherry trees is an occasion for national celebration in Japan.

To reflect

is to reflect on the most subtle details of one's actions.

Tseng-tzu

Sheltering from the monsoon rains, a monk reads a sacred text, Myanmar.

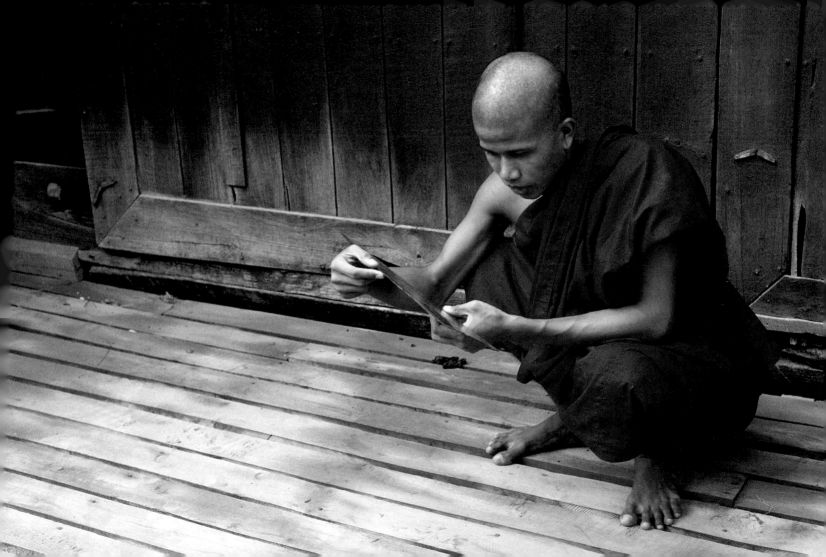

Between he who has conquered a hundred thousand men in battle
and he who has conquered himself,
it is the latter who is the greatest victor.

Master Ok-Sung Ann-Baron

Saeng Sae Kee, a pupil of Sitta Wangtarawut, martial arts master, Thailand.

To think is to choose to observe and comprehend,
even if one is disturbed by oneself or by others.
Ultimately, to think means to understand,
to understand primordial matter,
the first thing in history.

Master Taisen Deshimaru

Sunrise over the flooded terraces of Bada, in Yunnan province, China.

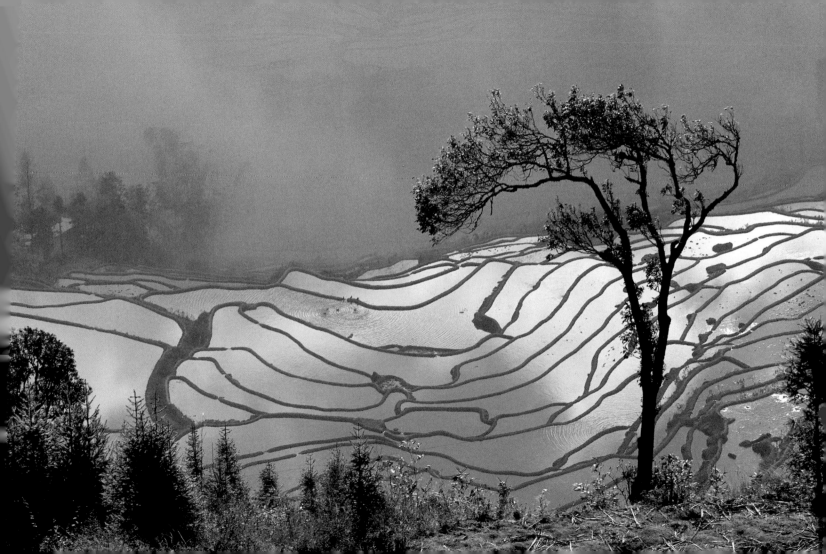

It is not necessary to use strength.

It is not necessary to move one's mind.

Master Taisen Deshimaru

Three young nuns pray in the pagoda of U Ponya on the hill at Sagaing, one of the most important centres of Buddhism in Myanmar.

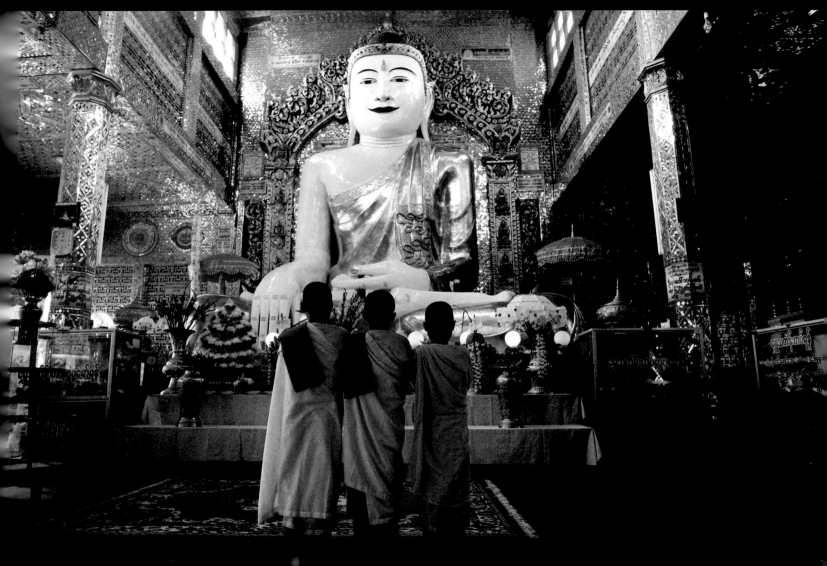

The wise man does not govern men from outside.

First he changes himself and then his influence spreads.

He strengthens nothing but his own abilities.

The bird flies high to avoid attacks from nets and arrows;

the field mouse hides deep in the hillside for fear of being smoked out of its nest.

Can you ignore the wisdom of these small creatures?

Chuang-tzu

The remote house of the chief of Yulchung village, looking onto the steep-sided valley of Zanskar, India.

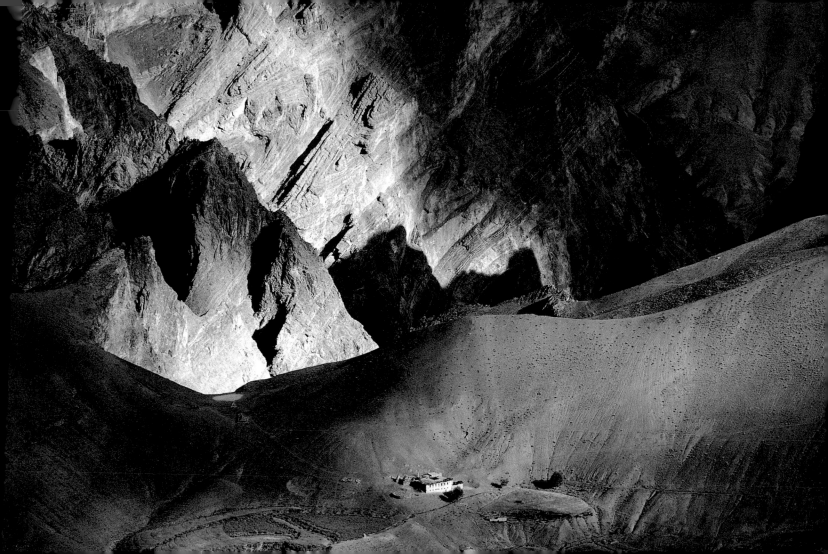

The way of the warrior poses a challenge:
we must emerge from our cocoon and venture out into space,
displaying both mindfulness and kindness.

Chögyam Trungpa

Moe Pcoint Phyu, aged 8, dressed in traditional costume for the Kayin New Year, Myanmar.

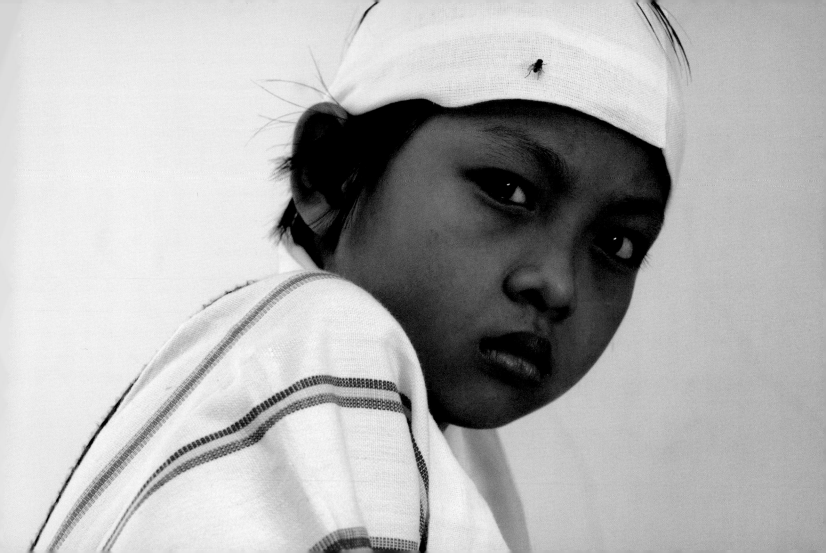

Know this,

heart speaks to heart, in secret.

Dogen Zenji

Keo, a grandmother aged 78, with her granddaughter in the village of Ben Sop Jam, which is famous for its shawls. Laos.

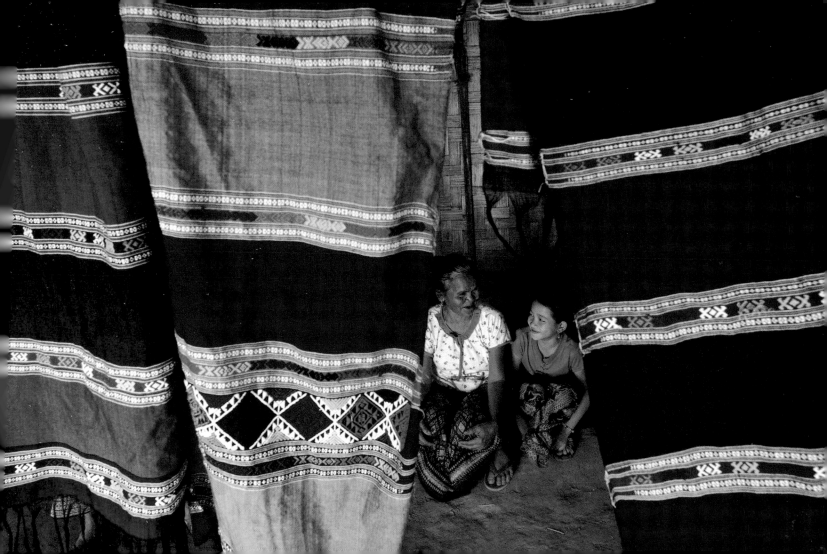

Keeping a sense of proportion about things
and giving others a place without losing one's own,
this is the secret of success in the theatre of the world.

Master Okakura Kakuzo

Morning at the temple of Sensoji, Tokyo, Japan.

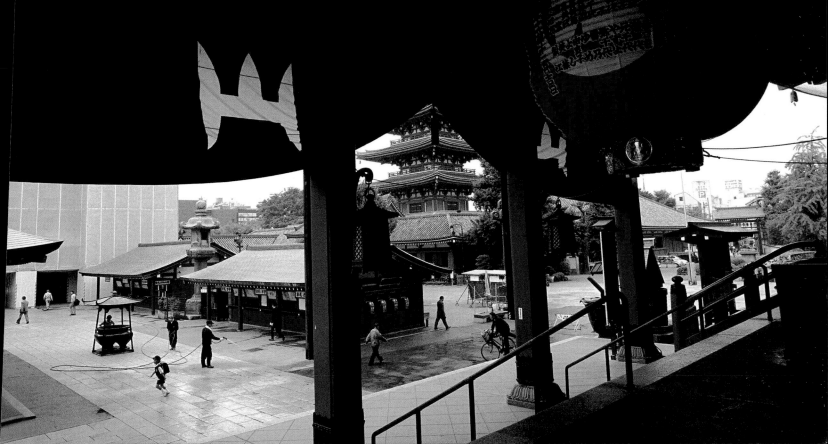

Adjusting one's mind means finding the correct point of view,
integrating oneself into a global vision of things
instead of fixing them in relation to one's own personality.
To make an abstraction of oneself in this way
implies perfect mastery of oneself.

Chao Yong

The work of the architect Hiroshi Hara, Kyoto's monumental railway station was built in 1997. Japan.

One truly basic act is to
sit on the ground, assume a correct posture
and cultivate the feeling of having one's own space.

Chögyam Trungpa

In the province of Yunnan, a musician from Jianshui plays in the 'Square of the Sun-Facing Tower', where the people of the town congregate every evening. China.

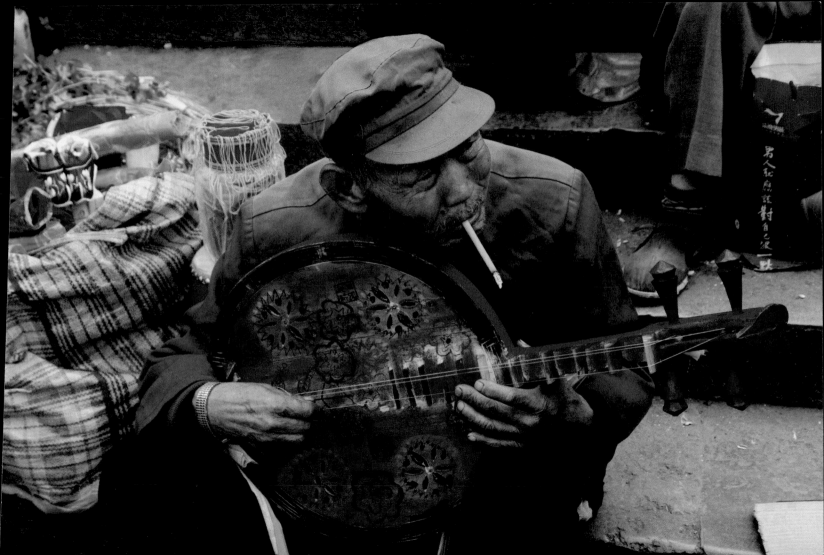

Perspective means taking a step back and realizing
that we are all just little fish in a very big pond.

Steve DeMasco, Kung Fu Master

In Koyasan, more than 100 Buddhist temples, with beautifully laid out gardens for contemplation, offer instruction and hospitality to pilgrims. Japan.

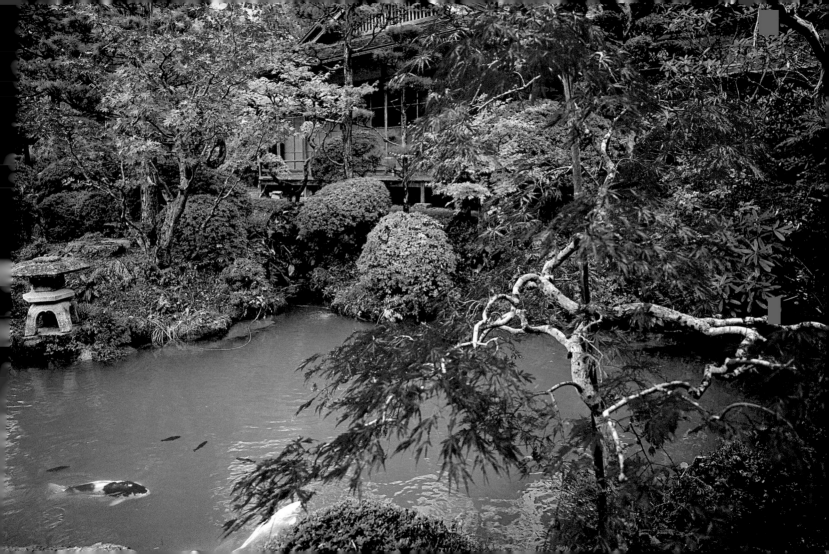

In general, the essential lies in the background, and the detail is on the surface,

which means that victory can always be achieved.

But when the detail lies in the background and the essential is on the surface,

victory is obtained only by chance...

One must therefore perfect what is essential and train oneself in the details...

Kenji Tokitsu

The gate of Sanmon, dating from 1619, gives access to the temple of Chionin, Kyoto, Japan.

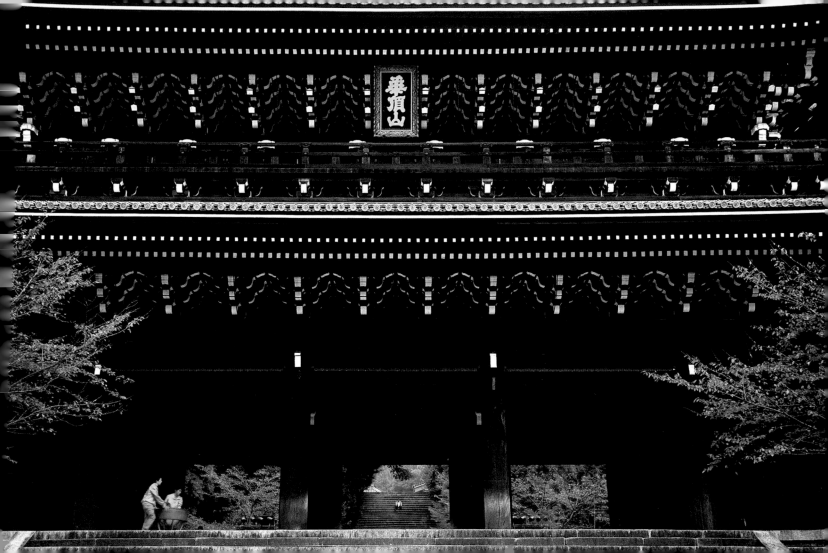

Although the feet of man occupy only a small corner of the earth,
it is because of the space that he does not fill that man can walk through the wide world.
Although the intelligence of man penetrates only a fragment of the truth,
it is because it does not penetrate that man can understand what heaven is.

Chuang-tzu

Seated on the ground, a young nun revises for her examinations at Sagaing, one of the most important Buddhist centres in Myanmar.
Overleaf: Springtime in the mountains of Zanskar in India, and a caravan makes its way through the Pensi pass, 4,400 metres (14,400 ft) high.

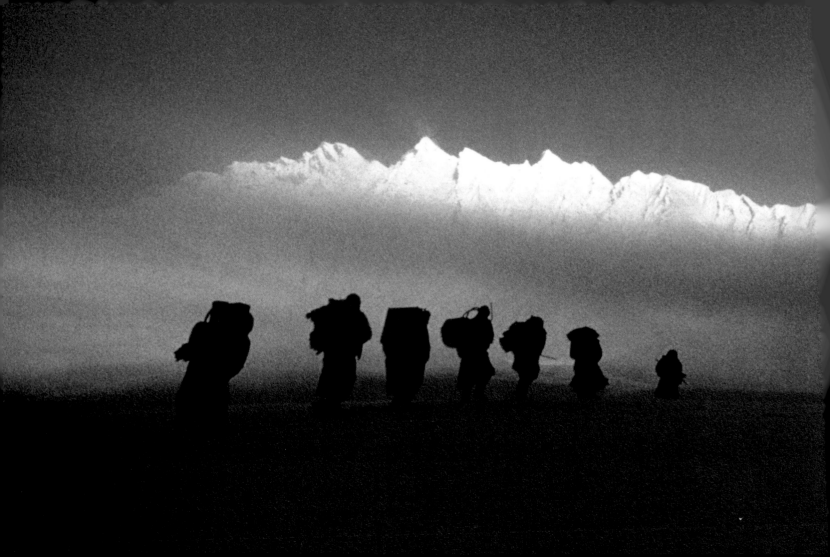

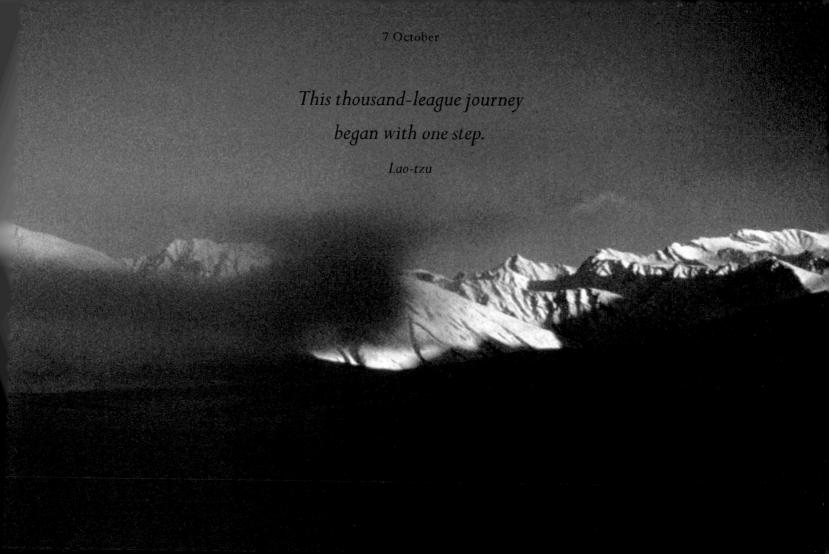

This thousand-league journey

began with one step.

Lao-tzu

The noble man is universal and admits no comparison,

The vulgar man admits comparison and is not universal.

Confucius

Pupils at the village primary school in Ben Sop Jam take their first exams. Laos.

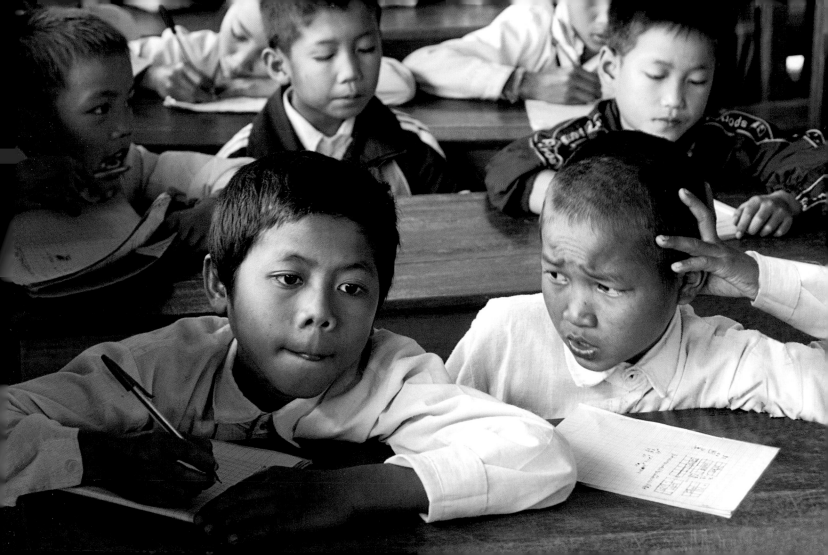

Fix all your attention on your own Path, and do not imitate others.

Your life is unique and your karma is yours alone.

Do not seek to imitate Buddha or Christ,

but follow their teaching and understand its essence, its depth and its reach,

and create your own true Path, throughout your life.

Master Taisen Deshimaru

The bridge of U Bein, 1.5 km (1 mile) long and made of teak, spans the shores of Lake Taungthaman, Myanmar.

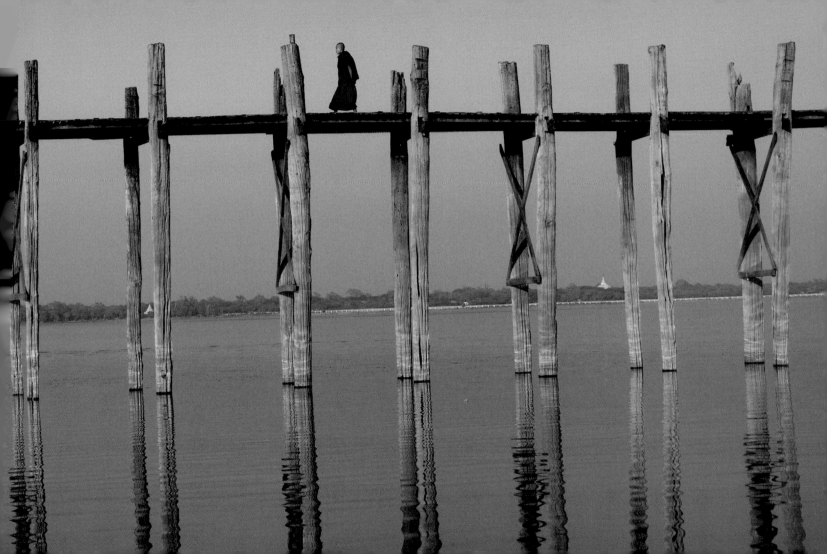

From very early on in our lives, self-worth is the platform for our behaviour
and the motivator that unconsciously dictates
who and what we are going to be for the rest of our lives.
It governs everything we do, from how we dress,
to the personal relationships we have,
to the jobs we choose and the choices we make.

Steve DeMasco, Kung Fu Master

Young novice monks relax in the monastery of Lan Tayar, Myanmar.

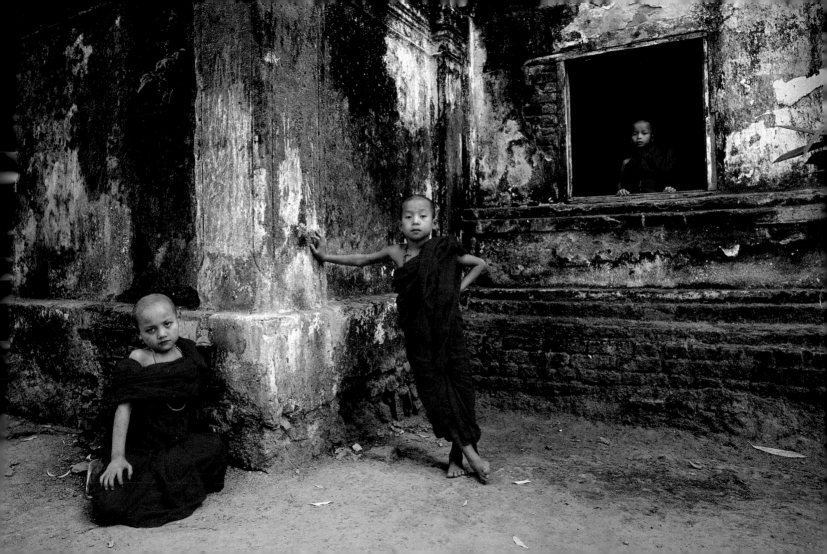

Having trust does not mean having confidence in a thing,
but remaining in a state of trust,
free from the spirit of competition, and of the need to beat others.
It is an unconditional state in which you possess nothing but an indomitable mind,
a mind that extends beyond any fixed point.

Chögyam Trungpa

Naw Chi Phaung and her baby brother, Myanmar.

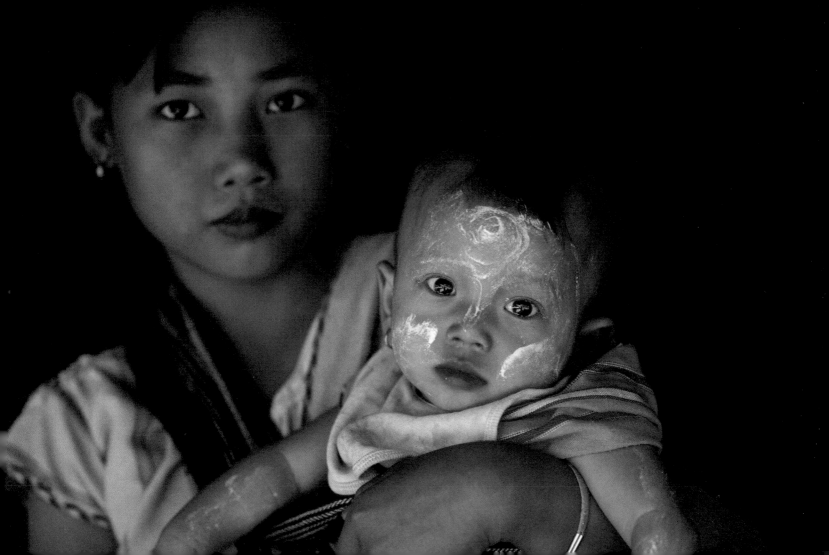

When I do not think,
and only listen,
one drop of rain
upon the roof
is myself.

Dogen Zenji

A traditional lantern in the colour of happiness, prosperity and passion, in the village of Zhouzhuang, China.

Do not compete, and you will be without reproach.

Lao-tzu

Most elderly people in China engage in some form of social activity every day.

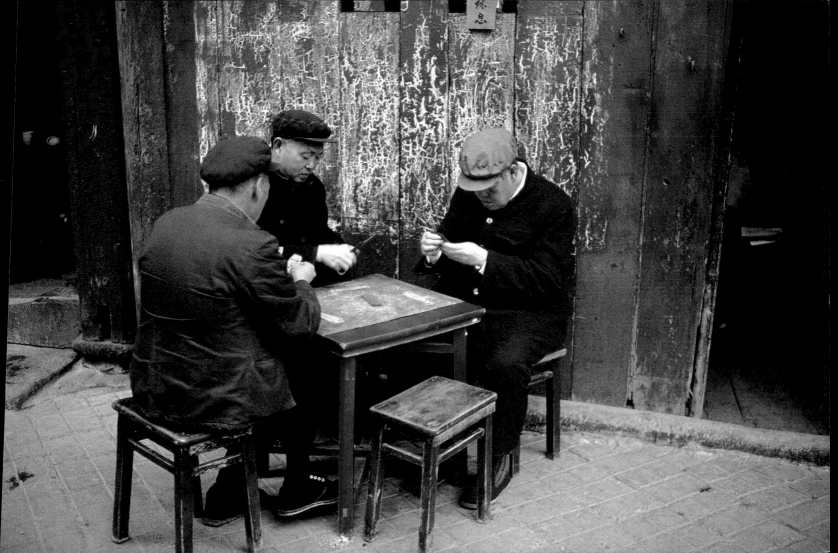

Every time I feel that I'm losing my own focus,

I ask myself one question:

What am I trying to accomplish?

Steve DeMasco, Kung Fu Master

Young monks attend a course in Buddhism and general knowledge at the temple school of Wat Sop in Luang Prabang, Laos.
Overleaf: In Koyasan, more than 100 Buddhist temples, with beautifully laid-out gardens for contemplation, provide teaching and hospitality for pilgrims. Japan.

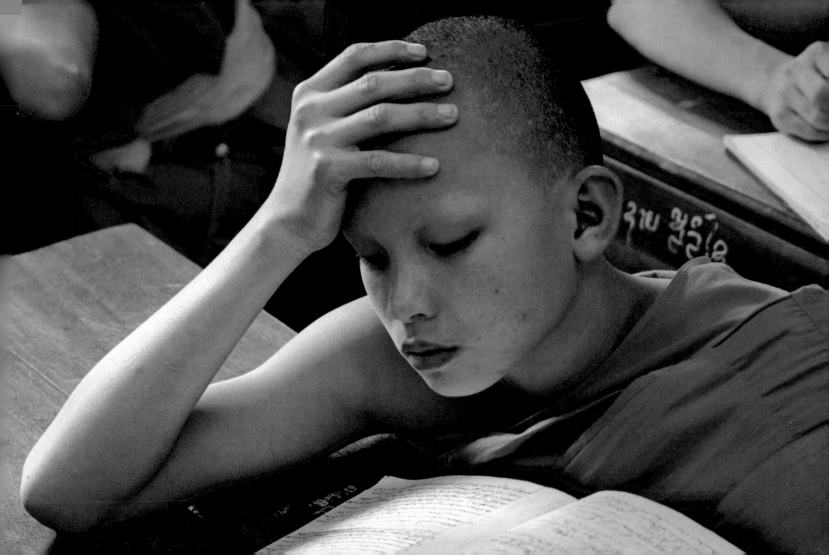

15 October

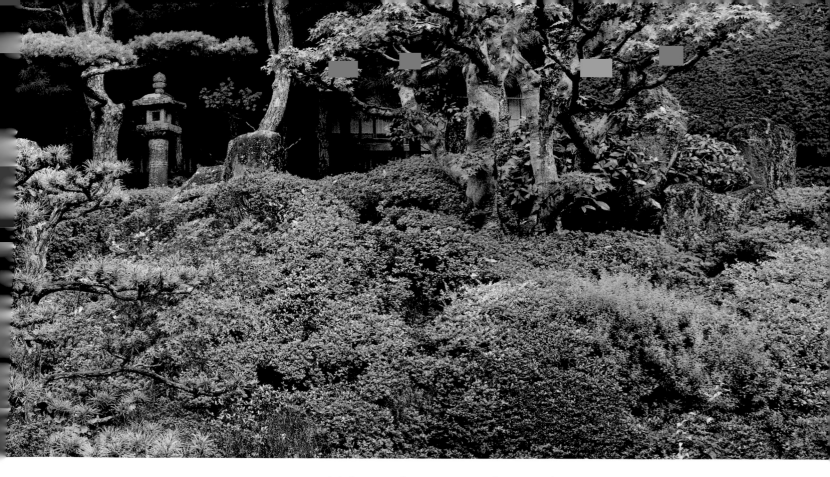

To know the Way is to know where to go and how to get there.

Tseng-tzu

Anything that is built must rest on a foundation.

Lao-tzu

Dedicated to the bodhisattva Kannon, the Buddhist temple of Sensoji is the oldest and one of the most venerated in Tokyo, Japan.

I cannot tell you that having discipline will guarantee success,

but I can tell you that the lack of it guarantees failure.

Steve DeMasco, Kung Fu Master

Saeng Sae Kee (left) practises martial arts with his instructor, Sitta Wangtarawut (right). Thailand.

Governing our world means

living in a dignified and disciplined way, without frivolity, while rejoicing in life.

It is truly the way to combine survival and celebration.

Chögyam Trungpa

A young geisha on parade during the festival of Jidai Matsuri, Kyoto, Japan.

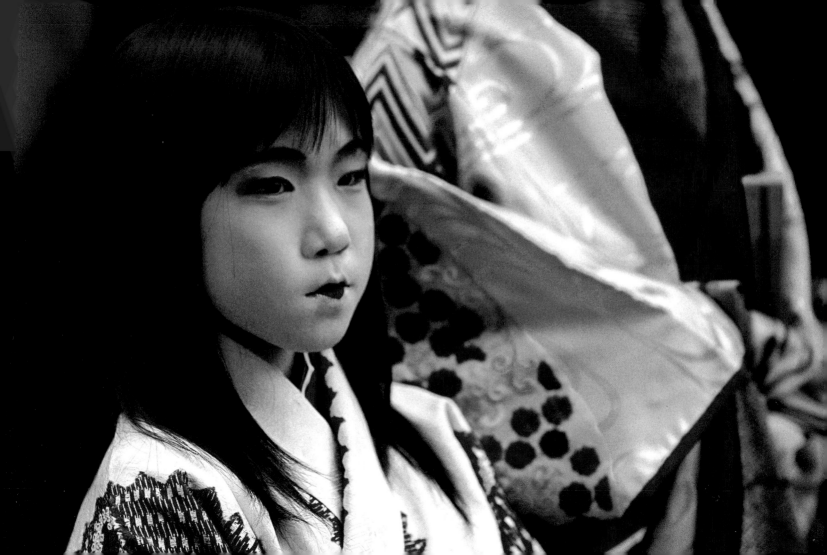

*Discipline usually involves
doing the things you don't want to do.*

Steve DeMasco, Kung Fu Master

A Tibetan master comes to the remote village of Shadi in the Zanskar region to conduct an initiation ceremony. India.

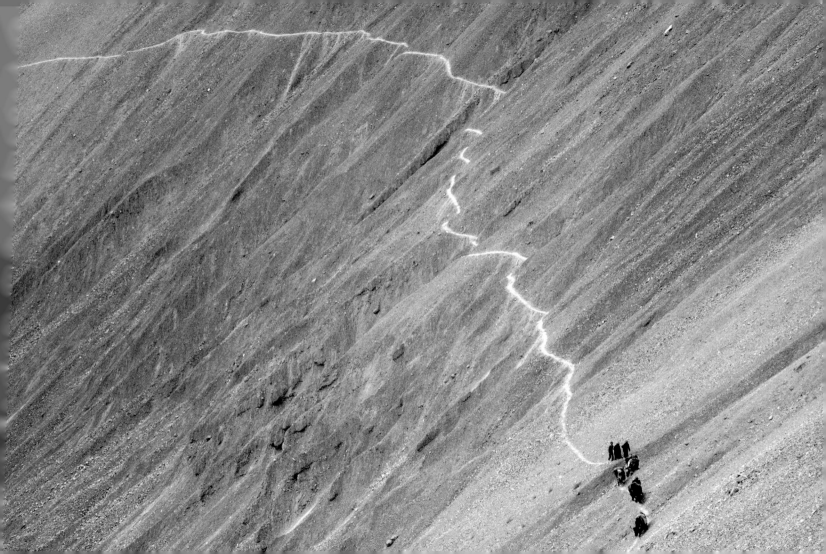

Live a well-thought-out, disciplined life

and you will live forever.

Steve DeMasco, Kung Fu Master

A lesson in Buddhism and general knowledge for young monks at the temple school of Wat Sop in Luang Prabang, Laos.

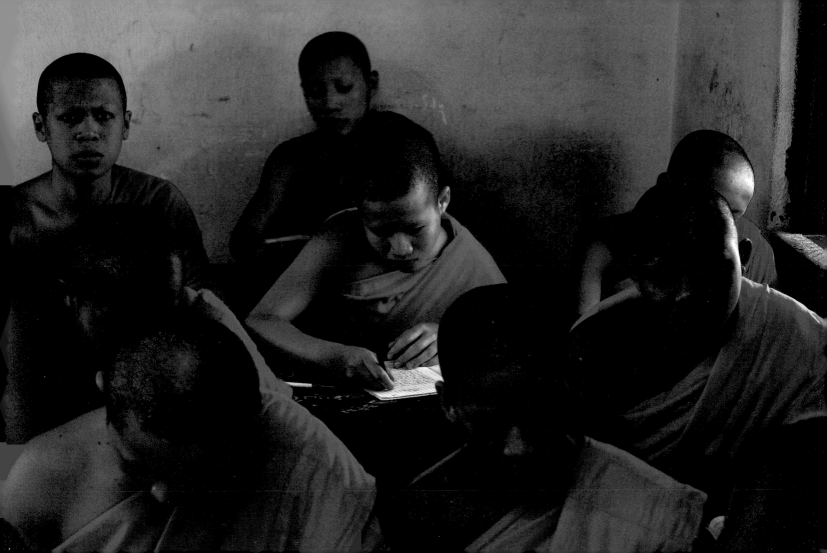

One day, a novice archer stood before a target with two arrows.

His master then said to him:

'Beginners should not use two arrows.

If you rely on the second one, you will not pay enough attention to the first.

So it is better to concentrate fully on a single arrow,

without worrying about whether it will hit its target.'

Yoshida Kenko

Du Jing Kong Xue hangs prayer flags around his house to celebrate the Tibetan New Year in the region of Kham, China.

Make the small large and the little a lot.

To do great work, begin with the small.

Great deeds must begin on a small scale.

Lao-tzu

No matter where you are in the world, the love between mother and child remains universal. Myanmar.

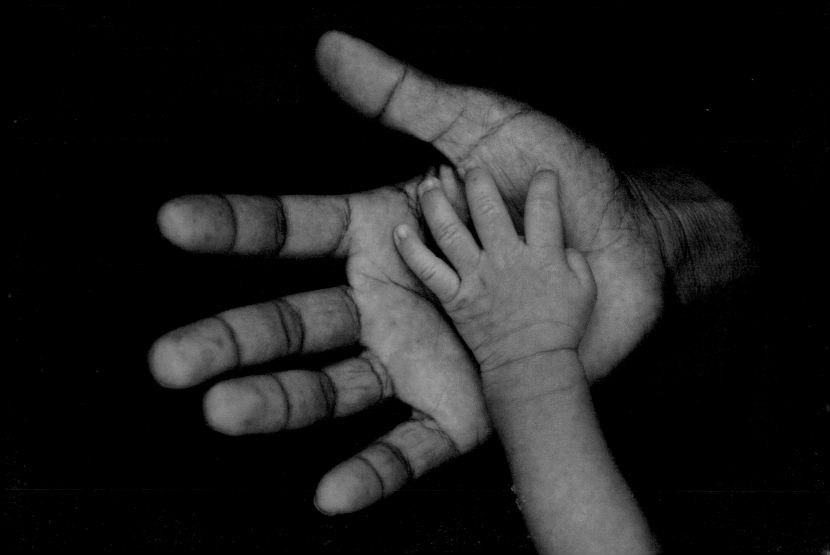

It is by practising vulnerability of the heart that we discover courage.

Chögyam Trungpa

Leun, aged 12, looks after her baby brother in the village of Baan Sa Phieu, Laos.

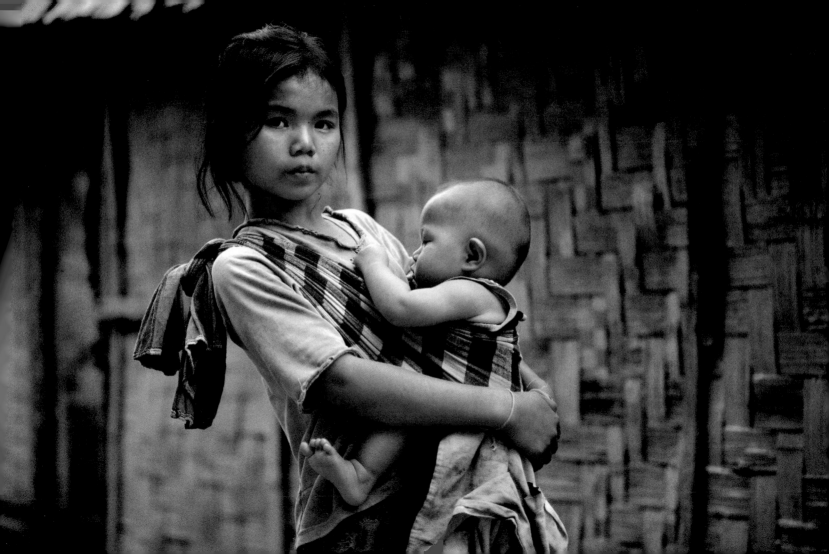

The ideal warrior must know sadness and tenderness;
it is from there that he must draw his great mindfulness.
Without that sadness that comes from deep in the heart,
mindfulness is as fragile as a porcelain cup.

Chögyam Trungpa

Lang, aged 6, beside a typical hut of the Mlabri people, in the village of Huany Yuak, Thailand.

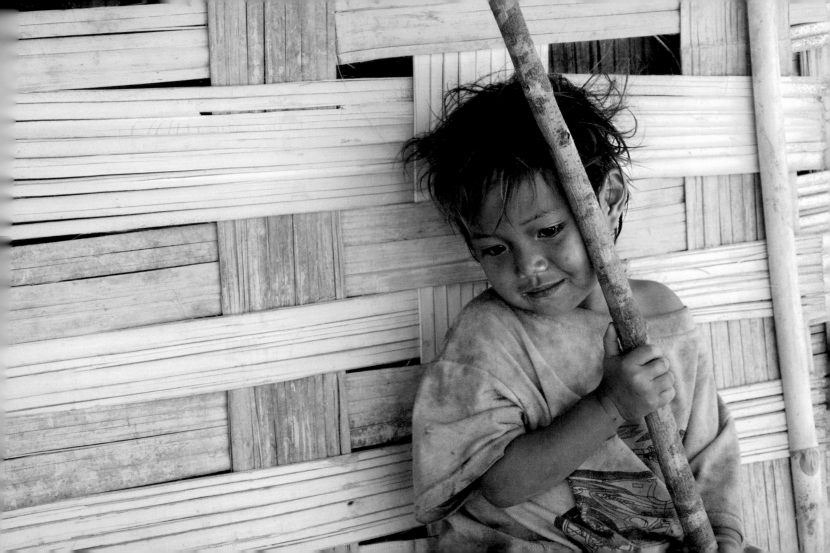

Approach all things and all beings with a face of kindness.

Dogen Zenji

An elderly lady on her way home from the pagoda of Shwedagon in Yangon, Myanmar.

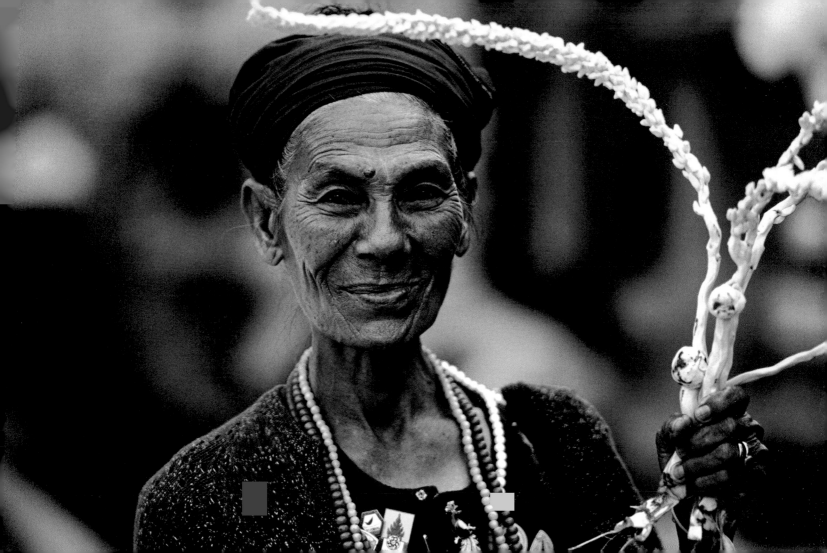

To be courageous without compassion,

to be generous without restraint,

to lead without humility

leads to death.

Lao-tzu

Wooden sculpture in the Buddhist temple of Haeinsa, one of the three Jewel Temples of Korea, built in the 9th century on Mount Kaya, South Korea.

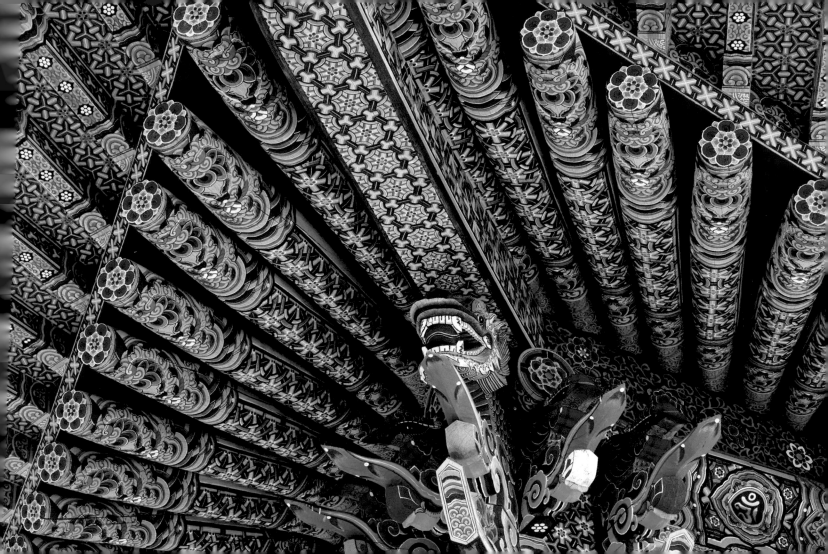

True courage is the product of tenderness.
It arises when we let the world touch our heart,
our heart that is so beautiful and so bare.
We are ready to open ourselves up, with no resistance or timidity,
and truly face the world.
We are ready to share our heart with others.

Chögyam Trungpa

Seng, aged 26, a young mother in the village of Ban Houey Ko on the banks of the Mekong, Laos.

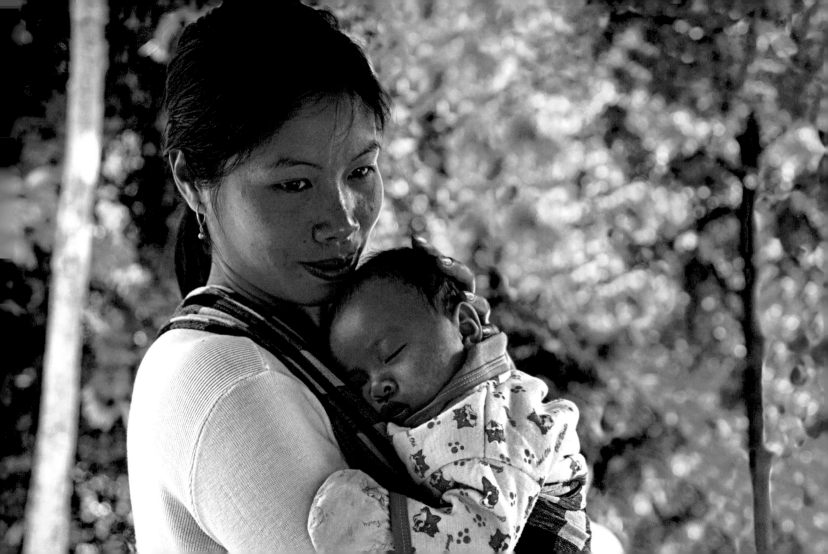

Let us strive to be fully human

and there will no longer be a place for evil.

Confucius

Diem Le, a little girl of 5, at her mother's stall. Mekong Delta, Vietnam.

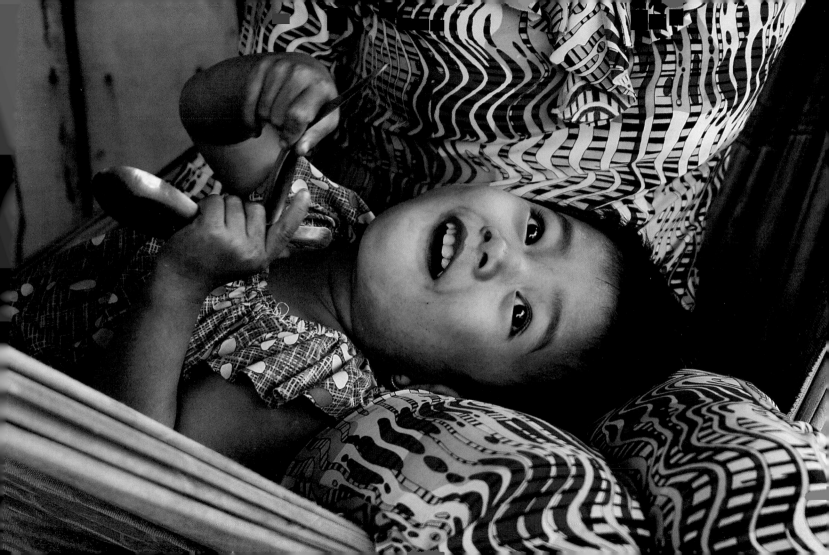

Five musical notes, but no one hears their variations.

Five colours, but no one has ever admired all their nuances.

Five flavours, but no one has tasted every combination.

These arts are inexhaustible, like the flow of a stream.

Zun Zi

Madam Wu, a musician at a teahouse in Zhouzhuang, sings the *tanzhi*, a traditional Suzhou song, and plays her *pipa*. China.

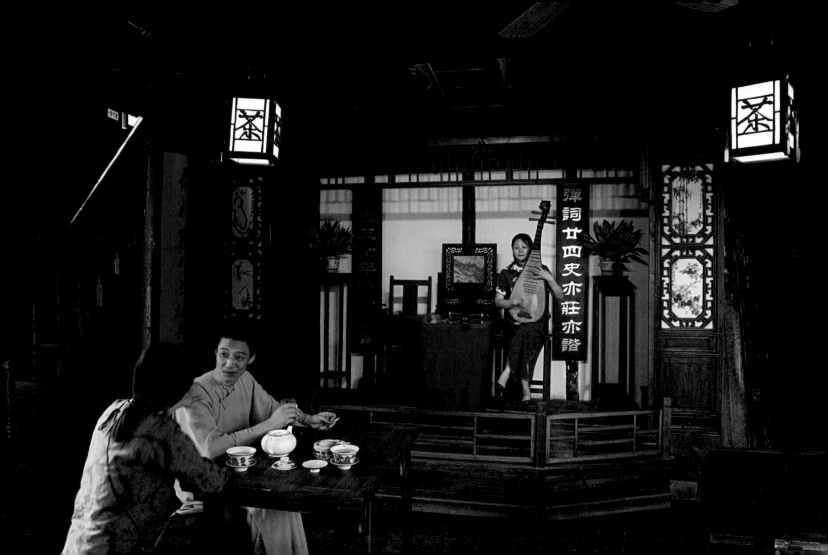

The honest man encourages what is good in people,
he does not encourage what is bad in them.
The vulgar man does the opposite.

Confucius

Phan Van Anh, aged 20, in traditional costume, in the village of Lai Chau, Vietnam.

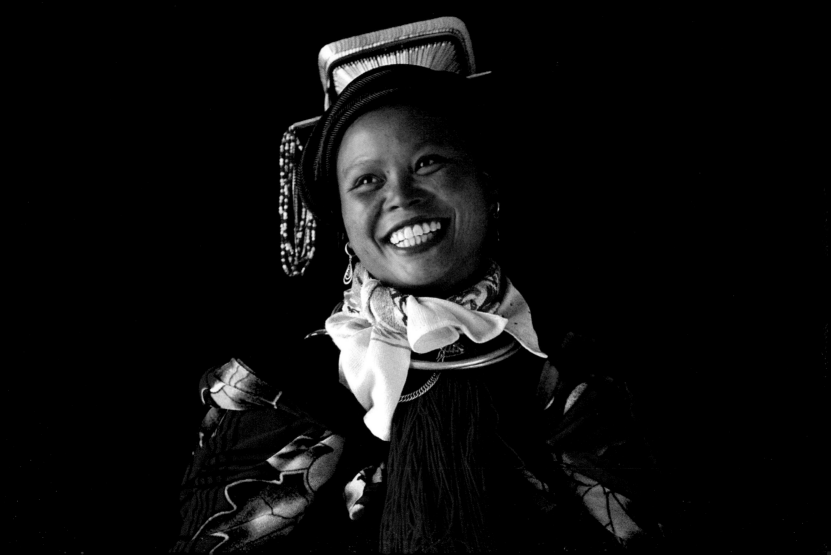

The Tao has no form.
If it can be spoken of, it is not the Tao.
The Tao is emptiness.
If it seems full, it is not the Tao.
Emptiness is its substance.
It is like shouting in the mountains:
the valley answers.

Lao-tzu

In the Zhuang region of China, the farmers grow vegetables and maize in the paddy fields when these are not flooded.

Your capacity to love others
depends entirely on your capacity to love yourself,
and take care of yourself.

Thich Nhat Hanh

Varunee Skaosang, aged 24, dressed in traditional Akha costume, Thailand.

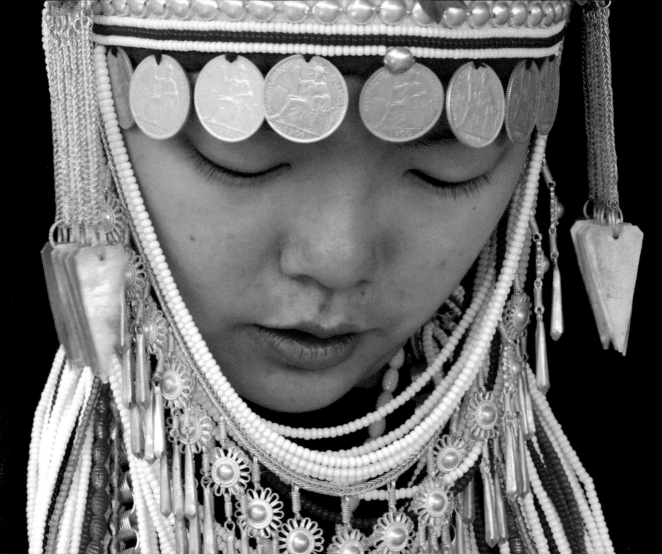

The way in which we look at someone
relies on the trust we have in ourselves
and the depth of our desire to look at them.

Chögyam Trungpa

Tin Htaw Nwe and his son. Amarapura, Myanmar.

We must first discover in ourselves
what we have to offer to the world
before establishing an enlightened society.

Chögyam Trungpa

Built on the side of a mountain, the Buddhist monastery of Karcha overlooks the plains of Zanskar in India, from a height of 3,600 m (11,800 ft).

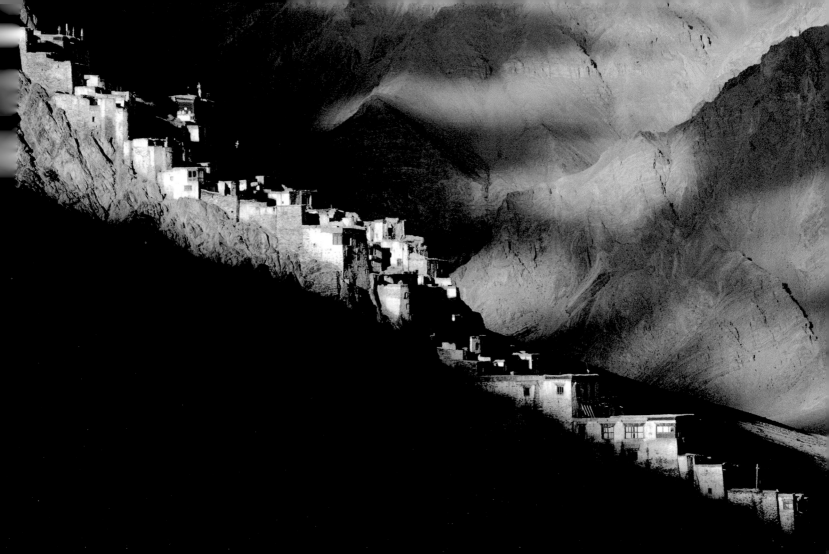

Understanding is the basis of love.

Thich Nhat Hanh

Hang Ti Chi, aged 10, and her best friend Cheo Su May, aged 12, in the village of Ta Van, Vietnam.
Overleaf: After the Pyatho festival, three monks return to their monastery near Bagan, Myanmar.

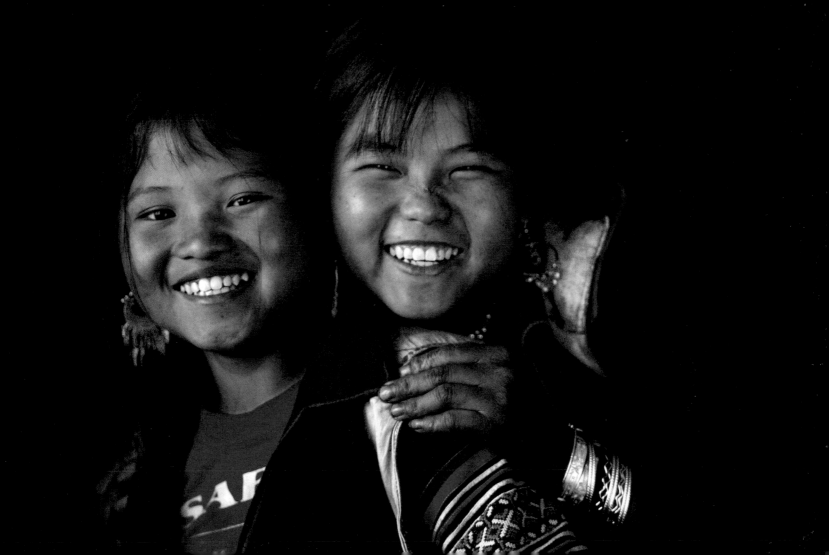

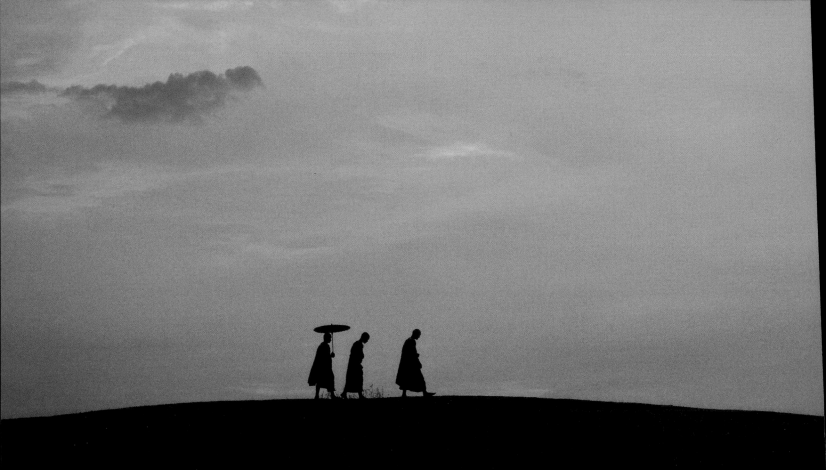

The degree of happiness you possess depends on the degree of freedom in your heart.

Thich Nhat Hanh

In seeing the true nature of others,
we also discover all their problems, their aspirations,
their suffering and their fears.

Thich Nhat Hanh

A peasant woman from Yunnan at the market in Dali, China.

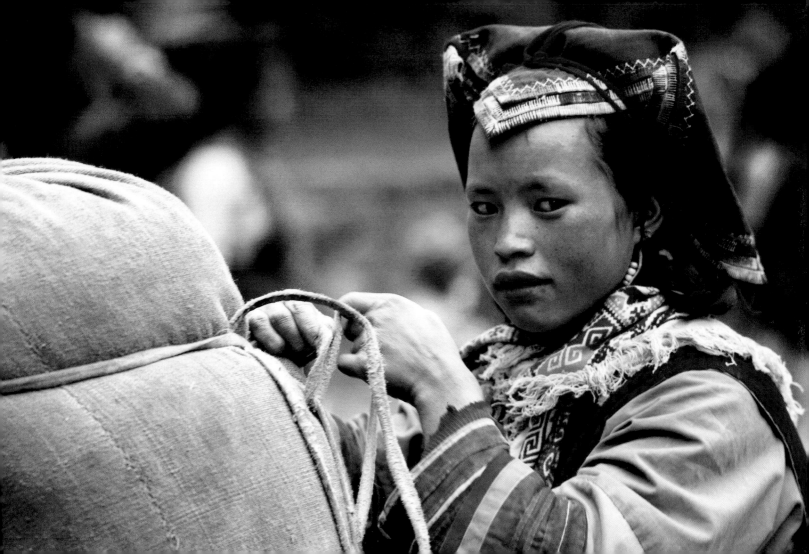

He who has made us suffer is suffering too, there is no doubt.

It is enough to sit, concentrate on our breathing

and look deeply:

we will surely see his suffering.

Thich Nhat Hanh

A fisherman hopes for one last catch as night falls on the Mekong, Laos.

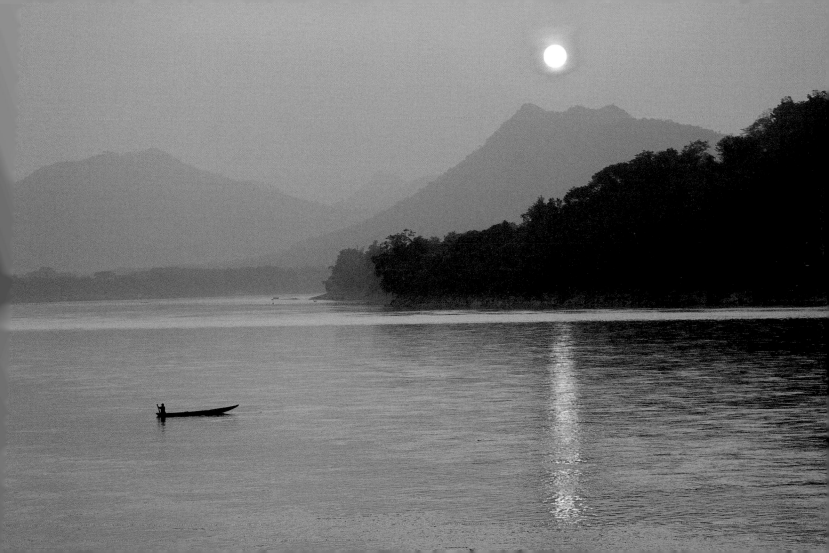

It is important to learn how to listen with compassion.
Listening with compassion
means listening with the will to relieve others of their suffering,
without judging or seeking to argue.

Thich Nhat Hanh

Yugong and his sister, dressed in traditional costume as they celebrate Losar, the Tibetan New Year, China.

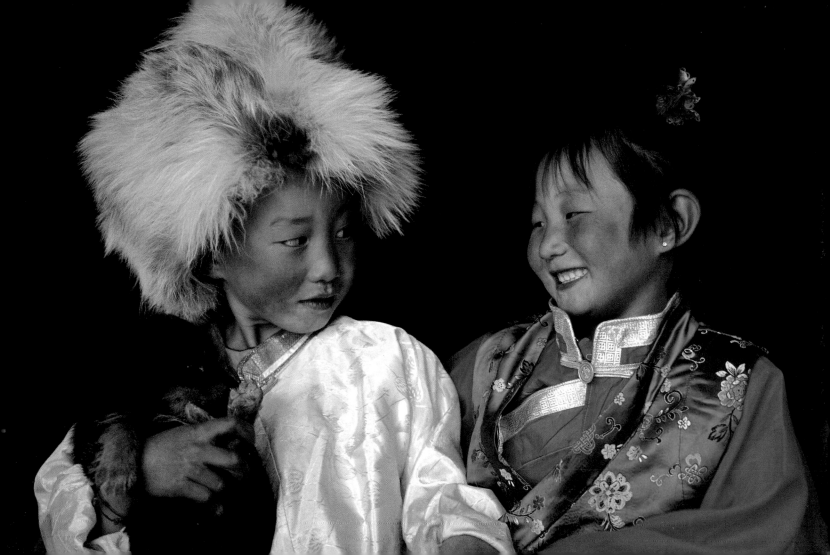

Willing effacement of the self and deep respect for others,
these are the two virtues through which the wise man
profoundly hopes to bring peace to the world.

Liou Kia-hway

The bamboo forest around the temple of Hokokuji in Kamakura, Japan.

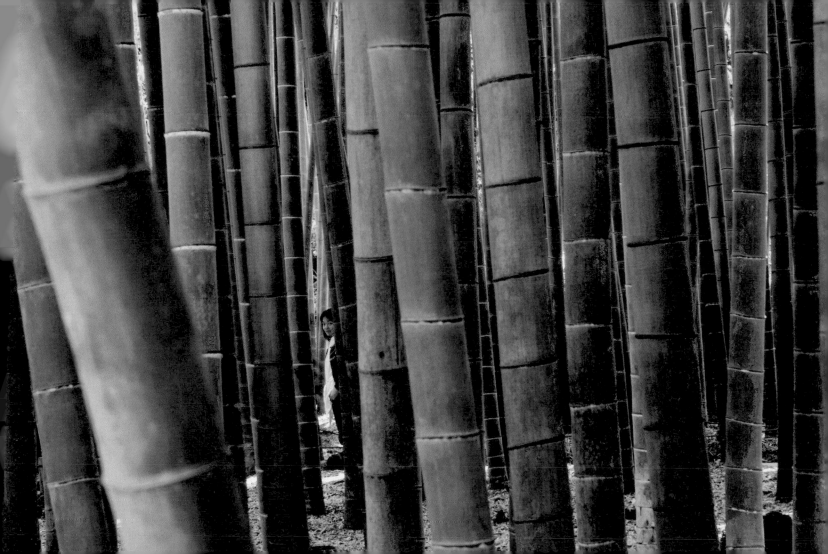

Since we have become beings with language, our mission as human beings
is to be the speakers within the realm of living things.
We communicate, and the universe makes sense,
and we ourselves make sense.

François Cheng

Thiwa Morpoku, aged 25, dressed in traditional Akha costume, Thailand.

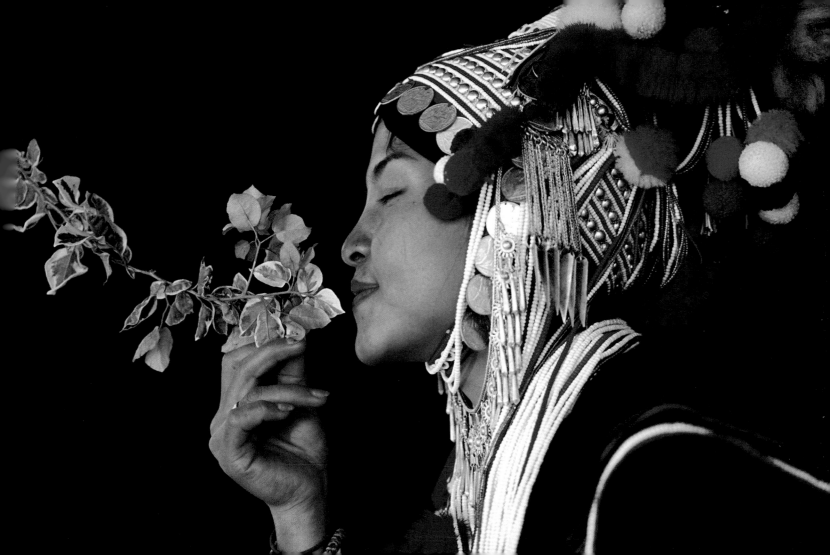

Take your own aspirations as a guide
assure for your neighbour the fate which you would wish for yourself
obtain for him what you would wish to attain for yourself.

Confucius

An elderly peasant woman from Yunnan returns from the fields, holding the stick that she uses to drive her buffalo. China.

Strong bonds are not made with ropes and no one can untie them.

The wise man is always ready to do good for mankind

with no exceptions.

The wise man is always ready to do good for things

with no exceptions.

This is what we call following the Light.

Lao-tzu

The venerable Kakchong, in charge of the library at the Buddhist college in Haeinsa, South Korea.

One can only know the best of oneself

through awareness of the best of other people.

François Cheng

The marine park of Tarutao, on the island of Adang, Thailand.

A true man does not cry for himself.

His tears are always destined for others.

Meng Jiao

Ha, aged 12, in the village of Lao Chai, Vietnam.

It is from the bottom of your heart that you react
when you see someone crying, laughing or frightened.

Chögyam Trungpa

A baby cries out for its mother's attention while she cooks the evening meal, in the village of Minnanthu, Myanmar.

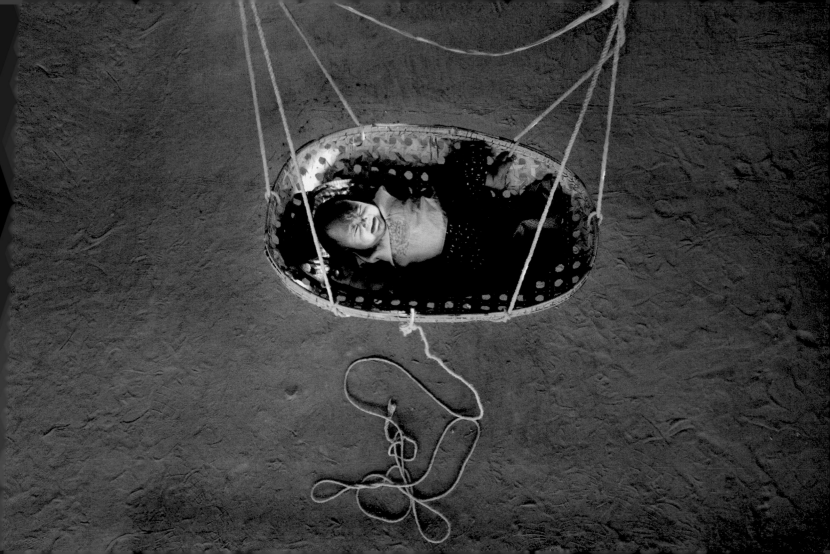

True enlightenment means rejoicing in the happiness of others:

compassion appears.

Master Taisen Deshimaru

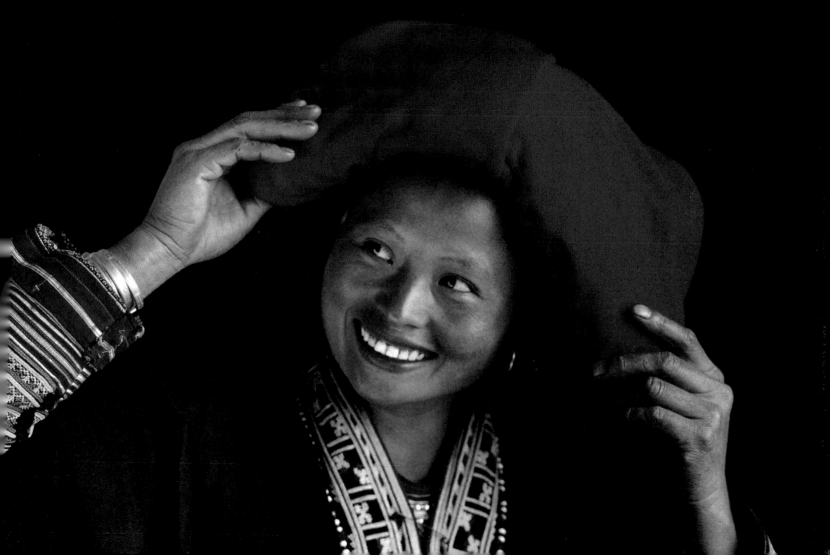

The power that gives form
to the rocks and the trees
Will feed my desire
in this sudden moment.
And all the beauty
born from its passage
Teaches me the way
to love you and transform myself.

François Cheng

The flowering of the cherry trees is an occasion for national celebration in Japan.

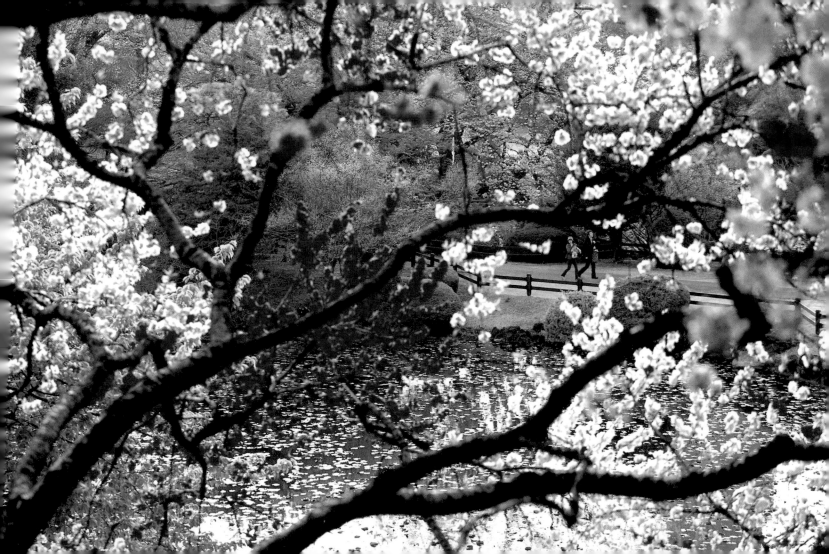

If you reach deeply into your own heart and the heart of others,
understanding will arise.
If there is understanding,
acceptance and love will follow,
and suffering will be eased.

Thich Nhat Hanh

Two generations get together at the entrance to a Naxi house in the region of Kham, China.

Hear what they are not saying.

Steve DeMasco, Kung Fu Master

In the village of Yugong, in the Kham region of China, 8-year-old Karmastin wears a cap made from the fur of a snow leopard as he celebrates the Tibetan New Year.

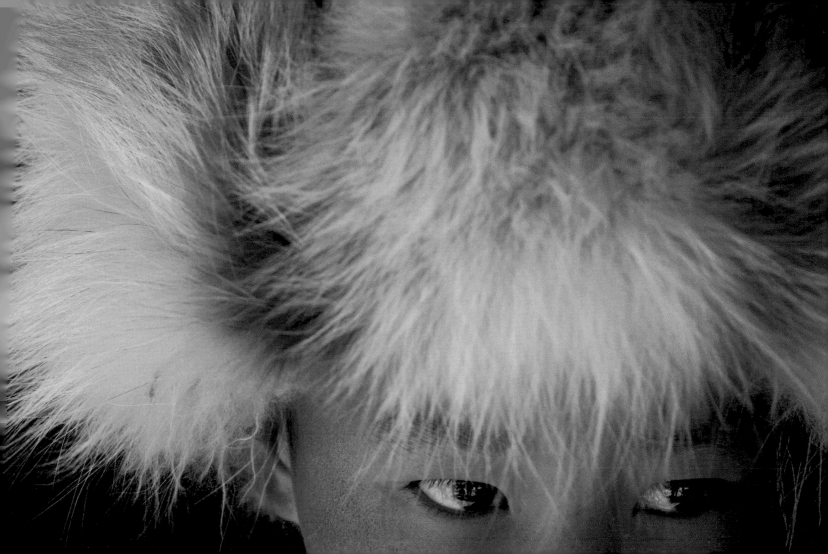

When the efforts of men are directed towards a common goal,
they will breathe in harmony with each other.

Han Yu

The ceremony of the November full moon, at the temple of That Luang in Vientiane, Laos.

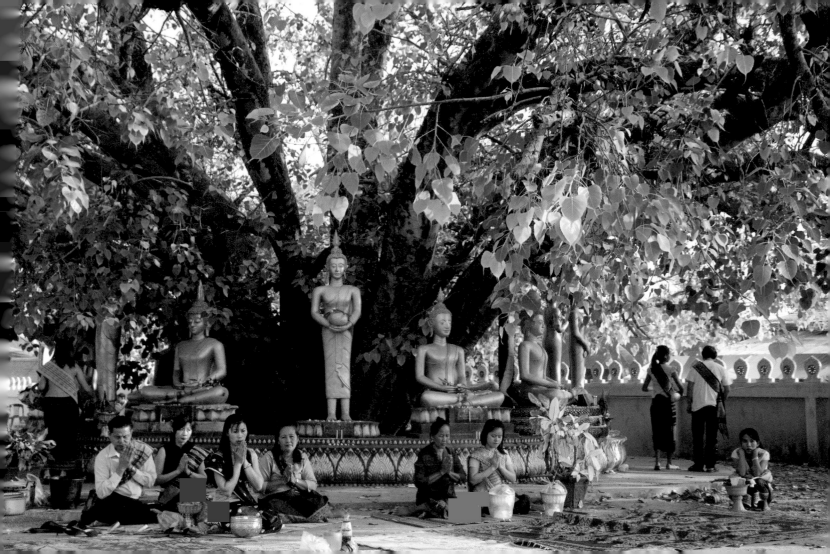

It is because it is empty that the drum makes a sound.

It is because it is empty that the mirror reflects an image.

Wang Tong

With a height of 4 metres (13 ft) and a base 5 metres (16 ft) in diameter, the bell of Mingun weighs 90 metric tonnes (99 tons). Myanmar.

There is pure goodness and contaminated goodness.
What we call pure goodness
is accomplished without awareness of the ego.
What we call contaminated goodness
is accomplished in the hope of personal gain.

Suzuki Shosan

A statue of the head of the Buddha is protected by the roots of a sacred banyan tree, Ayutthaya, Thailand.

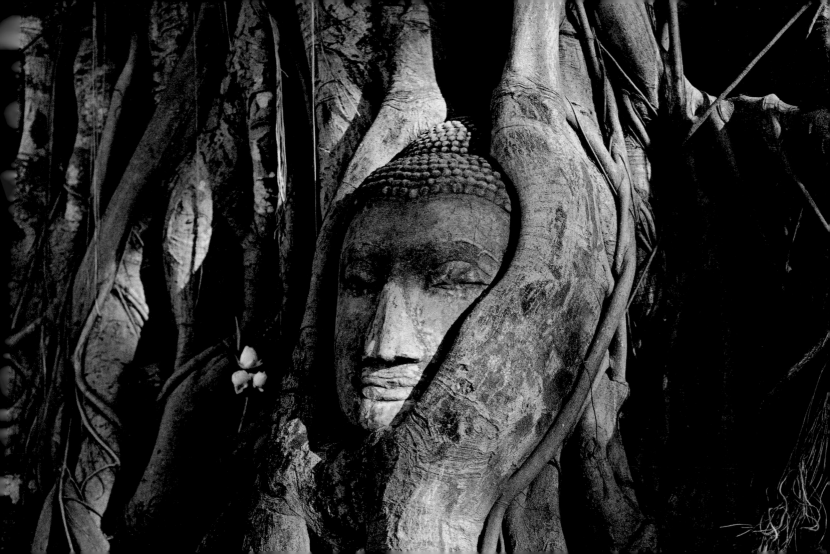

Expect nothing in return,

have no goal and no mind for profit.

Master Taisen Deshimaru

Wannaporn Weerawatpongsatorn, aged 7, dressed in traditional Akha costume, Thailand.

When you sit in a Zen posture,

it is not for yourself or the sake of your health.

You are doing it for the whole of humanity.

Master Taisen Deshimaru

Village life in Ben Sop Jam, on the banks of the Nam Ou, Laos.
Overleaf: One of the many islands in the huge marine park of Tarutao, in the Andaman Sea, Thailand.

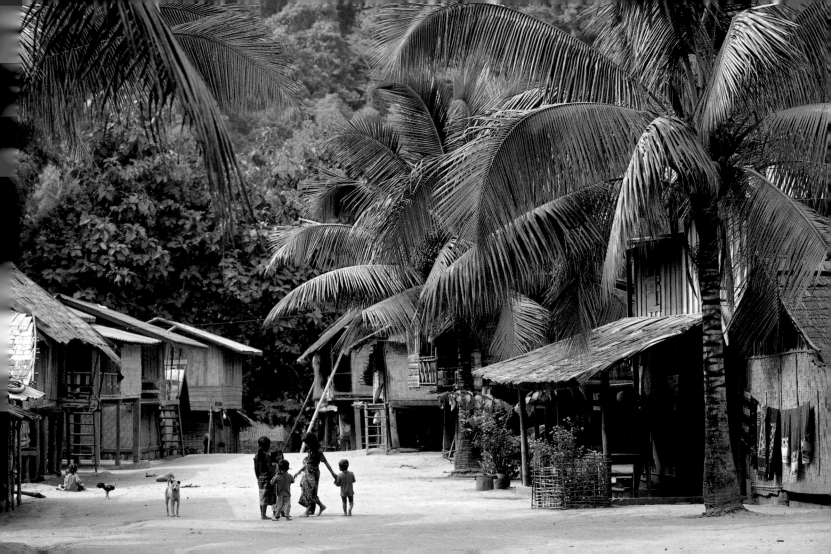

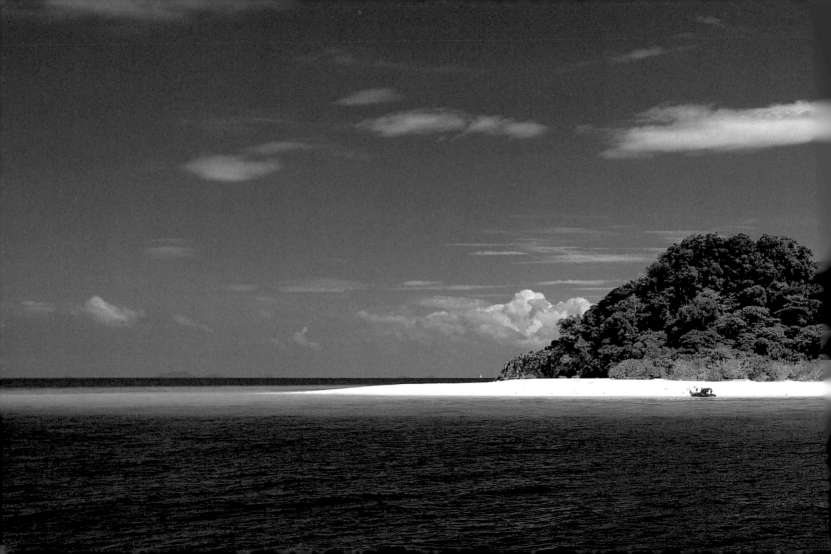

Emptiness is greatness. It is like the bird that spontaneously sings and feels it is part of the universe.

Chuang-tzu

Go, go, go together,
into the distance and beyond,
to the shore of Enlightenment.

Dogen Kenji

On the roofs of their houses, villagers replace worn-out prayer flags with new ones for the Tibetan New Year. Kham region, China.

The wise man devotes himself to saving mankind

and rejects no one.

Lao-tzu

A monk at prayer on a peaceful afternoon in Bagan, Myanmar.

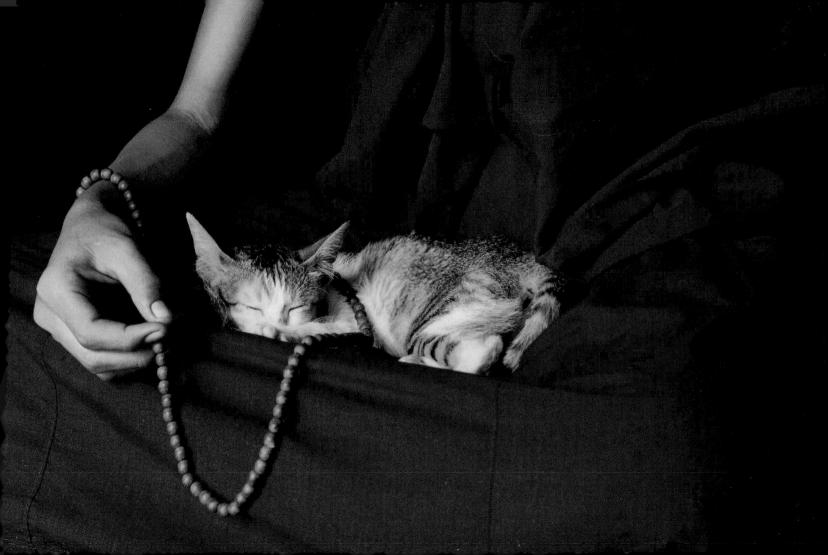

One day, someone calls her 'Mother'.

This is what she remains for the rest of her life.

Cao Xue Qin

Yuphin Saelee, aged 25, and her first child, Tanachot Uhphadee, aged 7 months, Thailand.

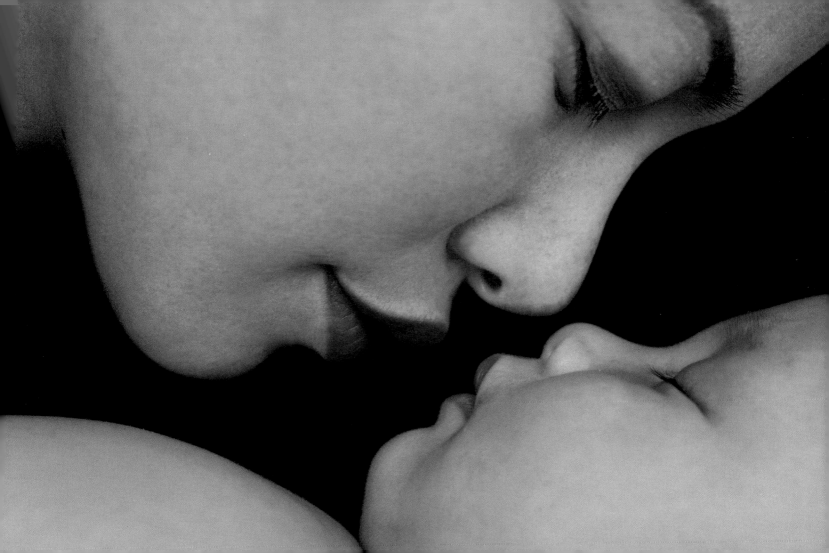

Women hold up half the sky.

Mo Zi

A woman from the village of Minnanthu, Myanmar, goes home after a hard day's work selling water.

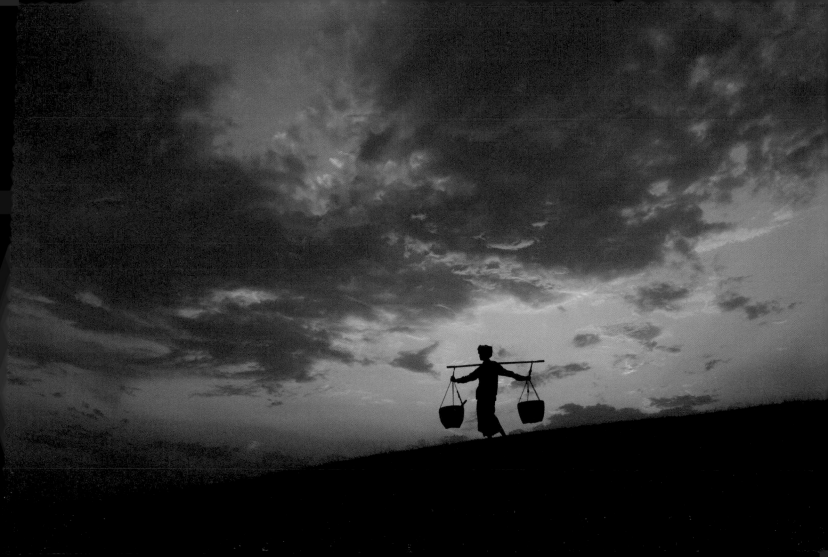

A great land is the low country
to which all the rivers run,
the meeting place of all things,
the Female in the universe.
The Female conquers through passivity,
conquers through being humble in passivity.

Lao-tzu

To celebrate the birthday of the Buddha, Keiko visits the temple of Myohonji,
the oldest temple of the order of Nichiren, Kamakura, Japan.

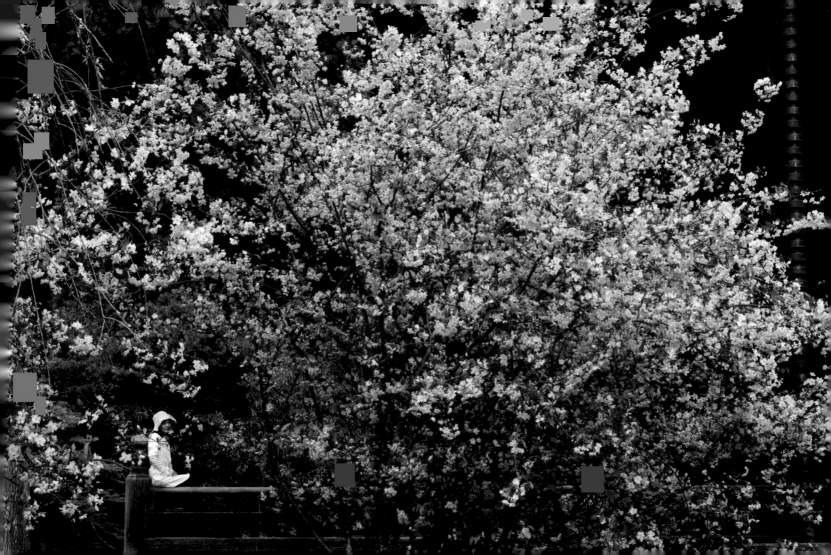

Beauty eclipses the moon and shames the flowers.

Wang Shi Fu

A geisha celebrating Jidai Matsuri, the festival of past eras in Kyoto, Japan.

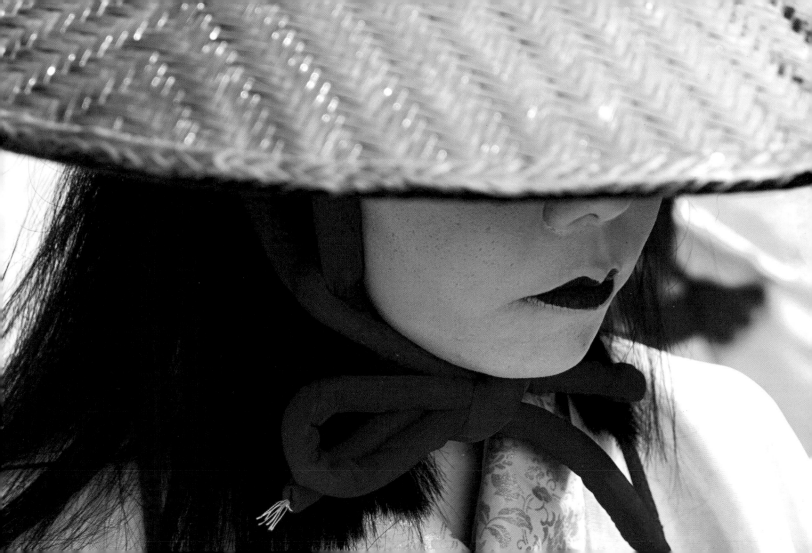

Know the male
but keep to the female,
become the Valley of the World.
To be the Valley of the World
is to be one with unchanging virtue,
it is to become a little child once more.

Lao-tzu

Tharistree Thangmangmee, a traditional dancer, performs the gesture of respect for those who are to be honoured, Thailand.

We shape clay to make a pot
But without the emptiness inside
What use would it be?

We create doors and windows
To make a room
But only the space inside makes it useful.

Living beings create phenomena
But without emptiness, they cannot be used.

Lao-tzu

A monk beats the drum to announce a religious ceremony in the Buddhist temple of Haeinsa,
one of the three Jewel Temples of Korea, on Mount Kaya, South Korea.

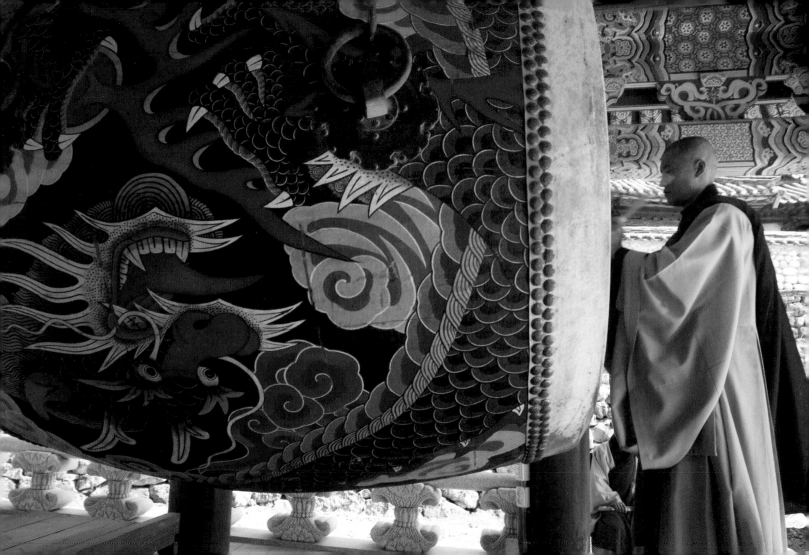

Great fullness is like emptiness:

it is inexhaustible.

Lao-tzu

The gardens of the temple of Rengejoin, an important centre of spiritual life, Koyasan, Japan.

Calm is the basis of right perception and understanding.

Calm is strength.

Thich Nhat Hanh

Shin Yay Wata, aged 19, a monk in the monastery of Nat Htaung Tike, Myanmar.

Like still water reflects the world,

the tranquil mind of the wise man is the mirror of the universe.

Chuang-tzu

Three monks on the Terrace of Elephants in Angkor, Cambodia.

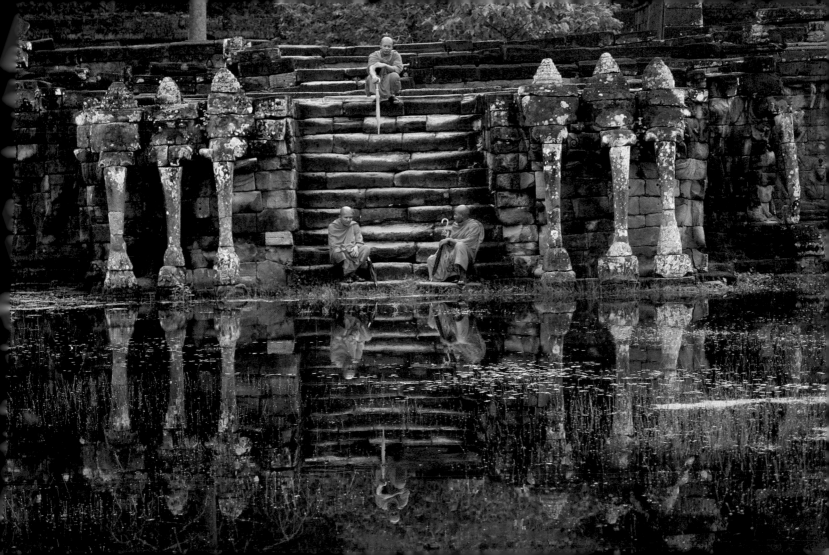

The old pine tree teaches wisdom
and the cry of the wild bird expresses truth.

Zen koan

Bonsai trees in the gardens of the Zhu family, constructed at the end of the 19th century in Jianshu, Yunnan province, China.

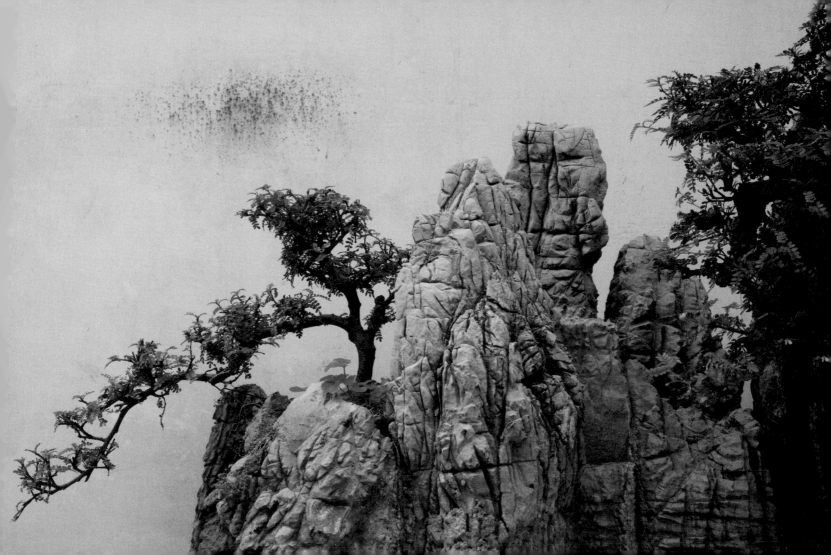

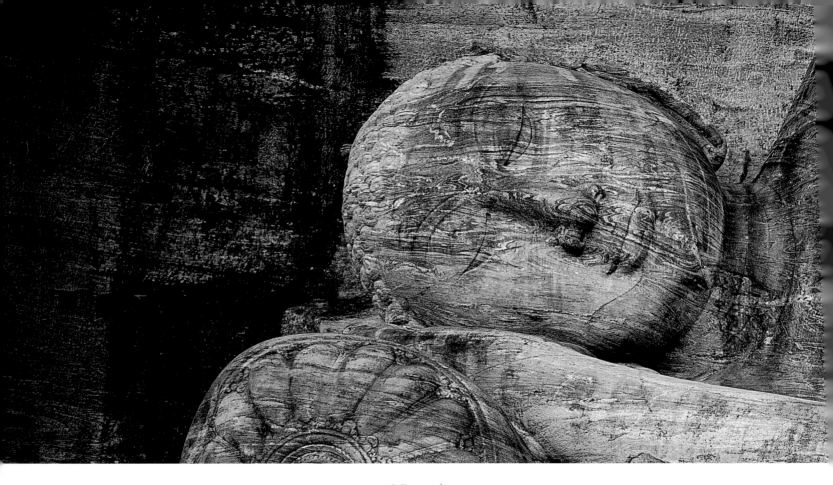

8 December

Serenity means the serenity with which you hold your place.

Tseng-tzu

The wind blows, calms, ceases.

The birds sing.

In the deep mountain valley

A flower falls.

The mountain is more peaceful still.

Keizan Zenji

The ornamental lake at the temple of Hokokuji in Kamakura, with blossoms falling from the cherry trees, Japan.
Previous pages: The reclining Buddha of Gal Vihara, the Temple of the Rock, built near the ancient capital Polonnaruva
when it was at its peak at the end of the 12th century, Sri Lanka.

Rest leads to emptiness,

an emptiness that is fullness,

a fullness that is completeness.

This emptiness gives the soul a tranquillity

that makes all actions effective.

Chuang-tzu

A woman selling incense and offerings at the temple of Angkor Wat, Cambodia.

Everything, in silence, seems to await

An ending. I feel

That nature is, more than I, serious.

The mountains hold

A melody: your own.

Your melody is in the wind.

Oh, the sound of the flute of memory.

François Cheng

A flowering cherry in the gardens of the Zhu family, built at the end of the 19th century, in Jianshu, Yunnan province, China.

In my green hermitage,

sitting or standing,

this is my only prayer:

let all beings pass before me.

Dogen Zenji

In the Cao Dai temple of Tay Ninh, the faithful practise a universal religion
that combines Buddhism, Confucianism, Taoism, Christianity and Islam, Vietnam.

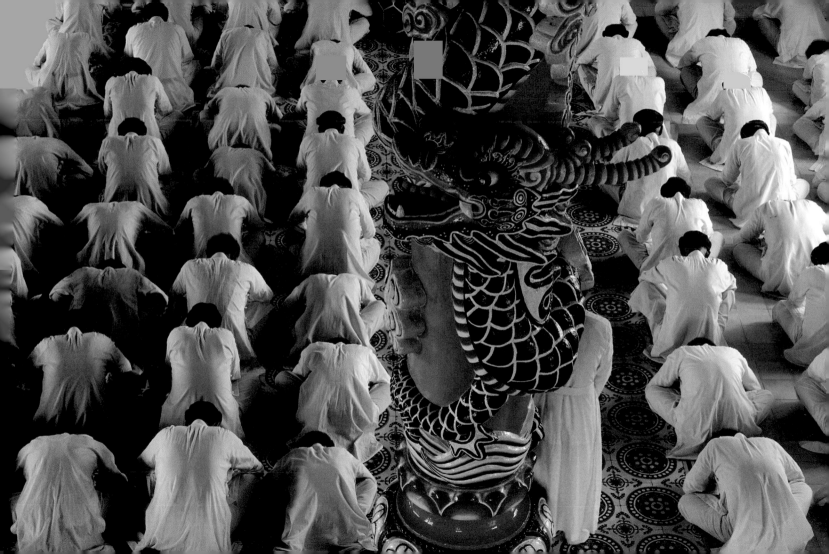

A bodhisattva is a being composed of two apparently contradictory forces:*

wisdom and compassion.

In his wisdom, he sees no people.

In his compassion, he is resolved to save them before himself.

Master Taisen Deshimaru

** An enlightened being.*

Dusk on the slopes of Kangla Gachu, at 6,000 metres (19,700 ft), a sacred mountain in Bhutan.

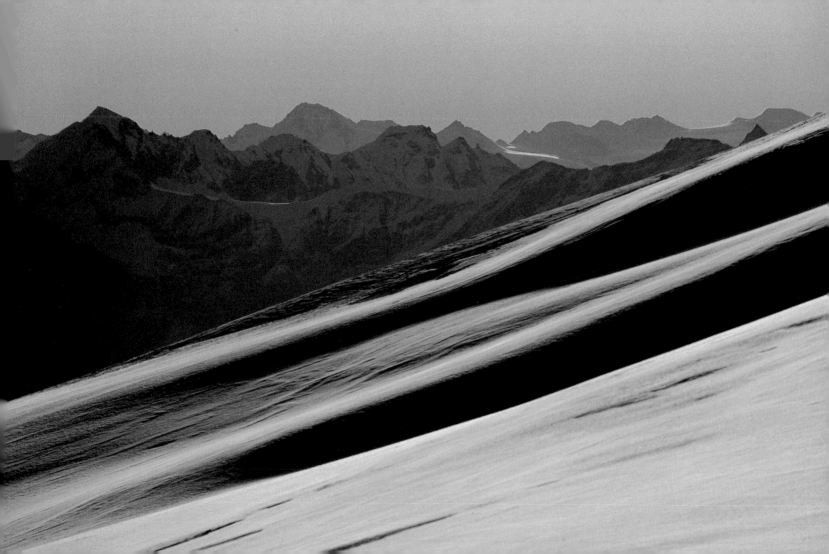

Wisdom is not only realization of the self,
it is also the best way to demonstrate the love of humanity.

Tseng-tzu

Thongbay, aged 17, at the temple of That Luang in Vientiane, Laos.

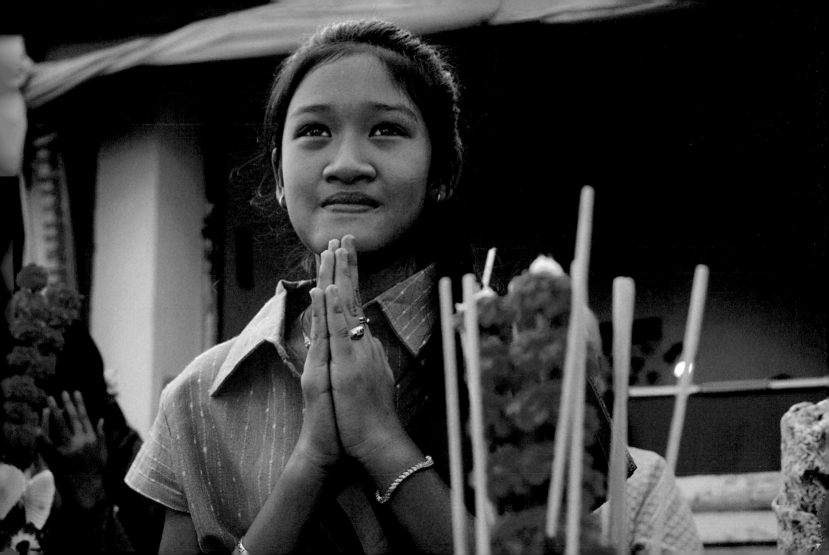

Have pity for the overturned tortoise and feed the sick sparrow.

When you look at the overturned tortoise and the sick sparrow,

do what is needed with only the desire to do good for your fellow beings

without expecting any reward.

Dogen Zenji

Bronze moulding on the bell of the Buddhist temple of Haeinsa, one of the three Jewel Temples of Korea, built in the 19th century on Mount Kaya, South Korea.

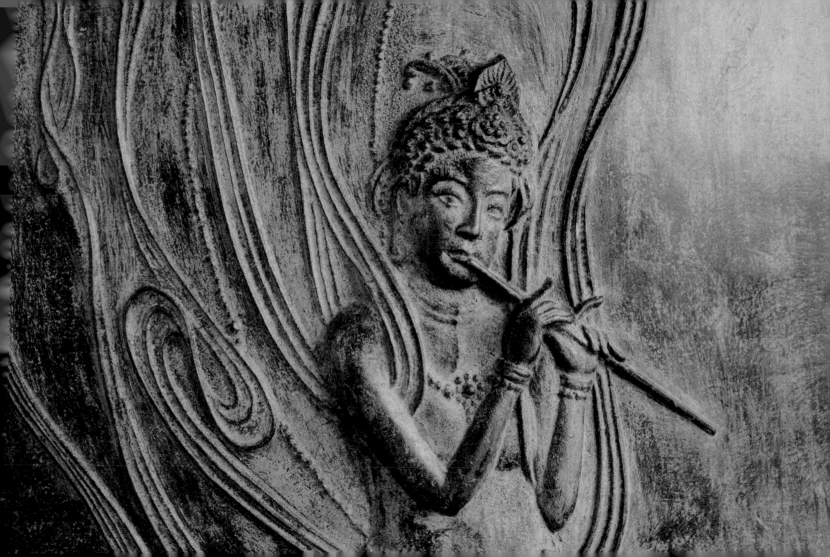

If we consider all lives as equal,

we return to our original nature.

Master Taisen Deshimaru

A woman meditates at the Shwedagon pagoda of peace,
the most venerated Buddhist shrine in Myanmar, built a century after the birth of the Buddha.

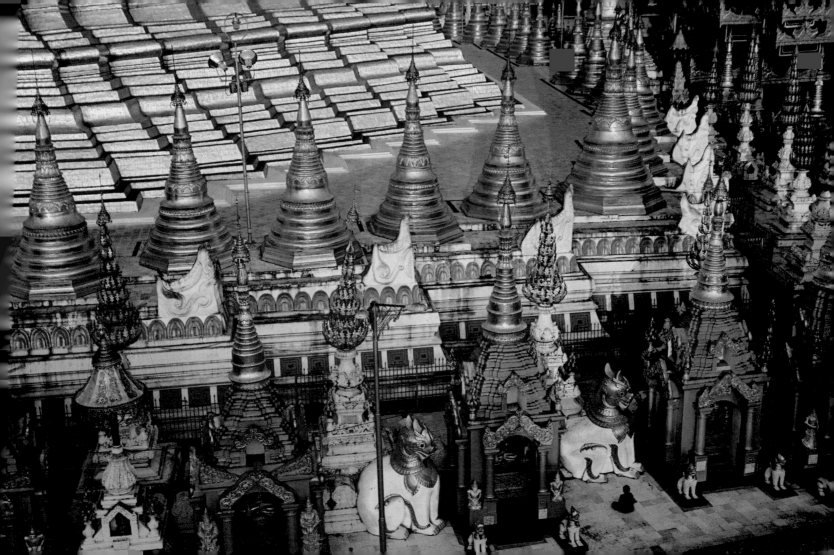

Love the beings of the world equally and universally.

The universe is One.

Chuang-tzu

A boatman watches the ducks on Lake Taungthaman, Myanmar.

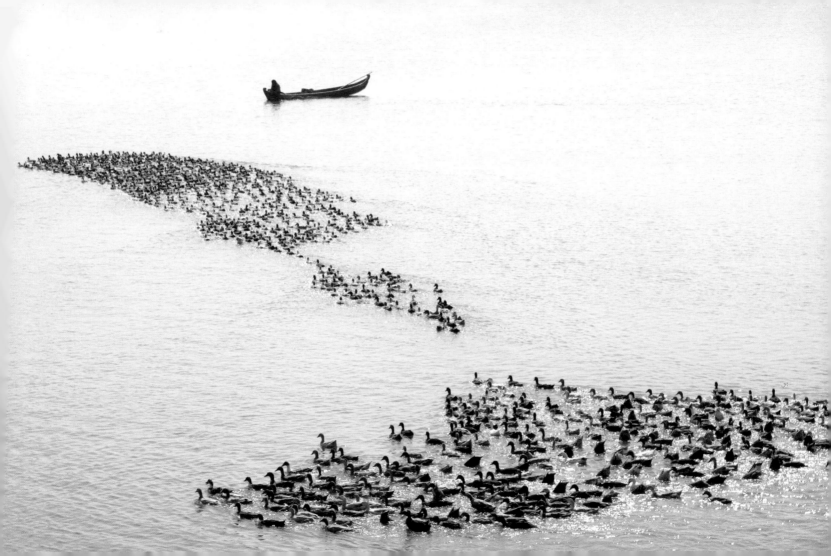

What all eyes see,
what all hands point to,
also demands great attention.

Zen practice

A Hani baby awakens from a nap, wrapped in the shawl on its mother's back. Yunnan province, China.

True freedom exists in our minds, beyond God or Buddha.

In every moment, true wisdom must be freshly created.

Master Taisen Deshimaru

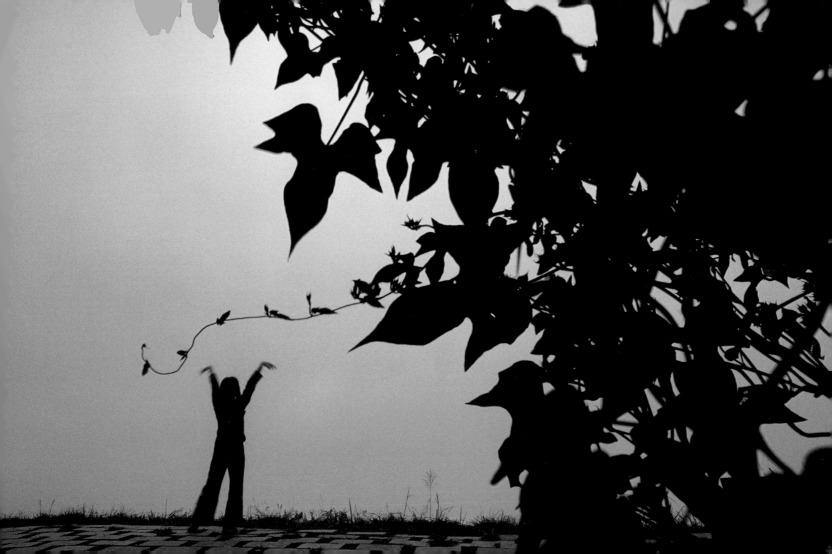

I breathe in, and I am the flower.
I breathe out, and I have its freshness.

Zen meditation

Geisha costume for the festival of Jidai Matsuri, Kyoto, Japan.

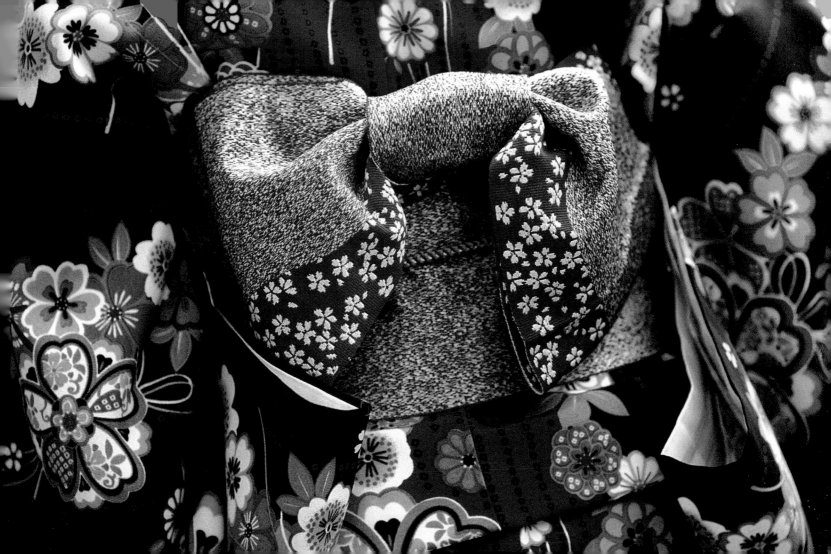

Our true home is in the now.

To live in the present moment is a miracle.

Thich Nhat Hanh

Two girls play on a swing – a popular pastime among the Akha people in the region of Chiang Rai, Thailand.

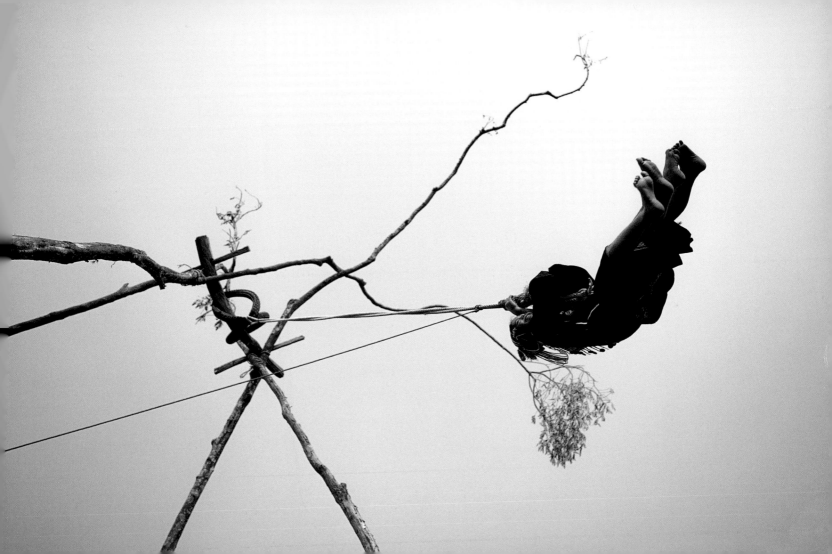

In the amber liquid that fills the ivory porcelain,

the initiate can taste at the same time

the exquisite restraint of Confucius, the spice of Lao-tzu

and the ethereal scent of Buddha Shakyamuni himself.

Okakura Kakuzo

Inside one of the many teahouses along the canal in the village of Jinchi, China.

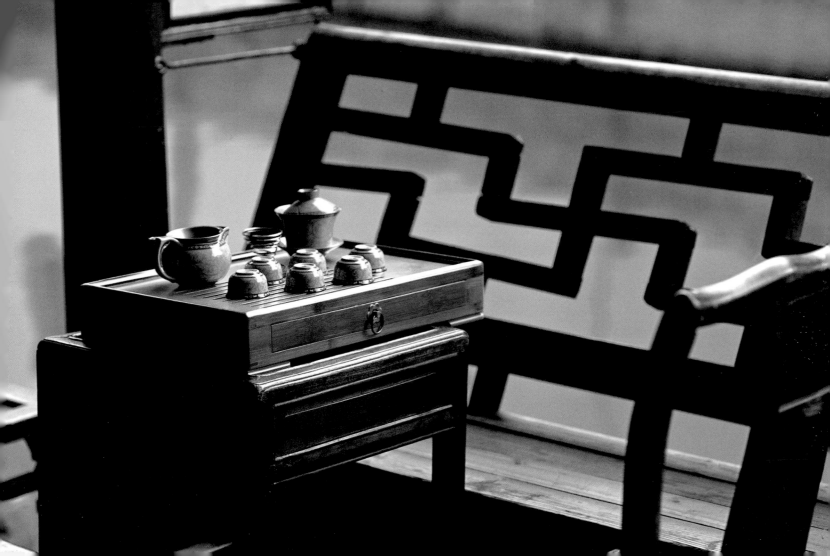

Think of the places where you plant your feet.

Inscription on the door of Zen dojos

Koyasan, the centre of the Shingon school of esoteric Buddhism established in 816 by Kukai, who was renamed Kobo Daishi after his death. Japan.

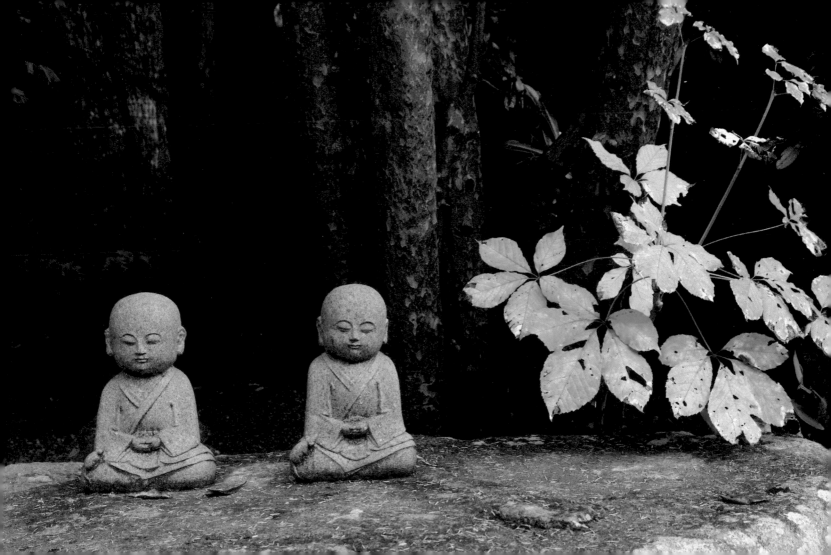

Art and life are one.

François Cheng

A performer has his lunch during the festival of Jidai Matsuri, Kyoto, Japan.

The full moon on the longest night
On the red leaves of autumn
The first snow
How can one not be tempted
To commemorate this?

Dogen Zenji

The northern side of a valley, at the foot of the mountain Jhomolhari, is covered with frost. Bhutan.

Absolute principles remain unformulated.

Chuang-tzu

Shin Nya Na, a 7-year-old novice monk, at Sagaing, a major Buddhist centre in Myanmar.

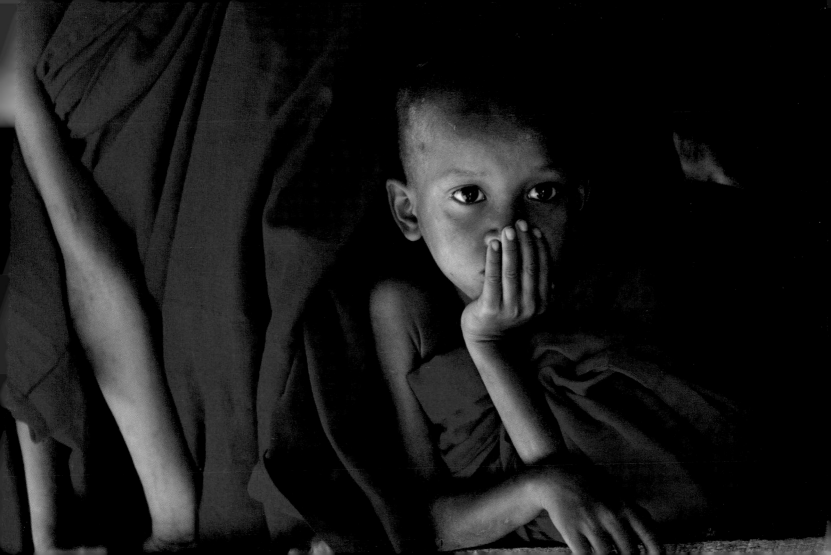

The One itself is everything.

All things themselves are One.

Master Taisen Deshimaru

In northern Tibet at 3,200 metres (10,500 ft), Lake Kokonor is one of the largest in Asia.

Silence
more powerful than a hundred thousand thunderbolts
rolling together in the sky.
Beyond all categories,
holding all silences,
alone and unique,
eternal silence.

Master Taisen Deshimaru

Borobudur is a place of worship and pilgrimage, constructed in around the 9th century, and it is the largest Buddhist monument as well as a wonder of the world. Indonesia.

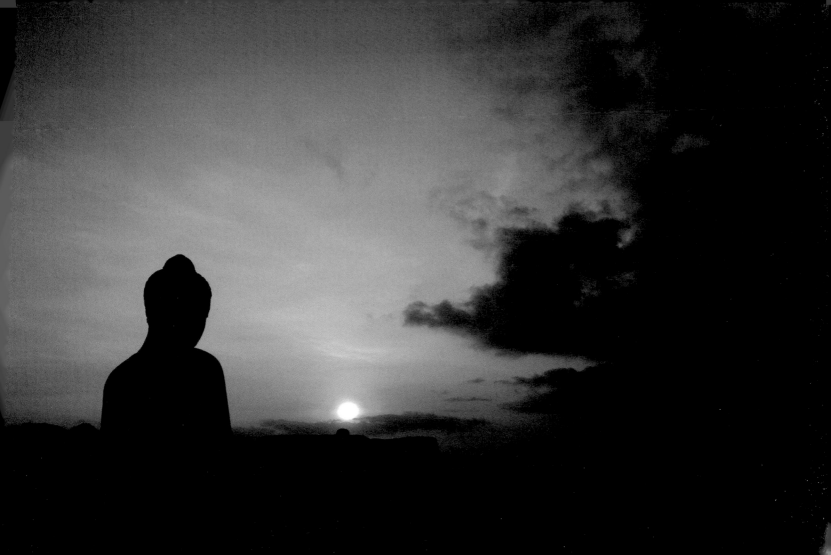

As the Way is circular, it has no beginning and no ending.

As it has no beginning and no ending, it is unlimited and infinite.

As it is unlimited, it has no roots and no branches.

Having no limits, it is neither wide nor narrow,

with no concept of movement, pause, forwards, backwards, exterior or interior.

It is identical, with no changing features and no different faces.

It is emptiness.

Master Taisen Deshimaru

Remember to take the journey step by step, moment by moment.

There are no shortcuts.

Steve DeMasco, Kung Fu Master

Shin Yay Wata, aged 19, a monk at the monastery of Nat Htaung Tike, Myanmar.
Overleaf: A row of *chortens* (Tibetan Buddhist stupas) facing the sacred mountain of Kawagebu, 6,740 metres (22,100 ft), China.

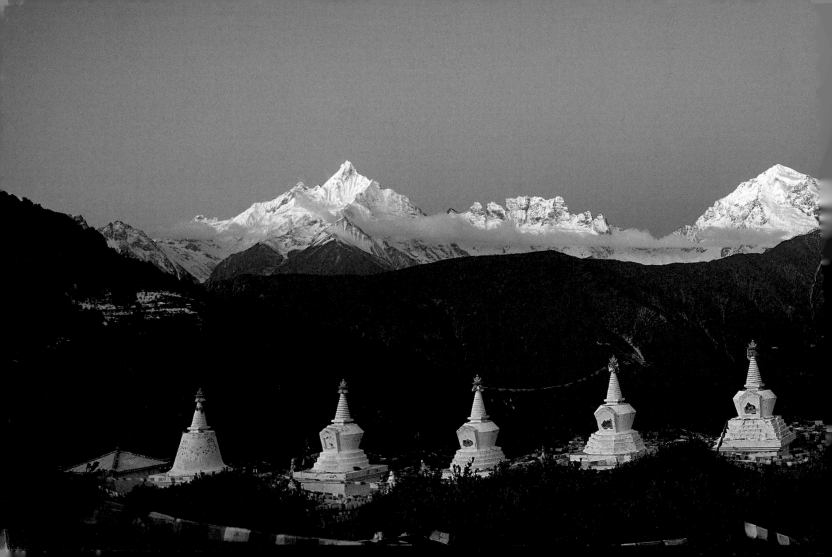

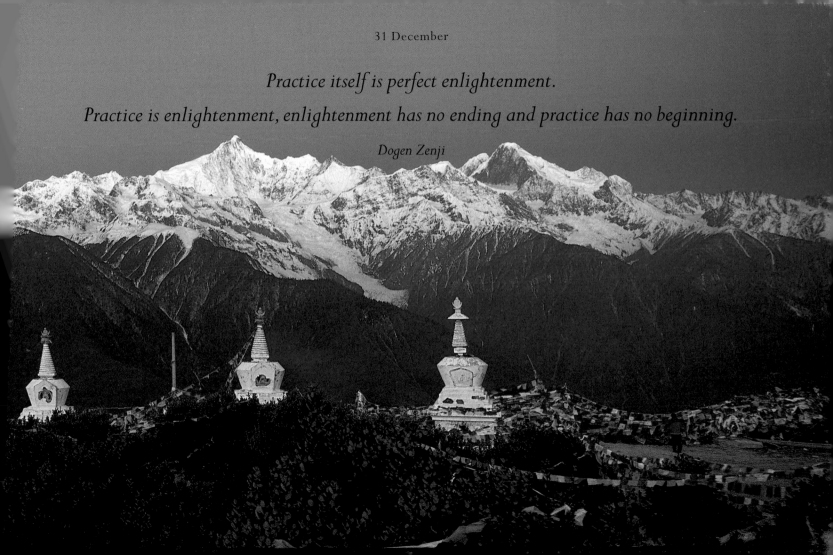

31 December

Practice itself is perfect enlightenment.

Practice is enlightenment, enlightenment has no ending and practice has no beginning.

Dogen Zenji

About the Authors

Danielle Pons-Föllmi is an anaesthetist from Latin America. Having lived there, travelled extensively in Europe, and adopted children in Asia, she speaks six different languages. Her open-mindedness and knowledge of all the continents have greatly helped in her work with academics and literary teams on the Offerings for Humanity project. Through the charity organization HOPE, which she created with Oliver Föllmi, she supports educational projects and aid programmes for villages all over the world: **www.hope-organisation.com**.

Of Latin and German descent, the photographer **Olivier Föllmi** was born in 1958. From the age of 18, he developed a passion for the Himalayas, where he lived for twenty years. Since 2003, he has travelled the world with his assistants, seeking to capture the souls of nations through his photography for the Offerings for Humanity project. Further details about his achievements, projects and ideas on photography are to be found at: **www.olivier-follmi.com**.

The venerable **Ajahn Chah Subhatto** (1918–92) was one of the great 20th-century masters of meditation. Famous for his informal, direct style, he had great influence on Theravada Buddhism. Ajahn Chah was one of the best-known monks in the Thai tradition of Theravada, and founded several monasteries, including Wat Nong Pah Pong and Wat Pah Nanachat. He never wrote any texts himself, but his teachings have been recorded, translated and published. A million people attended his funeral in 1992, including the royal family of Thailand.

Ananda W. P. Guruge is Sri Lanka's permanent ambassador to UNESCO.

Aung San Suu Kyi was born on 19 June 1945 in Rangoon, Myanmar (formerly Burma). She embodies Burmese opposition to the military dictatorship, and became world famous when she was awarded the Nobel Peace Prize in 1991 for her non-violent resistance. She is Secretary General of the National League for Democracy (NLD), which opposes the current dictatorship. She is now unable to take part in any political activities because she has been placed under house arrest by the military junta.

François Beyens is a doctor, acupuncturist, writer and teacher, who travels the world promoting and championing acupuncture at conferences, meetings and seminars. Baron Beyens is President of the Centre d'Études de Médicine Chinoise et d'Acupuncture.

The title of **Buddha** (a Sanskrit word meaning 'enlightened one') denotes someone who has attained enlightenment and entered Nirvana, the state of existence that ends the cycle of birth and rebirth. There have been several Buddhas, the most famous of them all being the founder of Buddhism, Siddhartha Gautama, who lived in the north of India during the 6th century BC.

Buddhadasa Bhikkhu (1906–93) was a Thai monk in the Theravada tradition of Buddhism, and he was one of the first to promote mutual understanding between religions. The emphasis he placed on the interdependence of all things made him a precursor of modern ecology and an apostle of peace between nations. His writings, which have been translated and published in many different languages, have had a considerable influence on the revitalization of Buddhist thought.

François Cheng was born in Nanchang, China, in 1929. Member of a literary family, he is an academician and Sinologist, and has written a number of major books on the art and poetry of China. In 2001, he was awarded the Grand Prix de la Francophonie by the Académie Française for his life's work.

Chuang-tzu was one of the great Chinese Taoist thinkers who lived during the era of Warring States, around the 4th century BC. The central concept of his philosophy was the Tao, which may be defined as the natural and spontaneous course of things. Using parables and stories, allegories and paradoxes, his writings laid out what were to become the foundations of the Taoist school.

Philosopher, teacher and government minister, **Confucius** (551–479 BC) is one of the greatest figures in Chinese history, and was the founder of the feudal educational system. In antiquity, he was regarded as the 'first of the sages' and the 'model for ten thousand generations'. His sayings were first collected around 400 BC, and this body of writings had a massive and lasting influence on Chinese society. His teachings led to Confucianism, the political and social doctrine that shaped ancient China.

Steve DeMasco came from humble beginnings, having been raised in Harlem by a violent father and disabled mother. At an early age, he discovered the philosophy of the Shaolin monks, and this helped him to survive and flourish. He has followed the path of Shaolin, but has adapted its teachings to the modern world, describing ten secrets of survival to help people live a more fulfilled life. Steve DeMasco is also a 10th degree black belt in Shaolin Kempo. He has devoted his life to helping prisoners, young people and victims of domestic violence, and lives in New Hampshire with his wife and three sons.

The Zen Dojo in Paris was founded in 1971 by Master **Taisen Deshimaru**, and it was officially recognized as a temple by the Japanese Zen authorities in 1974. Master Deshimaru, in the company of most of his closest disciples, taught there every day until his death in 1982. His sutra of perfect enlightenment describes Buddhist 'enlightenment' and the different methods of achieving this, whether swift or gradual. This has had considerable influence in China as well as in Korea and Japan.

Hubert Durt has lived in Japan since 1961 and is an expert on sociocultural aspects of classical Buddhism. He is an associate of the École Française d'Extrême-Orient (EFEO) and teaches in Tokyo at the International College of Postgraduate Buddhist Studies.

Dogen Zenji (1200–53) was born in Uji, near Kyoto, and was one of the great figures of Zen Buddhism, which he established in Japan. During the 13th century, it was he who disseminated the spirit and practices of Chinese Ch'an, and he prescribed various activities for temple life. One of his most important texts is called the *Tenzo Kyokun*.

Jigmé Douche is French and was born in 1957. He has practised the art of the brush for thirty years. He first trained in Latin alphabets in paleography and calligraphy, and produced a translation of the *I Ching*. He then studied Tibetan and Indian scripts, those of the Silk Road and of China. Relationships lie at the heart of his interests because they unite past and present, study and practice, translation and culture.

Han Fei Zi was a Chinese philosopher and political thinker, who died in 233 BC. He argued that order and prosperity could only be achieved through a strong state, based on very strict laws and not on morality or understanding.

Nan Huai Chin was born in 1918 in the Wenzhou region of China, where he received a traditional literary education. As a youth, he learned the martial arts. A gifted poet and calligrapher, he is also interested in traditional Chinese medicine.

Meng Jiao (751–814), a Chinese poet, belonged to a circle of intellectuals who gathered round the author and poet Han Yu (768–824).

Okakura Kakuzo (1862–1913) devoted his life to teaching, art, Zen and the preservation of Japanese art and culture. He worked as an ambassador, teacher and writer. At the time of his death, he was curator of Chinese and Japanese art at the Museum of Fine Arts in Boston.

The fourth successor to Dogen, the Japanese **Keizan Zenji** (1264–1325) created the second great temple in Japan, the Soji-ji. Keizan was the author of several works, most notably *Three Kinds of Zen Practitioners*, *Notes on Mindfulness in Zazen*, and *A Record of the Transmission of Luminosity*.

Japanese poet and author of haiku, Master **Issa Kobayashi** (1763–1828), whose real name was Kobayashi Nobuyuki (alias Yataro in his youth), was a member of the Katsushika haiku school. He later became a monk and adopted the name of Haikai-je Nyudu Issa ba – 'lay monk of the Temple of Haikai'. His haiku are characterized by an attractive combination of humour and compassion.

Lao-tzu (570–490 BC) was born in China some 2,500 years ago. He was the founder of Taoism, and lived at more or less the same time as Confucius and Buddha. These were the originators of the three major religions in China. There is very little reliable information about him, but that which we do have has come down to us through the biography written by Szu-ma Tsien several centuries after his death. Lao-tzu was an archivist and astronomer at the court of the Zhou. He wrote the *Tao Te Ching*, the 'Book of the Way and Virtue', a great philosophical treatise. Later he was associated with Taoism. The Tao, or the Way, is a complex principle that defies articulation since it is a transcendent reality that predates the universe. It is the energy from which all the energies of the invisible world spring.

A specialist in ancient China, **Jean Lévi** has published numerous essays on Taoism and popular Chinese religion, as well as translations of the great Chinese classics. He is also a novelist, author of *Le grand empereur et ses automates*, winner of the Prix Goncourt for historical novels, and *Le coup du Hibou*.

Lieh-tzu was the author of the *Chung-hsu chen-ching*, which may be translated as the 'True Classic of the Perfect Void'. This title dates only from AD 732, and was given as an imperial honour, fixing it for ever in this form.

Feng Menglong (1574–1645) was a Chinese author at the end of the Ming Dynasty. An open-minded but also critical writer, he compiled three collections of narratives in the vernacular as well as popular songs.

The Tibetan poet **Milarepa** (1040–1123) was a spiritual teacher, whose career was quite unique. Initially trained in the practice of the Bön faith, to perform black magic and to avenge his family at the behest of his mother, he completely changed direction and studied Tantric Buddhism under the great Tibetan teacher and yogi Marpa (1012–96). After passing many tests in order to make amends for his past actions, he was initiated into different forms of instruction and retired to the mountains, where he was able to meditate and to compose 'the hundred thousand songs'.

Pu Yen-T'u is a Chinese theorist who specializes in 18th-century art from the Qing Dynasty (1644–1911).

A samurai warrior in the Tokugawa army, **Shosan Suzuki** (1579–1655) became a Zen monk at the age of 42 and was later recognized as a spiritual Grand Master. Profoundly influenced by his military past, he was a forceful advocate of intense Buddhist practice, full of 'living energy', 'free and unrestricted'. Shosan favoured Zen practices close to those of daily life, to allow a synergy between action and meditation.

Shunryu Suzuki, from the line of Soto Zen, is a direct spiritual descendant of the great Dogen. In 1958, having already become a Zen Master highly respected in Japan, he settled in San Francisco. He is one of the most influential Zen masters of modern times, and was the driving force behind the foundation of seven meditation centres in the U.S.

A Buddhist master who was born in Vietnam in 1926, **Thich Nhat Han** is a Zen Master, poet and peace campaigner. In 1967, he was nominated for the Nobel Peace Prize by Martin Luther King Jr, and led the Vietnamese delegation during the peace talks in Paris. Advocate of a socially engaged form of Buddhism, Thich Nhat Han teaches the art of mindfulness integrated into daily life.

Kenji Tokitsu was born in 1947, graduated from Hitotsubashi University in Tokyo, took a doctorate in sociology at the University of Paris, and is also a master of karate and t'ai chi ch'uan. Since 1971 he has lived in Paris, where he teaches the martial arts.

Chögyam Trungpa (1939–87) was one of the most dynamic Buddhist teachers of the 20th century. He did pioneering work in bringing Tibetan Buddhist teachings to the West and adapting them to everyday life. He founded the Naropa Institute and the programme of Shambhala Training in the U.S.

Cheng Tsao was an 8th-century Chinese painter.

Tseng-tzu was a disciple of Confucius and wrote *The Great Learning*, which for nearly a thousand years was regarded by leading scholars as the 'gateway to wisdom'. It describes the eight rungs on the ladder of wisdom.

Sun Tzu (6th century BC) was a Chinese general, who wrote a famous work called *The Art of War*. Although it is now over 2,500 years old, this book is still in use for study and reference.

Cao Xue Qin or Cao Xueqin (1715–63) was one of the finest Chinese writers of the Qing Dynasty (1644–1911). Descended from an important family that had fallen out of favour, he wrote a great novel entitled *The Dream of the Red Chamber*, which remained unfinished and was published several years after his death.

Yoshida Kenko (1283–1350) was a Japanese author and Buddhist monk. He is also known under the name Urabe Kenko. His most famous work was *Tsurezuregusa* (The Hours of Idleness), one of the most important books in medieval Japanese literature written during the Muromachi and Kamakura eras.

Chao Yong (1011–77) was a Chinese philosopher.

Han Yu (768–824) was a Chinese poet, though he was best known for his essays, some of which despite their moral content are by no means lacking in humour. In these essays, he attacked Buddhism and Taoism, both of which he considered to be subversive.

Meng Zi was a Chinese thinker who lived around 380–289 BC. He is said to have studied under a disciple of Zisi, Confucius's grandson. During his travels across the chaotic China of the Warring States, in search of a wise king capable of restoring peace, he met a large number of princes and recorded his interviews with them in the book that bears his name, the *Mencius*, one of the Four Books which, together with the Five Canons, form the neo-Confucianist corpus.

Mo Zi (470–391 BC) was a Chinese philosopher, also known as Master Mo. He created his own school of thought, which argued against Taoism and Confucianism.

Hong Zicheng (1593–1665) was a 17th-century Chinese master from Sichuan, who wrote a famous treatise called *Vegetable Roots Discourse*.

Calligraphy by Ta Thuy Chi using the ancient Vietnamese writing system:

3 January: meaning Prosperity • 5 March: meaning Peace • 14 March: meaning Love

26 April: meaning Patience • 2 June: meaning Happiness • 25 September: meaning Mind

7 December: meaning Longevity

Bibliography

AUNG SAN SUU KYI, *Nationalisme et littérature en Birmanie,* © Editions Olizane, 1996: 15 May.

BASHO, ISSA, BUSON, SHIKI AND TAIGI, *Les grands maîtres du Haïku,* © Editions Dervy, 2003: 17 August; 23 September.

BUDDHA, *Paroles du Bouddha,* © Editions Albin Michel, 1993: 25 September.

BUDDHADASA BIKKHU, *Handbook for Mankind,* 1996, published for free distribution: 28, 30 July; 4 August.

FRANÇOIS CHENG, *Entre source et nuage,* © Editions Albin Michel, 2002: 25 August; 17 November; 11, 20 December.

FRANÇOIS CHENG, *Le dialogue,* © Desclée de Brouwer, 2002: 13 November.

FRANÇOIS CHENG, *Vide et plein, Le langage pictural chinois,* © Editions du Seuil, 1991: 10 January; 13 February; 1 July; 8, 11 September; 25 November; 4, 24 December.

FRANÇOIS CHENG, 'Les tribulations d'un Chinois en France', *Lire,* April 2004, © François Cheng/ Lire/ April 2004: 24 June; 10 November.

FRANÇOIS CHENG, 'Pour les Chinois, la ligne de vie est une courbe', *Télerama* no. 2704, November 2001, p. 76: 15 June.

CHUANG-TZU, *Œuvre complète,* translation foreword and notes by Liou Kia-hway, © Editions Gallimard/UNESCO, 1969: 1, 15 January; 5, 20, 27 February; 6, 8, 16, 19, 21, 29 March; 4, 6, 10, 11, 12 April; 1, 9, 12, 24, 26, 27 May; 4, 7, 8, 12, 25 June; 18 July; 7, 10, 14, 20, 21, 23, 24, 30 August; 19, 28 September; 6 October; 9 November; 10, 17 December.

THOMAS CLEARY, *La voie du Samouraï, Pratiques de la stratégie au Japon,* © Editions du Seuil, 1992: 22 March; 3 May; 18 August; 1, 3 September; 21 October; 22 November.

CONFUCIUS, *Entretiens,* introduction and notes by Pierre Ryckmans, © Editions Gallimard, 1987: 20, 22 January; 19, 22 February; 20 July; 16 September; 28, 30 October; 11 November.

STEVE DeMASCO, *The Shaolin Way,* HarperCollins, © Steve DeMasco, 2005: 18 March; 30 April; 4, 5, 7 May; 17 June; 3, 5, 6, 8, 9, 12 July; 4, 10, 14, 17, 19, 20 October; 19 November; 30 December.

TAISEN DESHIMARU, *L'esprit du Ch'an,* © Editions Albin Michel, 2000: inside back cover; 23, 24, 25 January; 1, 14, 15, 17 February; 20, 24, 25, 30, 31 March; 1, 2, 5, 9, 16, 28 April; 6, 21, 23, 29 May; 9 June; 24, 25, 27 July; 27, 28, 31 August; 15, 27 September; 9, 16, 27, 28, 29 December.

DOGEN ZENJI, *La vraie Loi, Trésor de l'Oeil,* © Editions du Seuil, 2004: 3, 7 April; 10 May; 27 June; 14, 30 September; 25 October; 15 December.

DOGEN ZENJI, *Polir la lune et labourer les nuages,* © Editions Albin Michel, 1998: 12 October; 25 December.

DOGEN ZENJI, *Le trésor du Zen,* commentary by Taisen Deshimaru, © Editions Albin Michel, 2003: 6, 7, 9, 13, 14 January; 10, 16 February; 28 March; 15 April; 5, 11 June; 13, 16, 23 July; 29 August; 10, 13, 21, 26 September; 9 October; 16, 23, 24 November; 12, 13, 19, 23, 31 December.

BERNARD DUCOURANT, *Sentences et proverbes de la sagesse chinoise,* © Editions Albin Michel, 1998: 18 February.

LAO-TZU, *Tao te king,* © Editions Albin Michel, 1984: 11 March; 19 April; 11, 16, 31 May; 3, 29 June; 22, 31 July; 3, 5, 6, 15 August; 26 October; 27 November; 3 December.

LAO-TZU, *La voie et sa vertu Tao-tê-king,* © Editions du Seuil, 1979: 8 January; 6, 9, 28 February; 4, 5, 10, 23 March; 17, 21, 26, 29 April; 2, 10, 26, 30 June; 26 July; 19 August; 7, 13, 22 October; 12, 30 November; 2 December.

FRÉDÉRIC LENOIR AND YSÉ TARDAN-MASQUELIER, *Le livre des Sagesses,* © Editions Bayard, 2005: 27 April.

JEAN LÉVI, *Confucius,* © Editions Flammarion, 2003: inside front cover; 16, 28 January; 4 February; 12 March.

LIEH-TZU, *Le vrai classique du vide parfait,* © Editions Gallimard/UNESCO, 1961: 12 January.

MILAREPA, *Œuvres complètes,* © Librairie Arthème Fayard, 2006: 11 January.

KAKUZO OKAKURA, *Le livre du thé,* © Editions Philippe Picquier, 2006: 1 March; 16 June; 14 July; 1 October; 22 December.

ERIK PIGANI, *Soyez Zen,* © Presses du Châtelet, 2007: 7 July; 13 August.

ISABELLE ROBINET, *Comprendre le Tao,* © Editions Bayard, 2002: 5 January; 26, 27 March; 24, 25 April; 20 May; 19, 21 July; 18 September.

EVELYN DE SMEDT, *La lumière du Satori,* © Editions Albin Michel, 1999: 2 August; 2 September; 26 November.

SOFIA STRIL-REVER, *L'initiation de Kalachakra,* © Desclée de Brouwer, 2002: 9 March.

SOFIA STRIL-REVER, *Enfants du Tibet: de cœur à cœur avec Jetsun Pema et Sœur Emmanuelle,* © Desclée de Brouwer, 2000: 31 October.

SHUNRYU SUZUKI, *Esprit Zen, esprit neuf,* © Editions du Seuil, 1977: 29 January; 1 August.

THICH NHAT HANH, *La plénitude de l'instant, Vivre en pleine conscience,* © Editions Dangles, 1994: 2 February; 20 June; 6, 8, 18 November; 5, 21 December.

THICH NHAT HANH, *Taming the Tiger Within,* Riverhead Books, © Unified Buddhist Church, 2004: 17 May; 1, 4, 5 November.

THICH NHAT HANH, *Transformation et guérison,* © Editions Albin Michel, 1999: 31 January; 2, 19 May; 6 June; 22 September; 7 November.

KENJI TOKITSU, *La voie du karaté, Pour une théorie des arts martiaux japonais,* © Editions du Seuil, 1979: 13 March; 11 August; 5 October.

CHÖGYAM TRUNGPA, *Shambhala, La voie sacrée du guerrier,* © Editions du Seuil, 1990: 17, 19 January; 24 February, 18 May; 19 June; 15, 17 July; 6, 12, 29 September; 3, 11, 18, 23, 24, 27 October; 3, 15 November.

CHÖGYAM TRUNGPA, *Dharma et créativité,* © Guy Trédaniel Editeur, 1999: 2 November.

TSENG-TZU, *La grande étude,* © Editions du Cerf. 1984: 21 January; 3, 7 March; 23 April; 21 June; 11 July; 17, 24 September; 2, 15 October; 8, 14 December.

SUN TZU, *L'art de la guerre (The Art of War),* translation and notes by Jean Lévi, © Editions Hachette Littératures, 2000: 14, 15 March.

MARC VERIN AND JULIETTE MORILLOT, *La Corée, terre des esprits,* © Editions Hermé, 2003: 26 August.

ALAN WATTS, *L'esprit du Zen,* © Éditions Dangles, 1976: 22 April; 4, 9 September; 7 December.

HONG ZICHENG, *Propos sur la racine des légumes,*
© Editions Zulma, 2002: 18 April; 8, 25, 30 May; 1,
14 June; 4, 29 July; 9 August; 20 September.

CENTRE D'ÉTUDES DHARMIQUES DE GRETZ,
Dhammapada: Les dits du Bouddha, © Editions Albin
Michel, 1993: 14 May.

LE LIVRE DE LA SAGESSE DE CONFUCIUS, translation and
introduction by Eulalie Steens, © Editions du Rocher,
1996: 20 April; 8 October.

MAXI PROVERBES CHINOIS, compiled by Patrice Serres,
© Presse du Châtelet, 1999: 3, 4 January; 7, 8, 21, 23,
25 February; 28 May; 13 June; 2 July; 8, 16, 22 August;
5 September; 16, 29 October; 14, 20, 21, 28, 29
November; 1, 6, 18, 26 December.

*PROPOS ET ANECDOTES SUR LA VIE SELON LE TAO, PRÉCÉDÉ
DE JARDIN D'ANECDOTES,* introduction by Jacques
Pimpaneau, © Editions Philippe Picquier, 2002:
17 March.

Acknowledgments

We were fortunate that our paths crossed with so many kind and generous people who helped us with this project. We would like to dedicate any merit that was earned by this book to the following:

IN ASIA

Cambodia

Khon Sakhoeun, Seng Samoeurn and Yorn Malay, monks in Siem Reap.

China

Master Nan Huai Chin, for his trust in us and for contributing the foreword to this book; Yida Wang in Kunming; Laure Raibaut in Beijing; Lan Wang in Shanghai; Jacky Wen Yutao as well as Stary and family in Pugaolaozhai, and to Hu Shi Zhong and Tang, Zhu Nan and Liu Feng for their help; Lin Ke Zi and family in Xingping; Duji Kanzhu and family in Yongzhe; Anwularong and Kesang Gerongpichu in Zhongdian; Dakpa Zhabagedan and Khampa Caravan in Zhongdian.

Japan

Tokyo: FUJIFILM and Mick Uranaka as well as Shin Yamaguchi from Knock on Wood, Sakata Masako and Amana Images, Kaoru Yunoki, Chie Jo, Hiroyuki Takahashi, Emilie de Cannart, and Ray and Diane Brook for their wise advice. Thanks also to Daniel Blade Olson and Keiko Yamada Olson in Kamakura for their warm welcome and generous help.

Korea

The Venerable Do Young, the Venerable Popchin and the Venerable Kakchong at Haeinsa Buddhist College, and also Kim Ji Yoon for the warm welcome.

Laos

Olivier Planchon, director of the Centre Culturel Français and Emilie Huard, in Vientiane; Virada Sitthisak who opened the doors of Laos for me; Thongdy

Siphanthong, and Tu, Sem and their family in Ban Nong Khiaw; Jason Smith and Joy Ittihepphana; Fabienne and Benoît Ferir-Legrand and their children in Luang Prabang.

Myanmar

Stéphane Dovert, cultural advisor to the French Embassy in Yangon, and his wife Agnès, as well as Wah Wah Tin, Alicia Thouy and Carine Blache. Raymond Imperiali and Massana Sandar Myint and all the team at Kinnari Travels, plus Su Su in Yangon who all made our travels possible, along with Swe Zin Oo, my wonderful guide and interpreter; Phyu Phyu Lin in Bagan; and Maung Maung and his wife.

Singapore

Didier and Marie Claude Millet for their trust and for having got me involved in the project *Thailand: 9 Days in the Kingdom*, and to their marvellous team, including Tanya Asavatesanuphab, Laura Jeanne Global and Melisa Teo.

Thailand

Bangkok: Maha Pinn Bhutawiriyo, monk at the Intra128ram temple for his helpfulness, patience and openness; Laurent Aublin, French Ambassador, and Madame Aublin for their help and advice; Rodolphe Imhoof, Swiss Ambassador, for his warm and enthusiastic welcome; Aruna Adiceam and Rafaël Grynberg at the Centre Culturel Français, for their perseverance in promoting our work; Sitta Wangtarawut, martial arts master, and his student Saeng Sae Kee; Hasachai Boonnueng and Chanpen Boonwiparat; Borpit Nakapiw, Teera Uhpadee, Kamonpan Khonsongsaeng, Kong and Wanchai for their excellent photographic assistance in Chiang Rai; Thiwa Morpoku, Tanachot Uhpadee, Yuphin Saelee, Nattharicha Yoo-luemg, Wannaporn Weerawatpongsatorn, Wasinee Maryoe, Ditpong Maryoe and Panawan Maryoe; Ekaphop Duangkha and Kiattisak Janepaii from the studio Creatimage for their photographic assistance; the team from Nex Studio for photographic assistance; Pimchan Monthawornwang and Tharistree Thangmangmee, wonderful models; Weerachai Saemongkol, Arisara Nammondee, Yawee Koedjuntuek, Wiboon Petritt

and of course Phyu Phyu; Bowki Ithtiraviwongse for the advice; Yvan Van Outrive, Pitipat Srichairat, Korakot Punlopruksa and Am in Bangkok; Wichit Yawichai and his wife in Nan for their support during the project *Thailand: 9 Days in the Kingdom*; Jatupat Sarikaputra for picture advice; Pitiphan Luenganantakul for literary assistance, Boonchai Heng for the original paintings for this book; Bernard Farkas and Henri Sallaz at Objectif; and special thanks to Maythee, Suwanna, Varunee, Pattama and Pimpapa Skaosang in Bangkok, for their trust and friendship.

Vietnam

Christian Chauvreau and his wife Thanh Thuy, and also Thong in Can Tho for showing me the villages of the Mekong Delta; Ven Vân Chiêù in Tri Tôm; Ta Thuy Chi, calligrapher, and Trong Luu, painter, in Hanoi; Anh Tuan in Ho Chi Minh City and Ho Ngoc Anh Tu in Vinh Long; Si in the village of Hau Thao; Ha; Phan Van Anh in the village of Lao Chai; Tinh Xan May; Chao No May in the village of Ta Phin; Hang Thi Chi and Cheo Su May in the village of Ta Van.

IN EUROPE

Marie Laure de Villepin, ambassadress of our project; Franck Portelance and FUJIFILM France for their trust and support; Madeleine Viviani, in Berne, at UNESCO's Swiss Commission, for her invaluable support throughout this project; Jean Pierre Boyer and Janine D'Artois in Paris at UNESCO's French Commission; Bruno Baudry who gave us the wings we needed for this project to take off; Pierre Bigorgne for his faithful support and constant enthusiasm; Jean Marc and Deki Youdon Falcombello and Myriam Rossi, Michel and Hye Sook Herlemont, Matthieu Ricard, Raphaëlle Demandre and Jean Michel Strobino for their friendship and generous advice; Bernard Gachet for his invaluable support and constant encouragement; Lama Denis, Lama Lhundroup and Lama Sengye at the Institut Karmaling in Arvillard for their guidance on this project, as well as Bernard Montaud; Philippe Lavorel for his generosity and advice throughout this project; Stéphane Méron in Annecy for technical assistance throughout the year; Jemel Gir Alyamak and Richard Petit from Mondo Fragilis, for their support with the Offerings for Humanity project; Matthias Huber, friend and publisher at Editions Olizane in Geneva, a specialist in Asia, for his generous advice; André Capurro fo his invaluable aid, along with Philippe Roux, Magalie Madec and Carine Malbosc from Orkis; Claude Levenson for his friendship, advice and translation skills; Charles Breger for his literary advice; Corneille Jest, our faithful and precious adviser; Jean Sellier for guiding our geographical choices throughout this projec François Beyens, Jigmé Douche, Hubert Durt and Young-Soo Vandersmissen for their literary advice and proofreading; Julia Summerton for her translations; Ki Sabatier for her calligraphy; and to Renaud Neuenbauer, our friend in Quito in Ecuador, a specialist in the cultures of Asia, who guided us in the preparatory s of this project.

Photographic assistance in Asia

Tenzin Diskit, my assistant in Thailand, Myanmar, Laos and Vietnam.
Lin Liao Yi, my interpreter in China.
Varunee Skaosang, my assistant in Thailand, China, Vietnam and Myanmar, and in charge of
selection and logistics in Bangkok and France.
Jacky Wen Yutao, my second assistant and guide in Yunnan, China.

Photographic assistance in Europe

At the Föllmi studio:
Viviane Bizien, Corinne Morvan-Sedik, Emmanuelle Courson, Stéphanie Ly and Nicolas Pasquier,
who provided the necessary framework for the creation of this book and were always on hand.
Guy de Régibus in Paris, for his detailed and demanding selection of photos.
Virginie de Borchgrave in Brussels, for editorial assistance and travel preparations.
At Editions de La Martinière: Emmanuelle Halkin and Illiari Mujica, Dominique Escartin and
team, Valérie Roland, Marianne Lassandro and team.
Thanks also to Elia Fumagalli, Carlo Fumagalli, Giancarlo Pinali, Elio Perego, Sara Scopel and
Sabrina Zorloni from the Articrom team in Milan.

Special thanks to Hervé de La Martinière for his unswerving support and deep trust.

DANIELLE AND OLIVIER FÖLLMI

Art Center College of Design
Library
1700 Lida Street
Pasadena, Calif. 91103

This book is the fifth volume in the
Offerings for Humanity series
promoting the spiritual heritage of mankind.

This seven-year project began in 2003 and its expeditions have been made possible
through the generosity of an anonymous donor and Lotus & Yves Mahé.

This project was carried out with the support of

FUJIFILM

and the Paris laboratories of

DUPON

and the cooperation of

 and **GRANDS REPORTAGES**

in Myanmar.

The Offerings for Humanity series is supported by

under the patronage of UNESCO's Swiss Commission.

To purchase images from this book: **www.follmishop.com**

To find out more about the photographer and his work: **www.olivier-follmi.com**

To find out more about the Sagesses de l'Humanité project: **www.sagesses.com**

Danielle & Olivier Föllmi founded the organization HOPE to aid village co-operation and education: **www.hope-organisation.com**

Translated from the French *Eveils: 365 pensées de sages d'Asie* by David H. Wilson

Jacket design by Shawn Dahl

Library of Congress Control Number: 2007929899

ISBN 10: 0-8109-9379-1
ISBN 13: 978-0-8109-9379-2

Copyright © 2006 Éditions de La Martinière, an imprint of La Martinière Groupe, Paris / Editions Föllmi, Annecy

English translation copyright © 2007 Thames & Hudson, London, and Abrams, New York

Published in North America in 2007 by Abrams, an imprint of Harry N. Abrams, Inc.
All rights reserved. No portion of this book may be reproduced, stored in a retrieval system, or transmitted in any form or by any means, mechanical, electronic, photocopying, recording, or otherwise, without written permission from the publisher.

Printed and bound in France
10 9 8 7 6 5 4 3 2 1

HNA ▌▌▌▌▌
harry n. abrams, inc.
a subsidiary of La Martinière Groupe
115 West 18th Street
New York, NY 10011
www.hnabooks.com

FRONT COVER: Statue of Buddha at the temple of That Luang in Vientiane, Laos.
BACK COVER: The sacred mountains of Huangshan, China.

The way is circular, peaceful, wide as the vast cosmos, perfect.

Master Taisen Deshimaru

Art Center College Library
1700 Lida St.
Pasadena, CA 91103